CHAGALL
AND
THE BIBLE

CHAGALL
AND
THE BIBLE

JEAN BLOCH ROSENSAFT

THE JEWISH MUSEUM, NEW YORK

UNIVERSE BOOKS
New York

The exhibition *Chagall and the Bible* has been made possible by
generous grants from:
 The Morris S. and Florence H. Bender Foundation
 The Joe and Emily Lowe Foundation
 S. H. and Helen R. Scheuer Family Foundation

Published in the United States of America in 1987
by Universe Books
381 Park Avenue South, New York, NY 10016

© 1987 The Jewish Museum
under the auspices of
The Jewish Theological Seminary of America

Cover etching: Jacob's Ladder

87 88 89 90 91 / 10 9 8 7 6 5 4 3 2 1

Printed in Hong Kong

Library of Congress Cataloging-in-Publication Data

Rosensaft, Jean.
 Chagall and the Bible.

 Exhibition of Chagall's etchings at the Jewish
Museum, New York.
 1. Chagall, Marc, 1887– –Exhibitions.
2. Bible. O.T.–Illustrations–Exhibitions.
3. Etching, Russian–France–Exhibitions.
4. Etching–20th century–France–Exhibitions.
I. Chagall, Marc, 1887– II. Jewish Museum
(New York, N.Y.) III. Title.
NE2056.5.C45A4 1987 769.92'4 86-30885
ISBN 0-87663-653-9
ISBN 0-87663-518-4 (pbk.)

TABLE OF CONTENTS

Introduction

Among the artists of the 20th century who have worked wtih Jewish themes, Marc Chagall is certainly the most well-known. In this exhibition, we see his works devoted to the Bible, whose teachings, stories and images form centuries of Jewish culture.

The Jewish Museum presents art and artifacts which encompass the continual generation and regeneration of Jewish culture. In this context, Chagall is a uniquely important figure. He is not only a master of modern art, but also an artist whose Jewish identity has been a well-spring for extraordinarily compelling imagery. In the forms, symbols and style of his work, Chagall expresses both the spirituality and charm of his experience as a Jew as well as the sense of mystery and philosophical struggle.

The inspiration for creating this exhibition was a fortunate acquisition in 1986 of suite No. 272 of Chagall's *Bible.* A gift of Mr. and Mrs. Curtis Hereld in memory of Dr. and Mrs. W. Reichmann, the suite serves as a tribute to the Reichmanns' interest in the merger of art and Judaism and also comprises an enormously valuable addition to the museum's collection of 20th-century art.

Exhibition curator Jean Bloch Rosensaft has presented the 105 *Bible* etchings as a basis for exploring a variety of forms of expression inspired by the *Bible* throughout Chagall's career. To realize this goal, eighteen paintings and works on paper, from Chagall's early Fauve and Cubist period in the 1910s through his late work of the 1980s, have been borrowed from public and private collections. We deeply appreciate the participation of these lenders, as their cooperation has been essential to the success of the exhibition:

> Albright-Knox Art Gallery
> Mr. and Mrs. Leon Gildesgame
> Phyllis and Leonard Greenberg
> Pierre Matisse Gallery
> The Metropolitan Museum of Art
> Musée National du Message Biblique–Marc Chagall
> The Museum of Modern Art
> Perls Galleries
> Philadelphia Museum of Art
> Rockefeller University Collection
> Dr. and Mrs. Fred Rosenblum
> The Evelyn Sharp Collection
> Harriet and Mortimer Spiller
> Anonymous lenders

In addition, we are most grateful to the following funders whose generous contributions have made this exhibition possible:

The Morris S. and Florence H. Bender Foundation

The Joe and Emily Lowe Foundation

S. H. and Helen R. Scheuer Family Foundation

The museum's operations for exhibitions are also supported, in part, by a grant from the New York State Council on the Arts. Many thanks are extended to all of these funders and lenders for their support.

On the museum staff, special thanks are due to Jean Bloch Rosensaft, who has added to her responsibilities as Assistant Director of Education in order to curate this exhibition and prepare the catalogue. She has performed this task with the care and zeal which reflect a profound enthusiasm for Chagall's work and her great commitment to the educational mission of the Jewish Museum.

Curator of Collections Norman Kleeblatt has guided Ms. Rosensaft's work, and I thank him for his attentive cooperation and assistance in helping to acquire and present a treasure of the Jewish Museum's collection to the public. I also thank the Board of Trustees of the Jewish Museum and the staff and Board of The Jewish Theological Seminary of America for their encouragement and continued support of an ambitious, vital and varied exhibition program.

Joan Rosenbaum
Director

Acknowledgments

Chagall and the Bible comprises two complementary components: this catalogue/study of Chagall's *Bible* suite from the Jewish Museum's collection and the related exhibition of these etchings, supplemented by major paintings and works on paper borrowed from private and public collections. Organized on the occasion of the centennial of the artist's birth, this exhibition and catalogue celebrate Chagall's unique role as a modern day prophet, rooted in the Old Testament, whose 'biblical message' teaches universal human understanding, peace and love.

I would like to express my sincerest gratitude and warmest appreciation to:

Mme. Valentina Chagall and Bella Meyer Simonds, for their kind interest and invaluable assistance from the very outset of this project;

Joan Rosenbaum, for her personal support and confidence in affording me this special opportunity;

Norman Kleeblatt, for his exemplary taste and judgment which have guided me throughout the course of *Chagall and the Bible*;

Susan Goodman, for her superb aesthetic sensibility and generous encouragement;

Judith Siegel, for her dedicated leadership and staunch, empathetic friendship;

Andrew Ackerman, for his cogent advocacy and insightful counsel;

Erika Sanger, Phyllis Greenspan, Sheila Friedland, Tamar Finkelstein Major and Fay Schreibman for their sustaining support and warm friendship;

Rosemarie Garipoli, Joan Diamond and Robin Rosenbluth, for their untiring efforts in engendering funding support for this exhibition, and Anne Scher for her assiduous promotion of the exhibition and its related public programs;

Vivian Mann for her thoughtful interest in the catalogue, and Ruth Dolkart, Robin Cramer and Sybil Weingast for their practical assistance with this publication;

Rita Feigenbaum and Susan Palamara, for their capable management of the complex loan arrangements;

Anne Driesse, Ginny Bowen and Belle Saunders Kayne, for their careful preparation of the etching suite for exhibition;

Harley Spiller, Emily Bilski, Edith Aussenberg, Naomi Birnbach and Sylvia Wiener, for facilitating my contact with several private collections;

Al Lazarte and his staff for their able supervision of the exhibition installation;

Breslin Mosseri Design, for the innovative and inspired installation of *Chagall and the Bible*;

Adele Ursone and Eileen Schlesinger of Universe Books for their enthusiastic assistance in the design and publication of this catalogue.

Finally, neither this catalogue nor the exhibition, *Chagall and the Bible*, would have been possible without the loving support of Lilly and Sam Bloch, Rose and David Czaban, Sonia Bloch and Gloria Bloch Golan; the devoted encouragement of Hadassah and Josef Rosensaft, who first introduced me to the profound beauty and Jewish essence of Chagall's art; and the infinite patience and understanding of my two dearest and wisest advisors, my husband Menachem and our daughter Jodi.

Jean Bloch Rosensaft
Exhibition Curator

CHAGALL AND THE *BIBLE*

Jean Bloch Rosensaft

I. CHAGALL'S *BIBLE*

Since my early youth
I have been fascinated by the Bible.
It has always seemed to me
and it seems to me still
that it is the greatest source
of poetry of all time.
Since then I have sought
this reflection in life and in art.
The Bible is like an echo
of nature and this secret
I have tried to transmit.[1]

Marc Chagall

Marc Chagall's *Bible* (1931–39, 1952–56) represents an enormous undertaking, embarked upon in his middle age and completed only after twenty-five years. It brings together the mature artist's spirituality and childhood's fantasy through the sophisticated artistry of a master printmaker. In Chagall's *Bible,* from *Genesis* through the *Prophets,* the Hasidim of Vitebsk encounter Rembrandt and El Greco beneath the vivid light of Palestine. And as the decade of the 1930s advances, Chagall's depiction of biblical antiquity becomes increasingly expressive of a contemporary world doomed for destruction.

Chagall approaches the *Bible* with an independent and uniquely humanist interpretation. Through psychologically acute portraits of key individuals in decisive moments, Chagall illustrates the Old Testament as a cycle of historic encounters between man and God. His focus on this relationship is made clear by beginning the suite with the creation of man. Drawing upon all the extremes of human emotion and experience within man's life cycle, Chagall illuminates the human condition. Thus, patriarchs, kings and prophets are never idealized but are revealed in their weakness and their strength.

Chagall devises symbolic representations to suggest the presence of God in the *Bible*: disks of light inscribed with God's name, God's rainbow and hands, and, most frequently, God's messengers — the angels. In Chagall's *Bible,* the supernatural and the natural coexist and communicate clearly through expressive glances, gestures and poses.

Chagall's *Bible* etchings range between pure expression and illustration.[2] Some extract the essence of the text while others visually delight in the evocative and descriptive poetry of the verses. Yet each work remains closely allied to the textual source, thereby enhancing the accessibility of its biblical message. Liberated from the distraction of color, Chagall achieves in these black and white prints a concentrated manifestation of humanity and sentiment.[3]

Chagall as a modern artist and as a Jewish artist is freed from the traditional Christian interpretation of the Old Testament, with its emphasis on sin and the prefiguration of the New Testament.[4] Chagall's biblical universe prefers to speak of grace and joy, fraternity and love and, if the sadness of the world is also present, then symbols of consolation are always close by.[5]

As Meyer Schapiro has explained, "Chagall's independent vision masters the epic of the *Bible* due to the happy conjunction of his Jewish culture — to which painting was alien — and modern art — to which the Bible has been a closed book."[6] Through these etchings and the large number of monumental, publicly exhibited works they have inspired, Chagall's biblical message is transmitted to people of all faiths in the hopes of fostering human understanding, peace and love.

II. CHAGALL'S PUBLISHERS: VOLLARD AND TÉRIADE

Come back, you're famous, and Vollard is
waiting for you.[7]

Letter from Blaise Cendrars to Marc Chagall in Berlin, 1922

When Chagall had left Russia for the first time, to live and work in Paris from 1910 to 1914, he had become good friends with the poet Cendrars. While in Paris, Chagall had been too intimidated to meet the noted art dealer and publisher, Ambroise Vollard,[8] whose celebrated gallery was filled with works by Cezanne, Renoir, Maillol, Bonnard, Pissaro, van Gogh, Picasso, Matisse and others. During Chagall's return to Russia from 1914 to 1922, Cendrars had sold a number of works which Chagall had left behind at his La Ruche studio. Vollard thus first discovered Chagall's paintings at the home of the art critic Gustave Cocquiot. Cocquiot, assuming that Chagall had disappeared in the Russian Revolution, referred Vollard to Cendrars.[9] Cendrars' exciting letter reached Chagall in Berlin, where the artist had spent some months after leaving Russia for the second and last time in 1922.

Chagall quickly returned to Paris and embarked on a relationship with Vollard that would dramatically broaden his horizons as an artist. As Chagall explained, "The encounter with Vollard, who commissioned from me large illustrated books. . .also contributed to orient me in another voice."[10]

Vollard's genius was in commissioning the important artists of his day to produce illustrated books.[11] As his first project for Vollard, Chagall chose to illustrate Gogol's *Dead Souls,* for which he etched 110 plates from 1923 to 1927. These satirical etchings sprang out of Chagall's Russian consciousness and his identification with the exiled Russian writer.[12] Chagall's second project, suggested by Vollard, was the illustration of La Fontaine's *Fables.* The assignment of this French classic read by all French school children to a foreign artist outraged the public. Yet Vollard defended Chagall's special ability to capture the Oriental quality of these stories. In 1930, while still completing the 100 plates for the *Fables,* printed from 1928 to 1931, Chagall and Vollard agreed on the third project, the *Bible.*

Le Livre des Prophètes, as this project was initially titled,[13] was originally intended to comprise five volumes: *Genesis, Book of Kings, Book of Prophets, Song of Songs* and *The Apocalypse.*[14] Vollard's equally impractical intention was for Chagall to create forty etchings for each volume.

Vollard frequently visited Chagall at the printmaking atelier of Maurice Potin, where Chagall completed etching his plates. Vollard greatly appreciated Chagall's work and felt that the Bible would be his and Chagall's monumental work. In his quest for fame, Vollard wanted to be immortalized as the publisher of a modern *Bible.*[15]

At the time of Vollard's accidental death in 1939, several months before the outbreak of the second World War, 65 *Bible* etchings had been printed and were in Vollard's possession, 35 remained to be printed at Potin's studio, and the last five plates had been delivered by Chagall to Vollard the morning before his death.[16] Neither *Dead Souls* nor *Fables,* although printed, had been issued by the eminent publisher, who was generally inclined to hoard artists' works for long periods of time. At his demise, large numbers of prints and artists' books by Rouault, Braque, Derain, Picasso and others had never been released.

Vollard's brother Lucien announced his intention to issue the *Bible* on June 1, 1940, but with the fall of France to the Germans, this was never realized. Upon Chagall's return to France in 1948, after his exile in the United States during the second World War, he and his daughter Ida reestablished contact with Lucien Vollard. They were able to recover the plates which had been divided among the publisher's heirs.[17] Ida, who had chosen the biblical passages for each etching,[18] was ultimately responsible for seeing that Chagall's three suites for Vollard were published by Tériade.[19]

Tériade began as the art page editor of *L'Intransigeant* (1928–32) and editor, from 1933, of the first issues of the surrealist revue *Minotaure.* Publisher of the celebrated art revue *Verve* (1937–60), Tériade

was responsible for publishing 26 artists' books by the greatest artists of the School of Paris, including Matisse's *Jazz* (1947), Picasso's *Le Chant des Morts* (1948) and Miro's *Ubu Roi* (1966).[20]

To realize the remaining 40 plates of the *Bible*, fifteen years after the initial 65 were pulled at the Potin atelier before the war, Tériade had to rediscover the inks and papers which had been used previously. Chagall saw to the homogeneous printing of the last 40 etchings at the atelier of Raymond Haasen from 1952 to 1956.[21]

Completed in 1956, the *Bible* ultimately comprised two volumes and 105 etchings. 275 sets on Montval paper and XX Hors Commerce sets for collaborators were signed by the artist. An additional 100 albums on Velin d'Arches paper were hand-colored, signed and numbered by Chagall. In addition, Tériade published a double issue of *Verve* (Nos. 33–34) in English and French editions, reproducing the entire *Bible* suite and including 16 color lithographs and 12 black lithographs plus a special cover and title page especially designed for this issue by Chagall.

III. CHAGALL AND ETCHING

It seems to me that I would have lacked something if, aside from color, I had not also busied myself at a moment of my life with engraving and lithographs. From my earliest youth, when I first began to use a pencil, I searched for that something that could spread out like a great river pouring from the distant, beckoning shores. When I held a lithographic stone or copper plate, it seemed to me that I could put all my sorrows and my joys into them . . . everything that has crossed my life in the course of the years: births, deaths, marriages, flowers, animals, birds, poor working people, parents, lovers in the night, Biblical prophets, in the street, in the home, in the Temple and in the sky. And as I grew old, the tragedy of life within us and around us.[22]

Marc Chagall

Chagall first began making prints in 1922 in Berlin, when he was 35 years old and had been a painter for 15 years.[23] The art dealer and publisher Paul Cassirer and his director Walter Feilchenfeldt were responsible for introducing Chagall to the great German printmaker Hermann Struck. Their hope was that Chagall would produce etched illustrations for their publication of the artist's autobiography, *Mein Leben* (*My Life*),[24] which Chagall had completed in Moscow in 1922. While in Germany during that year, Chagall devoted himself to printmaking, perhaps influenced by the importance of prints in 20th century German art, beginning with the woodcuts and etchings of the German Expressionists.[25] Chagall briefly experimented with lithography and woodcuts, but quickly developed a preference for the more time-consuming and demanding (and thus less popular) technique of etching. Etching allowed for much more complex possibilities in terms of tonal intensity, texture and patterning.

Through Chagall's illustrations of three books for Vollard, the artist technically advanced from the naive linearity of his crowded, animated scenes for Gogol's *Dead Souls* (1923–27), to the complex textures and painterly effects of La Fontaine's *Fables* (1928–31), culminating in the monumentality and subtlety of his *Bible* etchings (1931–39, 1952–56). With the *Bible*, Chagall utilized unconventional methods of making an etching. Rather than using the traditional etching tools, he preferred using anything capable of scratching or cutting, including phonograph needles and pens.

Chagall built up the dark areas of his etchings by carefully bitten lines, delicate cross-hatchings and shading in drypoint. These darkened areas and forms were achieved by dense webs of woven strokes rather than by linear drawing. By covering a previously etched section with a porous lacquer, he intensified patches of light within the already darkened areas of the plate. These light areas were then reworked with a burin to achieve translucent effects. Chagall also used sandpaper or a somewhat transparent varnish to produce the most subtle gradations of light in plates featuring brilliant, light-filled skies. The complexity and sophistication of Chagall's process are documented by the trial proofs of the suite, which indicate that there were no less than four and sometimes as many as 14 states for each etching.[26]

IV. BIBLICAL ROOTS IN VITEBSK

If my art played no part in my family's life, their lives and their achievements greatly influenced my art.[27]

Marc Chagall

Chagall was born on July 7, 1887 in Vitebsk, Russia, into a large family of modest circumstances. During his childhood, Vitebsk's population was approximately 66,000, of which a little more than half were Jews. A center of Orthodox Judaism, Vitebsk combined the tradition of Lithuanian Jewish scholarship with the strong influence of Habad Hasidism. Habad had been established by the founders of Lithuanian Hasidism, Menahem Mendel of Vitebsk and Schneur Zalman of Lyady, at the end of the 18th century. Their doctrine formulated a rational form of Hasidism which synthesized mystical faith and knowledge through learning.[28]

As a young child, Chagall went to *cheder* (religious school), as did three-quarters of school-age Jewish children in Vitebsk during the last years of the 19th century.[29] Of his memories of his early education, Chagall recalled: "I think my first little rabbi from Mohileff had the greatest influence on me. Just imagine! Every Saturday, instead of going bathing in the river, my mother sent me to him to study *Bible*."[30]

Inflecting this education was the pervasive atmosphere of Hasidism, which permeated Chagall's home and community and provided the sustenance and foundation for his art. Hasidism, founded in the mid-18th century by the mystic Baal-Shem-Tov, sought a simple, democratic Judaism based on genuine emotional faith rather than scholarship and formal observance of law and ritual. Appealing to a large segment of Eastern European Jewry, Hasidism defined true piousness as man's communion with God through fervent prayer and joy. The essential teachings of Hasidism asserted that God could be found everywhere and in everything, even in the simplest of material objects. This form of Judaism also held the Kabbalistic belief that man, through constant interaction with God, could influence God's will. In lieu of dry erudition and the rote observance of ritual, Hasidism promoted worship imbued with religious ecstasy through song and movement. Through Hasidism, holiness could be discovered in the everyday, the weary and the poor.

Chagall's autobiography, *My Life,* reflected his Hasidic milieu in his descriptions of wedding cele-brations,[31] his grandfather at prayer in the synagogue,[32] and even his visit to consult the spiritual leader of Habad Hasidism, Rabbi Schneersohn, on whether to remain in Vitebsk or move to Petro-grad.[33] The Hasidic belief in the ever present possibility of the arrival of the Messiah was expressed in Chagall's childhood fantasies about Elijah arriving at his door disguised as a weary beggar.[34]

Thus, the Hasidic dance and music of Vitebsk were imbued in scenes of celebration in the *Bible,* such as *Dance of Miriam, Sister of Moses* [Plate 35], *The Ark Carried to Jerusalem* [Plate 68], and *Anointing of King Solomon* [Plate 76]. Similarly, the non-idealized, real faces and awkward, clumsy figures

portraying the biblical patriarchs, kings and prophets were the everyday people of Chagall's simple milieu whose Hasidism elevated them above the hard reality of their lives and brought them close to God.

Even Chagall's unique narrative skills (in his writing and in his art) were rooted in Hasidism. The Hasidic tradition was made up of aphorisms, tales and parables whose disconnected structure and sudden transitions and omitted explanations provided illumination rather than reasoning.[35] Chagall's Hasidic love for stories and story-telling was certainly reflected in the *Bible.* He clearly related his etchings to the biblical texts yet enlivened them with idiosyncratic compositions, cryptic symbolism and abrupt shifts in scale within each plate. His intermingling of the natural and the supernatural into a reality where angels and man sit together at the same table [Plate 7][36] was surely rooted in the mysticism of Hasidism.

V. PREFIGURATIONS OF THE *BIBLE* IN CHAGALL'S EARLY ART AND WRITING

My God is the Jewish God, the God of our ancestors! My sacred book is the Bible.[37]

Marc Chagall

Among the earliest manifestations of biblical subject matter in Chagall's work were his depictions of Adam and Eve in works dated 1910–12. His treatment of this subject, which he curiously omitted from the *Bible* suite, ranged from lending an Old Testament title to a caricaturesque depiction of an everyday scene of a Russian man and woman eating fruit at the table in *Adam and Eve* (1910) to his more mystical reflections on the nature of man and creation in his *Homage to Apollinaire* (1911–12) and its preparatory studies.

Chagall's other early biblical works included those with overt biblical subjects and titles, such as *Cain and Abel* (1911) as well as works inflected with biblical symbolism, as in his depiction of the prophet Elijah disguised as a floating beggar in *Over Vitebsk* (1914) or transformed into a Russian peasant flying off in a cart in *The Flying Carriage* (1913). Simultaneously with these Old Testament works, Chagall also delved into New Testament subjects, including his *Resurrection of Lazarus* (1910) and his first treatment of the crucifixion in *Calvary* (1912).

In addition to depicting Old and New Testament subjects in several of his 1910–14 paintings and works on paper, Chagall actually utilized biblical texts for the Hebrew lettering backgrounds for *Jew in Green* (1914) and *Jew in Bright Red* (1914–15). These texts referred to Moses' instructions on vows between man, woman and God and biblical injunctions to return to the Promised Land to marry. Specifically chosen by Chagall for their private meaning, these texts directly related to Chagall's having returned to Russia to marry his first wife, Bella Rosenfeld.[38] In *Cemetery Gates* (1917), Chagall inscribed words from *Ezekiel,* promising God's redemption of the dead, over the gateway into a Jewish cemetery. The unusual inclusion of this inscription, usually not found in such a place, transformed the work into a memorial for Russian Jews who perished in 19th- and 20th-century pogroms.[39]

Aside from the visual depiction of biblical texts and imagery in his early paintings and works on paper, Chagall filled his early writings with a number of biblical references. In *My Life,* the autobiography written in Moscow between 1921 and 1922, Chagall frequently alluded to his study of the Bible in his fascination with the prophet Elijah,[40] and his dreams of angels[41] and nightmares inspired by such biblical events as Abraham's sacrifice of Isaac.[42]

These early manifestations of Chagall's profound interest in the Bible explain his suggestion of the *Bible* to Vollard as the theme for their third collaboration. With the *Bible*, Chagall was finally able to immerse himself in the images that had long haunted his imagination.

VI. OTHER SOURCES FOR THE *BIBLE*: ABROAD AND AT HOME

I never work from my head. When I had to illustrate the Bible for Vollard, he told me: "Go to Place Pigalle." But I wanted to see Palestine, I wanted to touch the earth. I went to verify certain feelings, without a camera, without even a brush. No records, no tourist impressions, and all the same I'm glad (is that the word?) to have been there. There, in the steep streets, from thousands of years before Jesus walked. There, far away, bearded Jews dressed in blue, yellow, red, wearing fur caps, go and come back to the Wailing Wall. Nowhere will you see so much despair, so much joy; nowhere will you be so distressed and so happy as when seeing the age-old mass of stones and dust of Jerusalem, of Safed, of the mountains where prophets are buried over prophets.[43]

Marc Chagall

After executing some preparatory sketches for the suite in 1930, Chagall decided that he needed contact with the real world of the Bible and he thus embarked in 1931 on a trip to Palestine, Syria and Egypt with his wife Bella and their daughter Ida. During their visits to Alexandria, Cairo and the Pyramids, they met and travelled with two distinguished writers, Chaim Nachman Bialik and Edmond Fleg,[44] whose writings undoubtedly were of great interest to Chagall in the context of his preoccupation with his *Bible*. Bialik, the great Hebrew poet, essayist, storywriter, translator and editor, was in the process of freeing Hebrew poetry from its biblical influence and florid style. In his work, religious, Hasidic folk roots were transformed into a modern, philosophical and humanist rationale for Jewish existence. Fleg, the noted French poet, playwright and essayist, had returned from assimilation to Judaism to produce plays and verses expressing Messianic yearnings, to write biographies of such biblical figures as Moses and Solomon, and to analyze Christ as both victim and persecutor. Their conversations were undoubtedly as inspiring to Chagall's imagination as his experience of the Egyptian scenery.

In Palestine, Chagall and his family travelled to Haifa, where Chagall encountered his former etching teacher Hermann Struck,[45] to Tel Aviv, where Mayor Meier Dizengoff, a leading pioneer of modern Israel welcomed them and Chagall dedicated the new museum,[46] to Jerusalem, where he painted the *Wailing Wall*, and to Safed, where he painted the ethereal interiors of synagogues.

While in Palestine, Chagall often worked outdoors[47] and absorbed details of the arid landscape and Bedouin figures that would enrich his etchings. He also renewed contact with the familiar face and body types of Vitebsk for his biblical figures through his encounters with the Yiddish-speaking, Russian-Jewish pioneers of Palestine. Most important, however, was his vivid sensation of a completely new and overwhelming light and sky. Chagall later imbued his biblical etchings with this extraordinary light, bathing his Vitebskian, rustic figures with a spiritual illumination that placed them in the land of the Bible.[48]

During the 1930s, Chagall travelled frequently. In 1932, he visited Holland to study the works of Rembrandt, whose influence can be discerned in *Potiphar's Wife* [Plate 21], *Blessing of Ephraim and Manasseh* [Plate 25] and *Sacrifice of Manoach* [Plate 53]. The impact of El Greco absorbed during Chagall's 1934 trip to Spain can be detected in *Pharaoh's Dream* [Plate 22] and *Darkness Over Egypt* [Plate 31].

In 1935, Chagall travelled to Vilna and Warsaw, where he was again reminded of his Eastern

European roots through the familiar faces and synagogues and was struck by a new consciousness of the isolation of Polish Jewry.[49] In 1937, he journeyed to Italy and produced 15 *Bible* etchings in Tuscany.[50]

Aside from the impact of these travels and his encounters with the works of great old masters he admired, Chagall's *Bible* was also influenced by artists and writers closer to him. His collaboration with Vollard undoubtedly brought Chagall into closer contact with the work of another Vollard artist: Henri Rousseau. Chagall's *Prophet Killed by a Lion* [Plate 82] shares with Rousseau's paintings a kindred metaphysical vision, rooted in the ancient past, and not borrowed from other painters.[51]

The influence of his wife Bella, however, had the most impact on Chagall. Her renewed contacts with Jewish life in Palestine in 1931 and in Vilna in 1935 impressed her so deeply that she was inspired to write about her Vitebsk childhood in Yiddish. She described her early life as the youngest of seven children of a wealthy, Hasidic merchant family. Her portraits encompassed her home, her teacher, the sabbath, holy days and festivals and a traditional wedding. Chagall's 36 pen and ink drawings sensitively illustrated this volume, entitled *Burning Lights.* Their unique collaboration on this project continually reinforced Chagall's consciousness of his Vitebsk roots, thereby enhancing his access to the biblical fantasies and dreams of his childhood.

VII. BIBLICAL ANTIQUITY DEPICTED THROUGH THE LENS OF CONTEMPORARY JEWISH EXPERIENCE

How is it that the air, the soil of Vitebsk, my native town, the thousands of years of the Diaspora find themselves mixed with the air and soil of Jerusalem? How could I have imagined that in my work I would not only be led by my own hands, with their paints, but also by the poor hands of my parents, and that behind me would jostle and murmur still others, eyes closed and lips silent, wanting also to take part in my life. It seems to me that your tragic and heroic resistance movements in the ghettos have become mixed with my flowers, my beasts, my fiery colors.[52]

Marc Chagall

In the suite, Chagall relived the *Bible* as if it were his own life,[53] sometimes to the point of including his own features for Joseph [Plate 21] or God's messenger [Plate 45]. Similarly, Chagall's own life experience inevitably inflected his depiction of biblical antiquity.

As Chagall progressed on the suite from 1931 to 1939, developments in contemporary history increasingly began to mirror ancient Israel's darker moments. Chagall's distinct memories of Jewish persecution in Russia during the Kishinev pogrom of 1903 and during the first World War[54] were now sharply renewed by the rise of Nazism and anti-Semitic legislation in Germany. In 1933, Chagall's works in Mannheim, Germany, were destroyed by order of Goebbels.[55] In France, there was a progressive influx of refugees and exiles from the Reich. On November 9, 1938, *Kristallnacht*, thousands of synagogues were destroyed and tens of thousands of Jews were arrested in Germany, Austria and German-occupied Czechoslovakia. Thus, depictions of Israel's distress and salvation in the *Bible* by necessity became charged with the intensity of Chagall's personal, contemporary experience. *Capture of Jerusalem* [Plate 101], the last etching completed in Europe before the war, not only expressed the impending doom of European Jewry but prophetically represented the death marches of the Holocaust.

We are pleased to send you
this publication as one of the benefits
of your membership in
The Jewish Museum

When Chagall completed the last four etchings of the suite from 1951 to 1956, contemporary and personal history continued to influence these works. Chagall's escape from France to the United States in 1941 (through The Museum of Modern Art's sponsorship and the efforts of Valerian Fry's Emergency Rescue Committee) had removed him from the threat of deportation and annihilation during the war. Yet the Holocaust haunted his imagination—in his art and in his writings. In 1950, Chagall expressed some guilt at his survival and cited his biblical works in eulogizing the artist-martyrs of the Holocaust:

> Did I know them? Did I go to their studio? Did I contemplate their art from close or from far? And now, I leave myself, my years and go towards their unknown graves. They call me. They pull me with them into their graves, me the innocent one. Me, the guilty one. They ask me: where were you? I ran away.[56] . . . Suddenly, he descends towards me, out of my paintings, the King David I have painted with his harp in his hand. He wants to help me cry, he wants to play the strophes of the Psalms. Here also comes our Moses, who says: don't have fear of anyone; he commands you to stay asleep, tranquil, just until he engraves the new Tablets of the Law, for a new world.[57]

Chagall's hope for a new world was undoubtedly reinforced by the dramatic establishment in 1948 of the State of Israel, which Chagall visited in 1951. Thus, the impact on Chagall of the destruction of European Jewry and the rebirth of a Jewish homeland in Israel provided him with the historical and emotional context for his final, expressionist etchings based on the words of Jeremiah and Ezekiel.

By infusing biblical history with modern history throughout the *Bible* suite, Chagall combined the past, present and future in a timeless expression of man's complex relationship with God.

VIII. IMPACT OF THE *BIBLE* ON CHAGALL'S OEUVRE

Unlike Picasso, Chagall's graphic art and his painting have always been closely inter-related, the one affecting the other.[58] The *Bible* suite represents a central theme that enlivens Chagall's paintings, sculpture, mosaics, stained-glass windows, tapestries and ceramics for the duration of his career. The *corpus* of imagery he develops for the *Bible* is the source for virtually every important, monumental project from the 1950s on: his 17 paintings (1955–67) and sculptures (1951), mosaics (1971), and harpsichord decoration (1980) for his Museum of the Biblical Message in Nice;[59] the Old Testament imagery for his stained-glass windows for Metz Cathedral (1958–62) and the United Nations (1964);[60] the windows for the Zurich Fraumünster Church (1970)[61] and the Union Church of Pocantico Hills (1964–66)[62]; the *Crossing of the Red Sea* ceramic for the baptistry of Notre Dame de Toute-Grâce, Plateau d'Assy (1957)[63]; and the Gobelin tapestries for Israel's Knesset (1963–68).[64] In these major works, the themes and images first established in the *Bible* are faithfully quoted and reinterpreted through more complex presentations and elaborate technical processes.

Furthermore, Chagall's vocabulary of biblical images are also quoted in major works which do not initially seem to be at all biblical. In works celebrating music, images of David playing the lyre [Plate 66] are combined with the representation of Orpheus, as in *The Concert* (1957) and *The Source of Music* (1965–66). In late arcadian compositions, such as *Peasants by the Well* (1981), one can find the *Meeting of Jacob and Rachel* [Plate 15]. Even in Chagall's stage design of *A Fantasy of St. Petersburg (Scene 4)* (1942) for the ballet *Aleko*, Elijah's chariot [Plate 89] provides the backdrop for the tragic fate of a Russian poet.

Thus, for Chagall, the Bible becomes so intrinsic to his imagination that it emerges consciously and unconsciously in many of his works, adding additional layers of meaning open to multiple interpretations.

IX. THE *BIBLE* FOR CHAGALL

To best understand Chagall's devotion to the *Bible* as a major source of inspiration for his creativity and a dominant theme of his oeuvre, one should always return to his writings. His words, like his works of art, exude a simplicity and sincerity that cut through to the essence of the human spirit and reveal a deeper, more mystical reality:

> . . . *I went back to the great universal book, the Bible. Since my childhood, it has filled me with vision about the fate of the world and inspired me in my work. In moments of doubt, its highly poetic grandeur and wisdom have comforted me. For me it is like a second nature.*
>
> *I see the events of life and works of art through the wisdom of the Bible. A truly great work is penetrated by its spirit and harmony. I am probably not the only one to think so, especially in our times. Since in my inner life the spirit and world of the Bible occupy a large place, I have tried to express it. It is essential to show the elements of the world that are not visible and not to reproduce nature in all its aspects.* [65]
>
> <div align="right">*Marc Chagall*</div>

BIBLE

Chagall's *Bible* was published by Tériade in Paris in 1956. It comprises two volumes and 105 etchings of which 66 were printed by Maurice Potin (1931–39) and 39 were printed by Raymond Haasen (1952–56). The dimensions of 101 of the etchings are approximately 11½ to 12¼″ high by 8¹⁵⁄₁₆ to 9½″ wide; in four etchings, these dimensions are reversed. This catalogue reproduces the etchings in suite No. 272 out of the 275 sets printed on Montval paper and the XX Hors Commerce sets for collaborators. This suite of Chagall's *Bible* was purchased by the Jewish Museum through the generous gift of Mr. and Mrs. Curtis Hereld in memory of Dr. and Mrs. W. Reichmann.

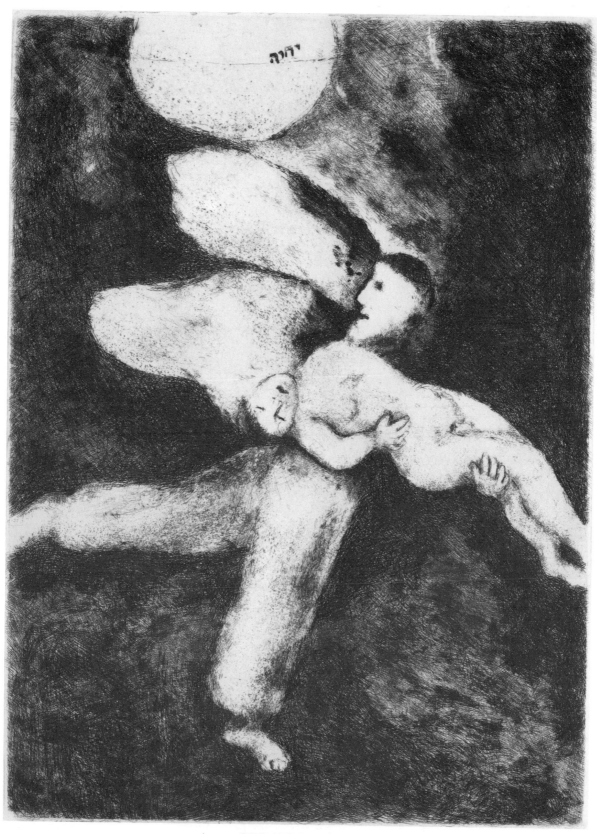

1 CREATION OF MAN

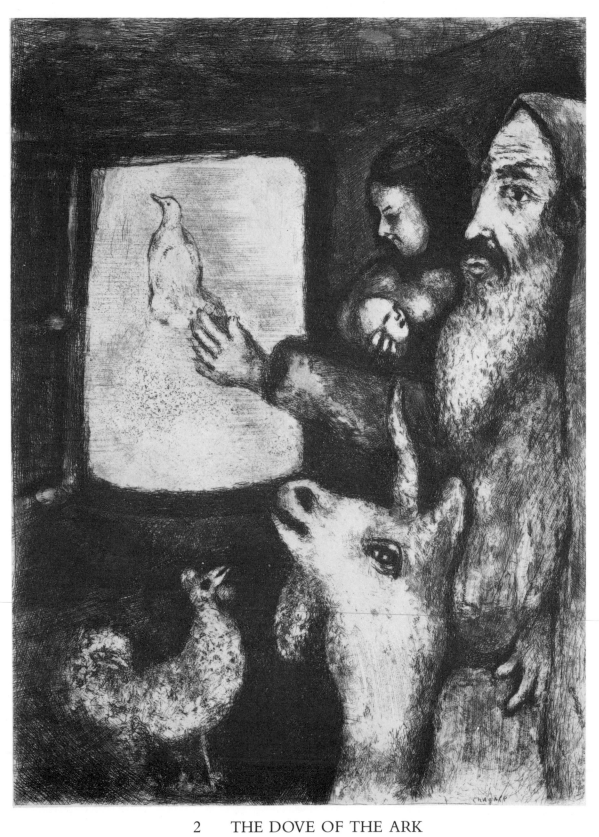

2 THE DOVE OF THE ARK

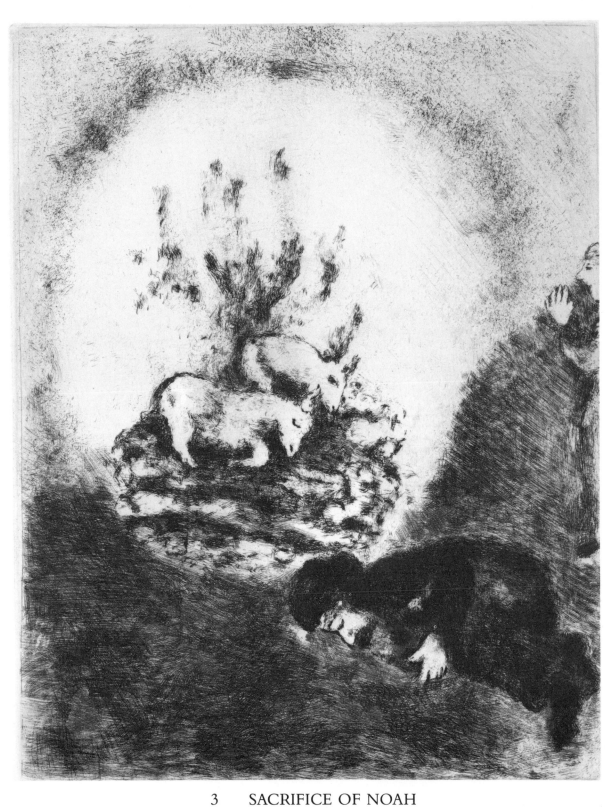

3 SACRIFICE OF NOAH

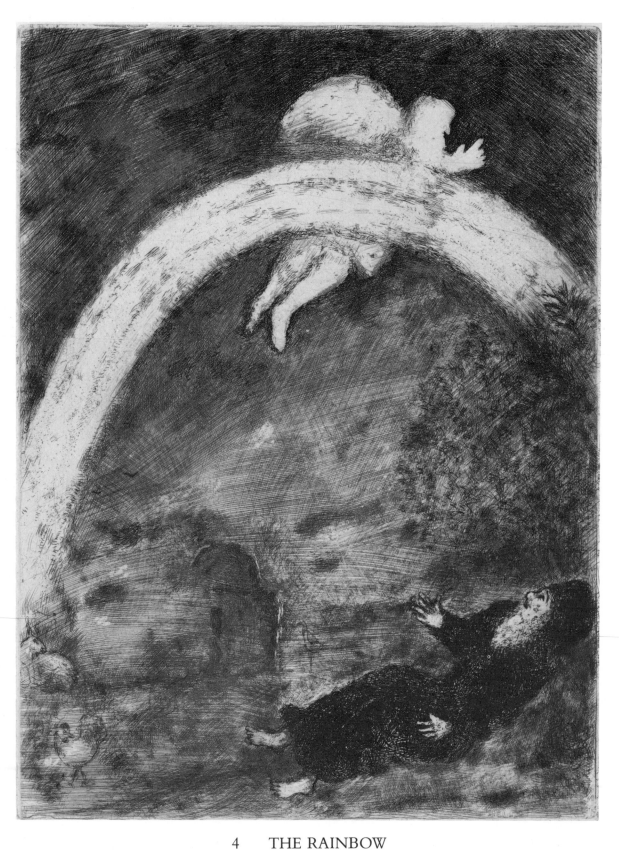

4 THE RAINBOW

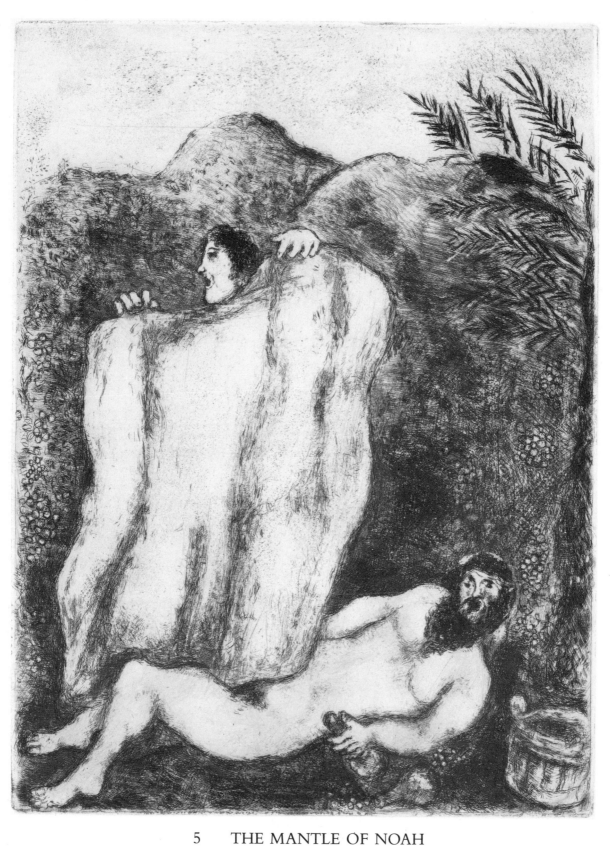

5 THE MANTLE OF NOAH

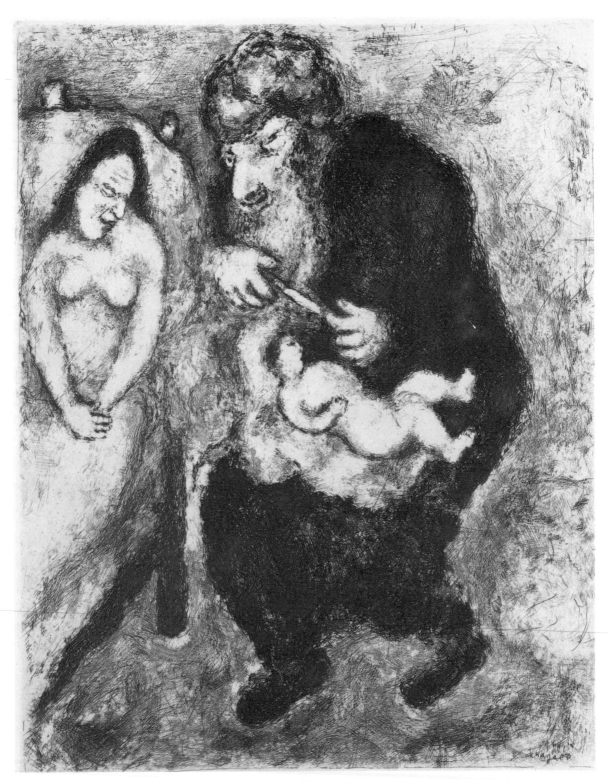

6 THE CIRCUMCISION

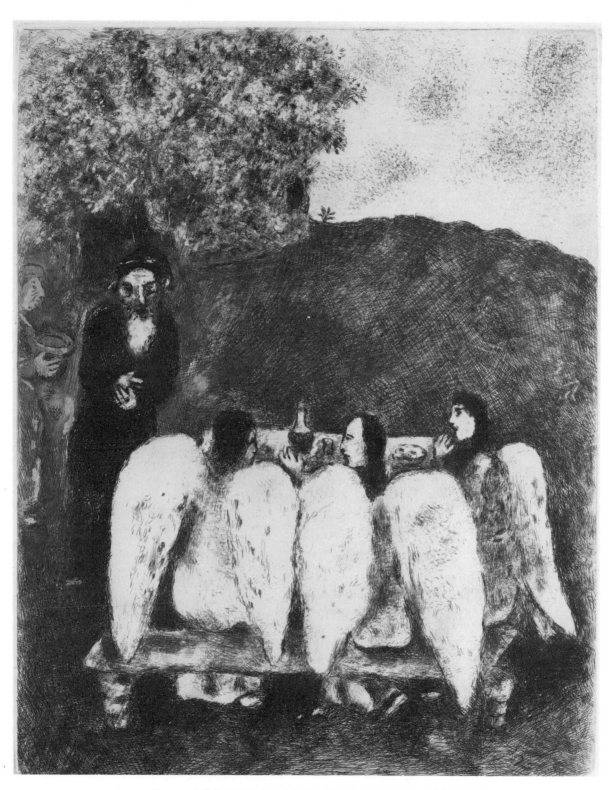

7 ABRAHAM AND THE THREE ANGELS

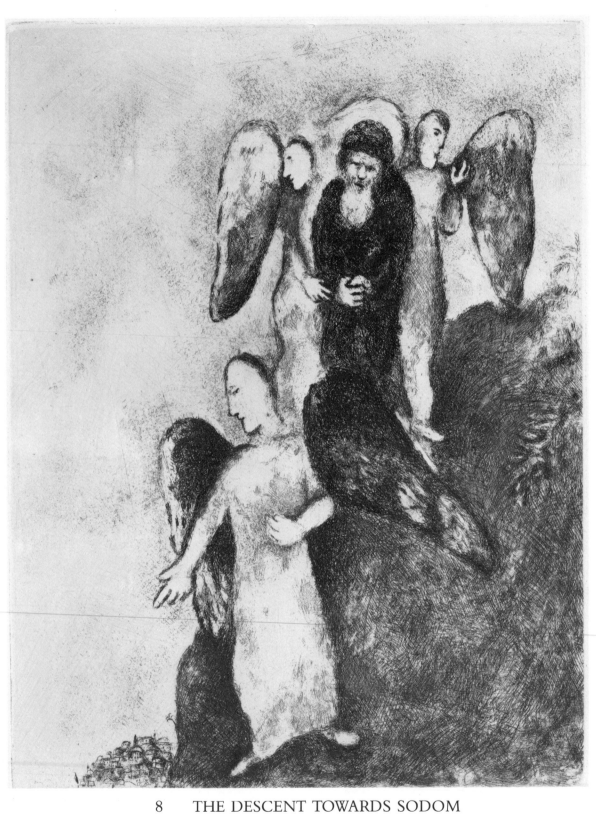

8 THE DESCENT TOWARDS SODOM

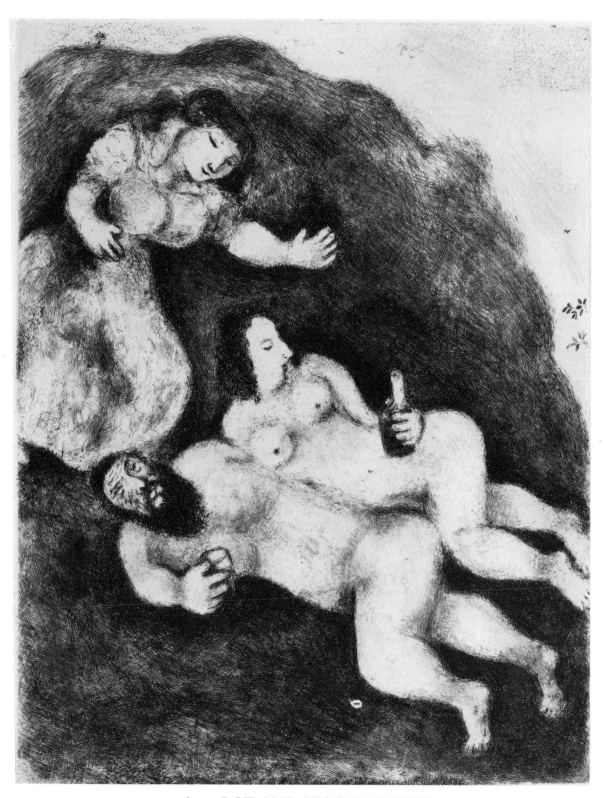

9 LOT AND HIS DAUGHTERS

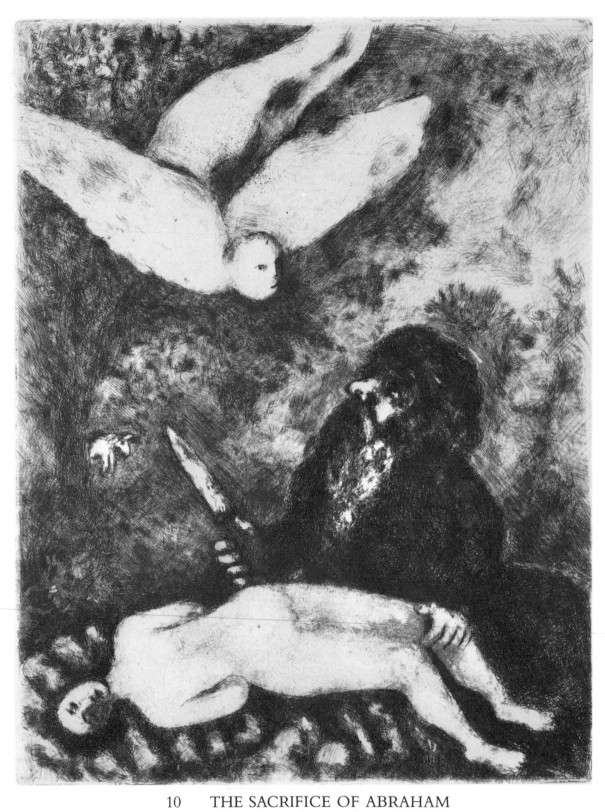

10 THE SACRIFICE OF ABRAHAM

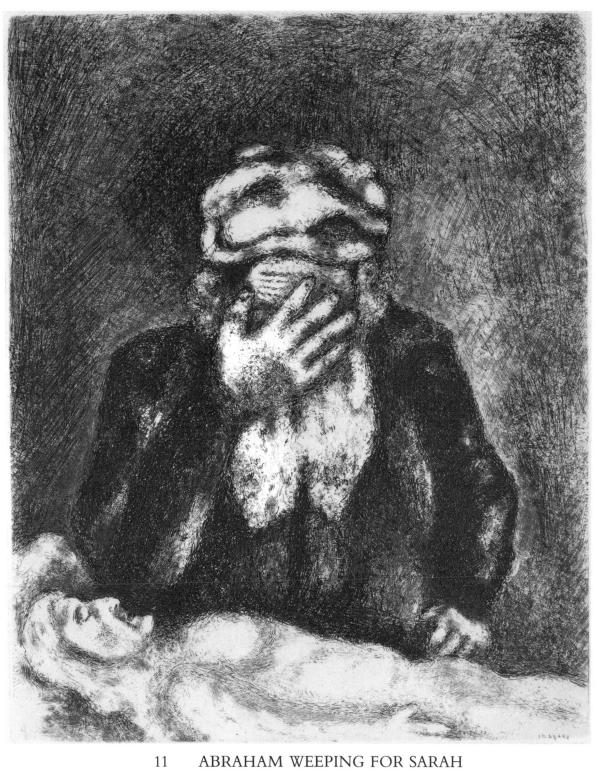

11 ABRAHAM WEEPING FOR SARAH

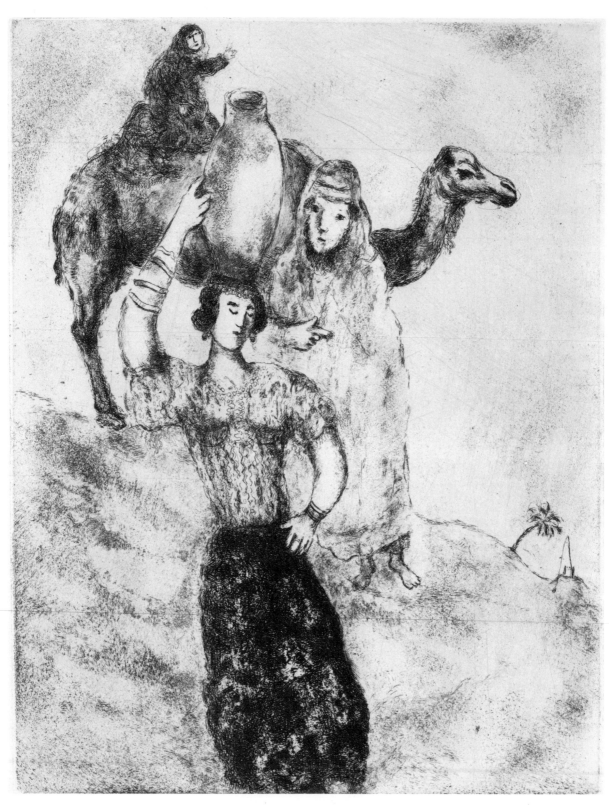

12 REBECCA AT THE WELL

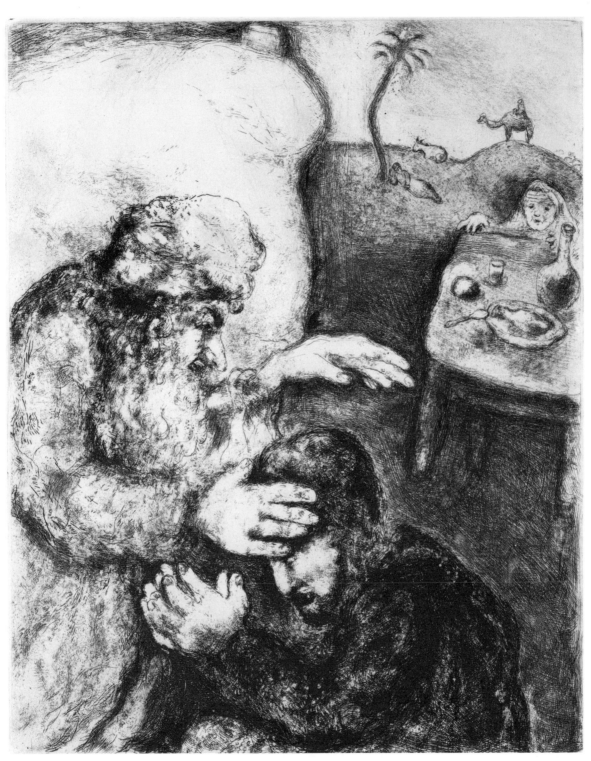

13 JACOB BLESSED BY ISAAC

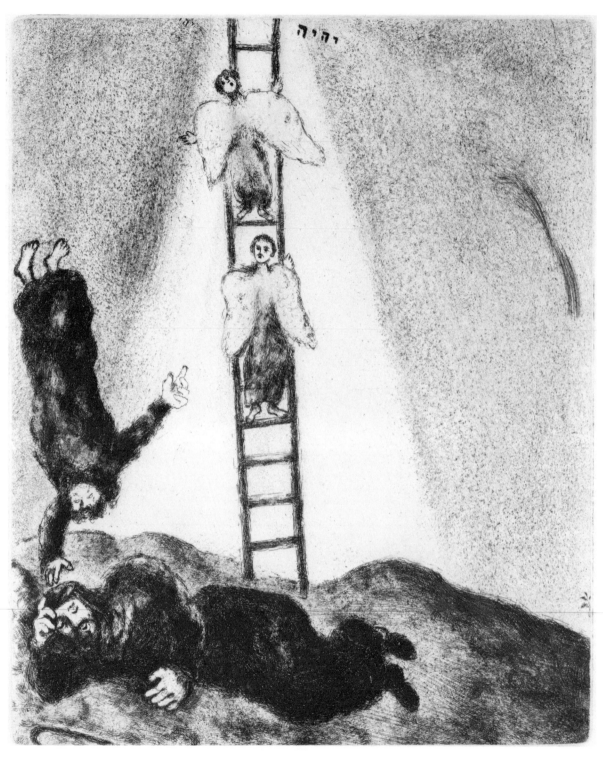

14 JACOB'S LADDER

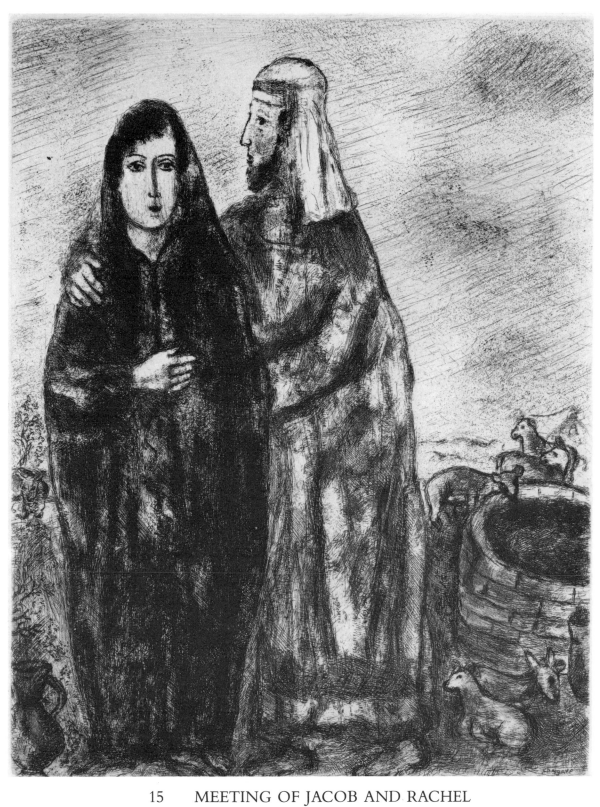

15 MEETING OF JACOB AND RACHEL

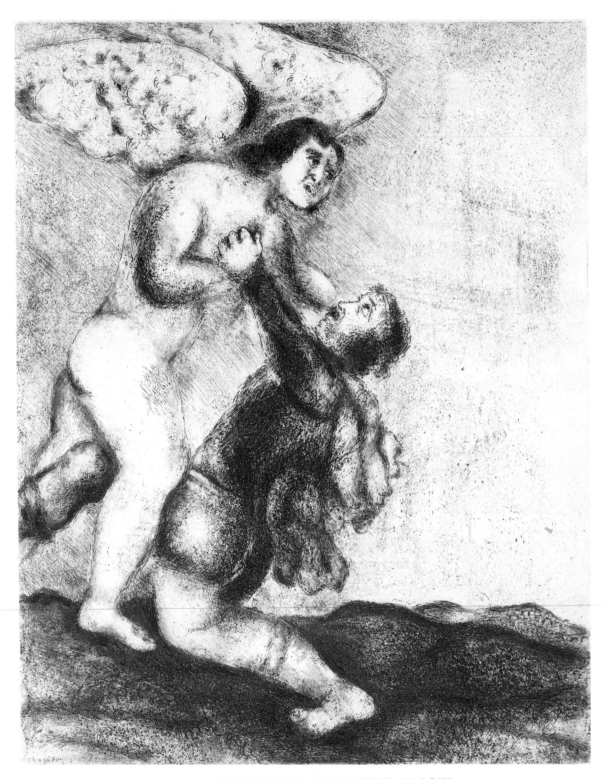

16 WRESTLING WITH THE ANGEL

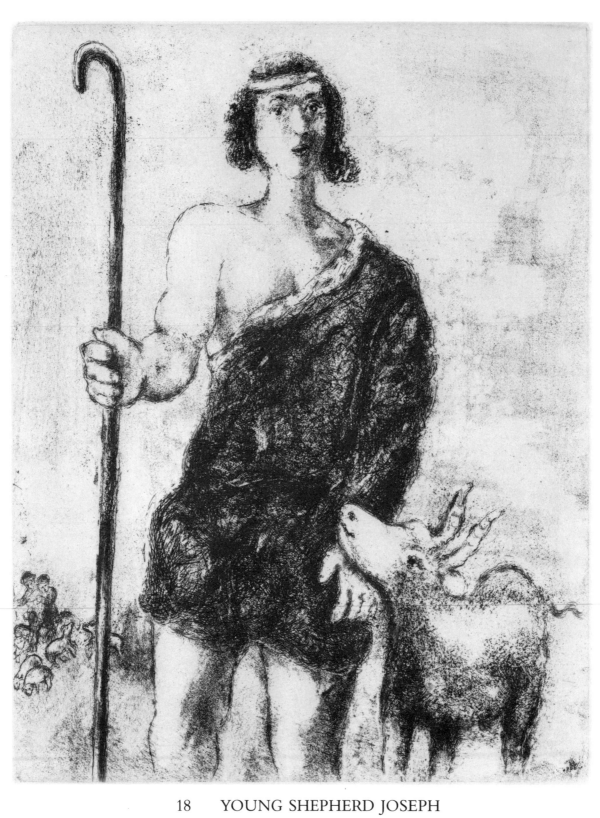

18 YOUNG SHEPHERD JOSEPH

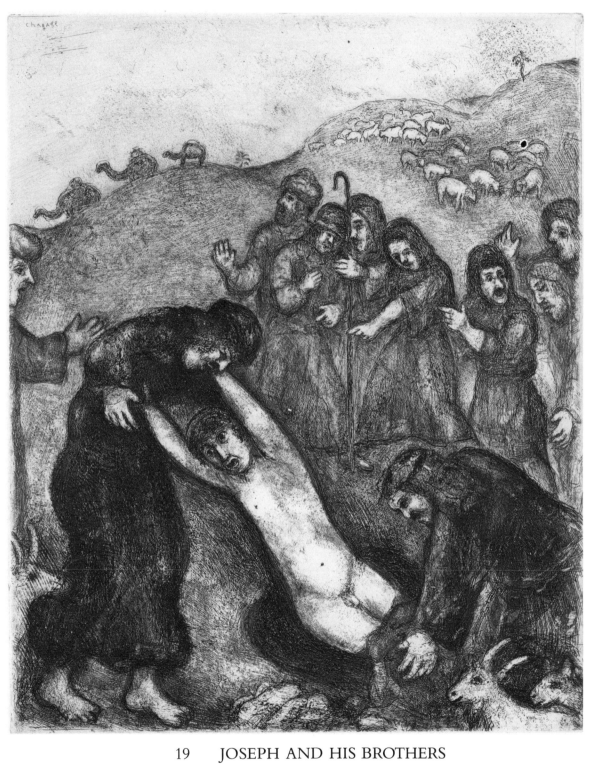

19 JOSEPH AND HIS BROTHERS

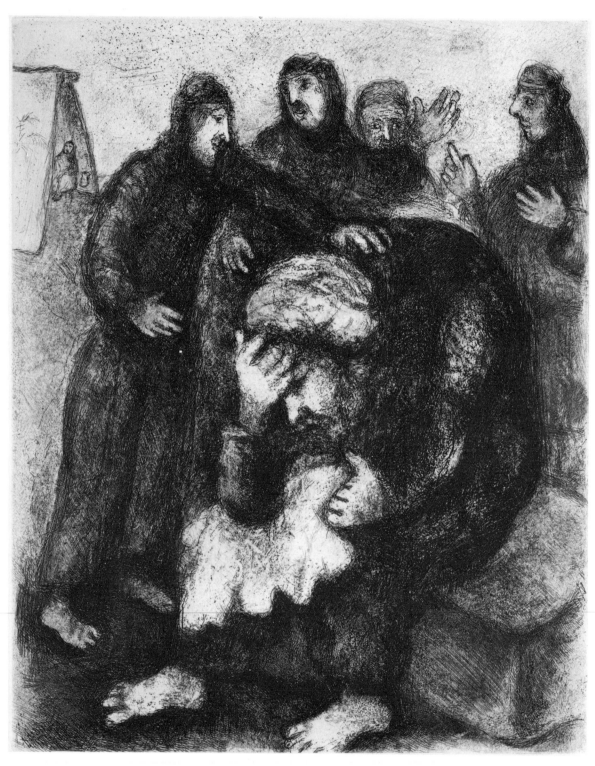

20 JACOB WEEPING FOR JOSEPH

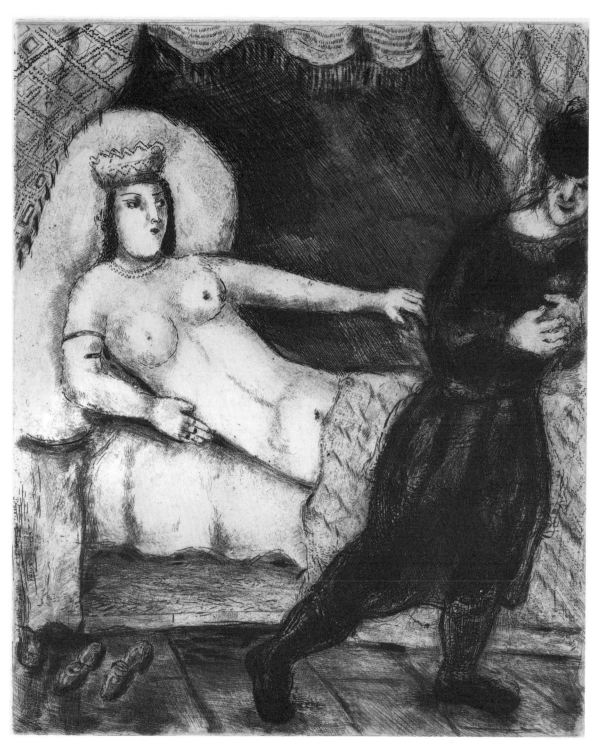

21 POTIPHAR'S WIFE

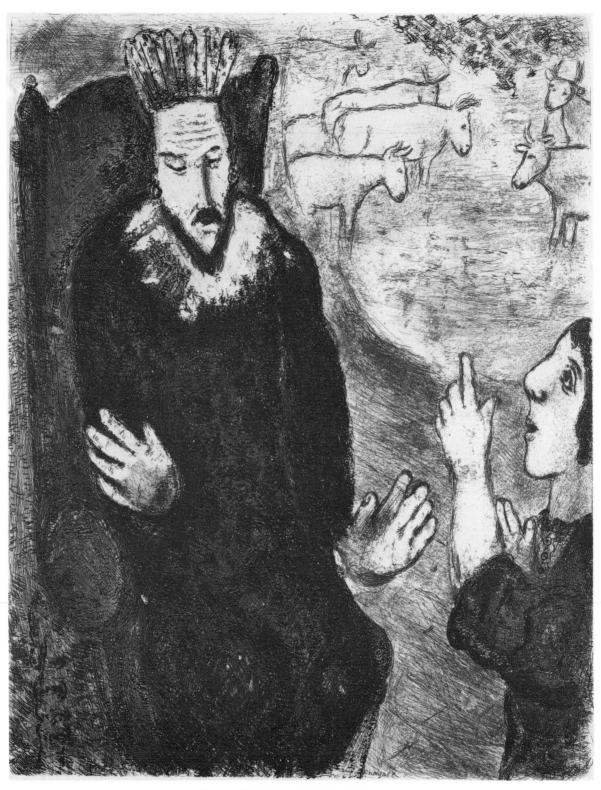

22 PHARAOH'S DREAM

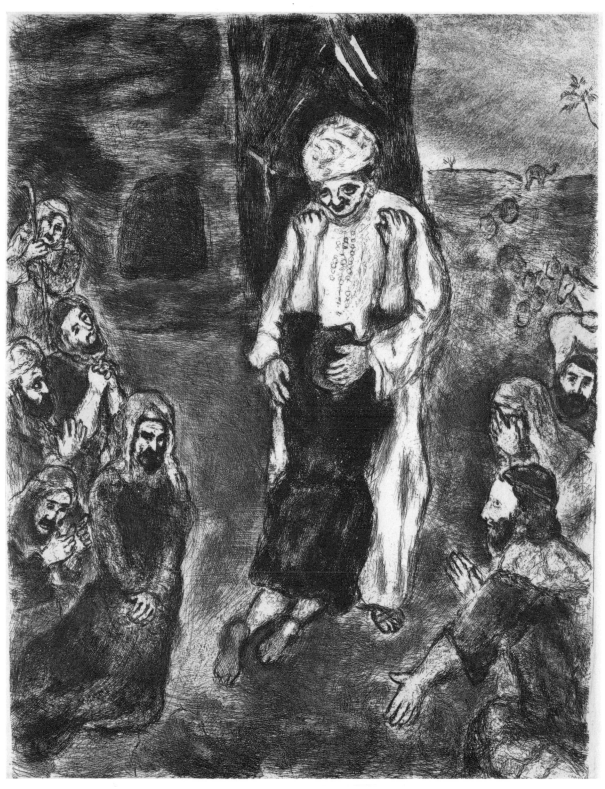

23 JOSEPH RECOGNIZED BY HIS BROTHERS

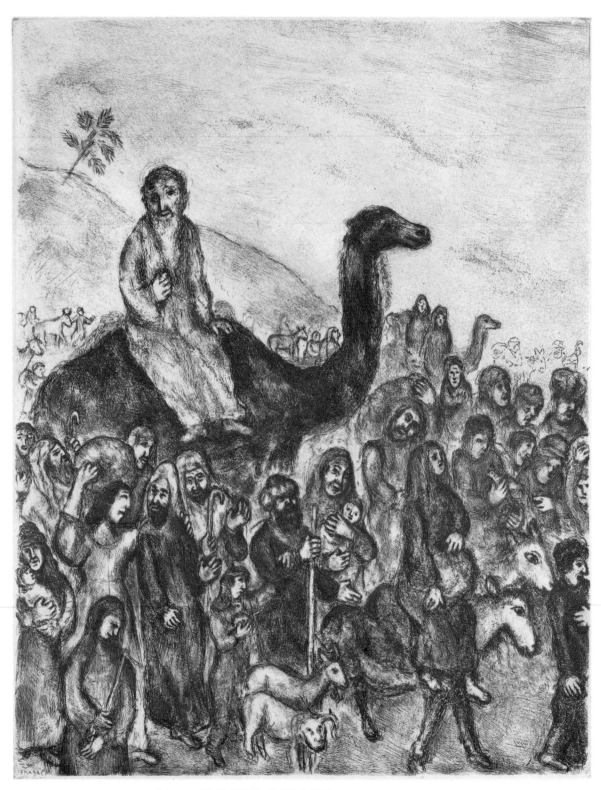

24 JACOB'S DEPARTURE FOR EGYPT

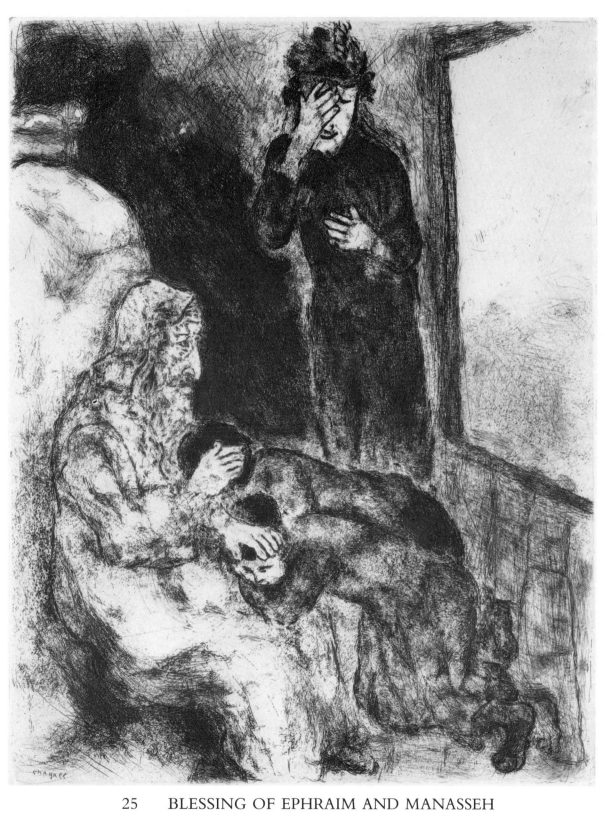

25 BLESSING OF EPHRAIM AND MANASSEH

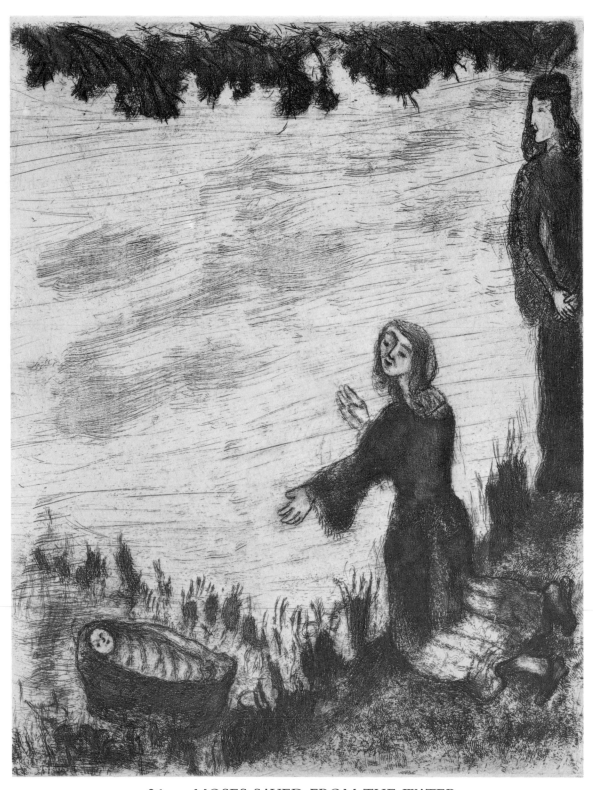

26 MOSES SAVED FROM THE WATER

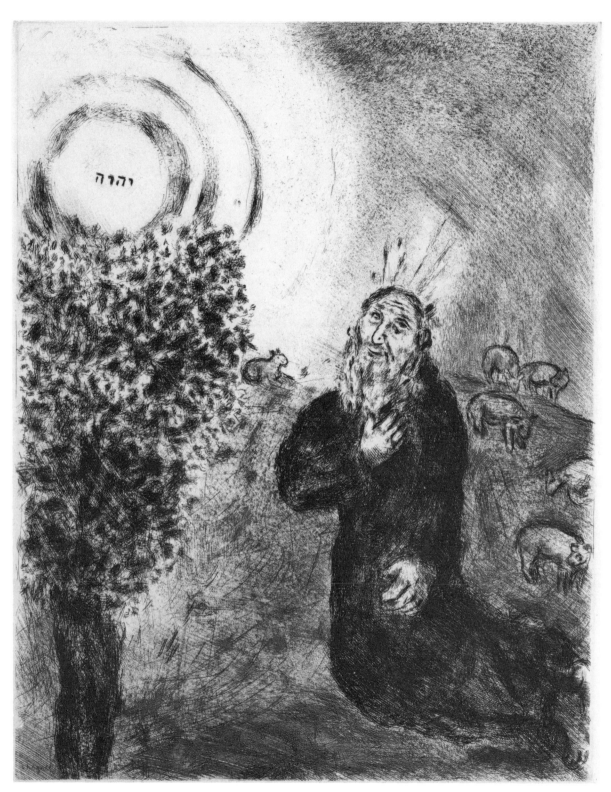

27 THE BURNING BUSH

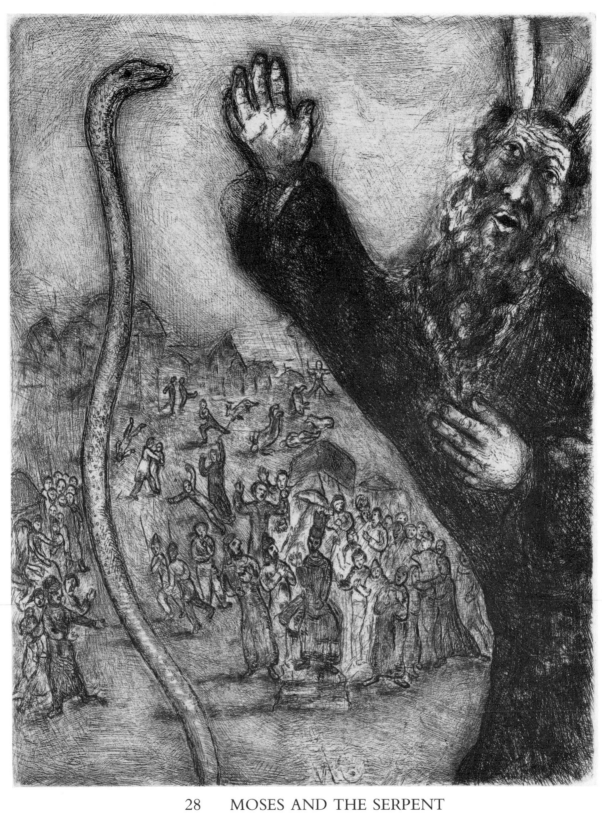

28 MOSES AND THE SERPENT

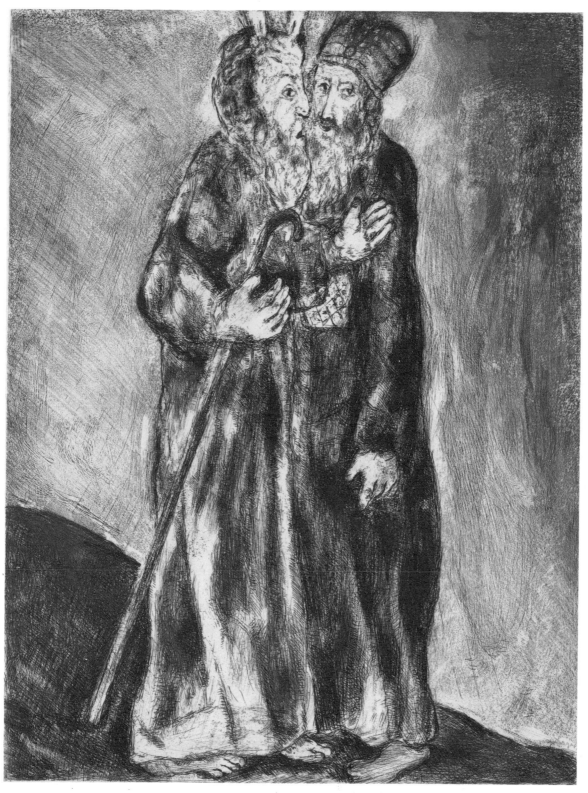

29 MEETING OF MOSES AND AARON

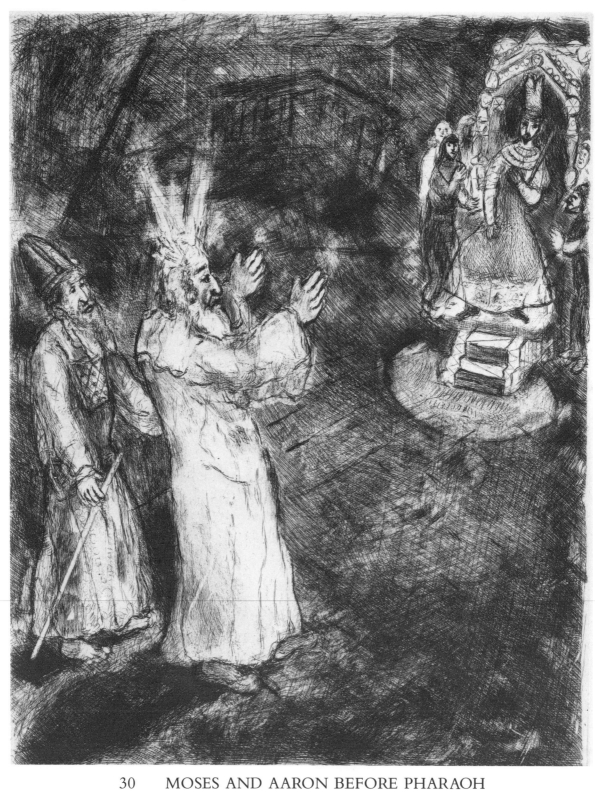

30 MOSES AND AARON BEFORE PHARAOH

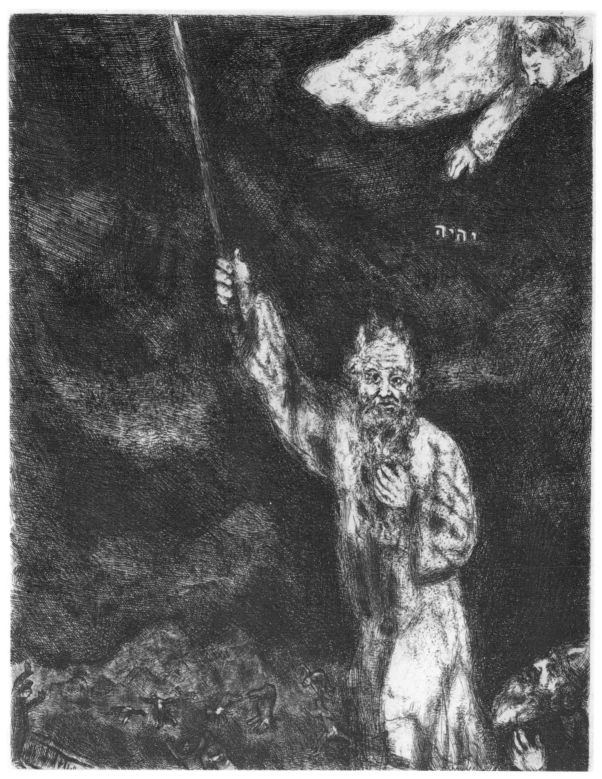

31 DARKNESS OVER EGYPT

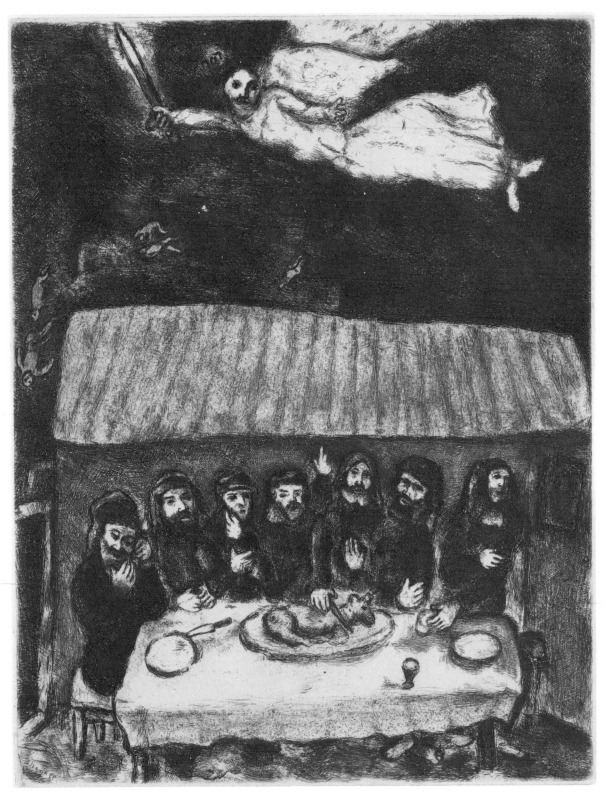

32 THE PASSOVER MEAL

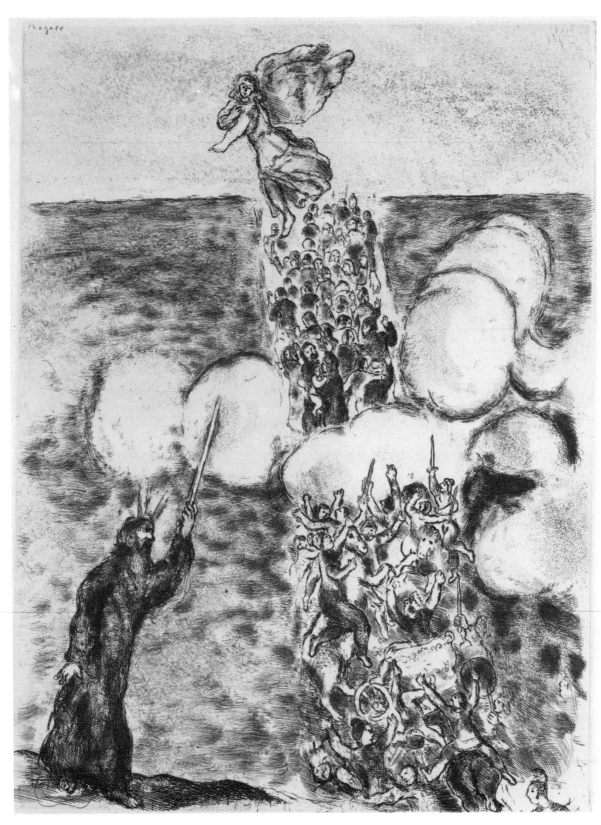

34 CROSSING OF THE RED SEA

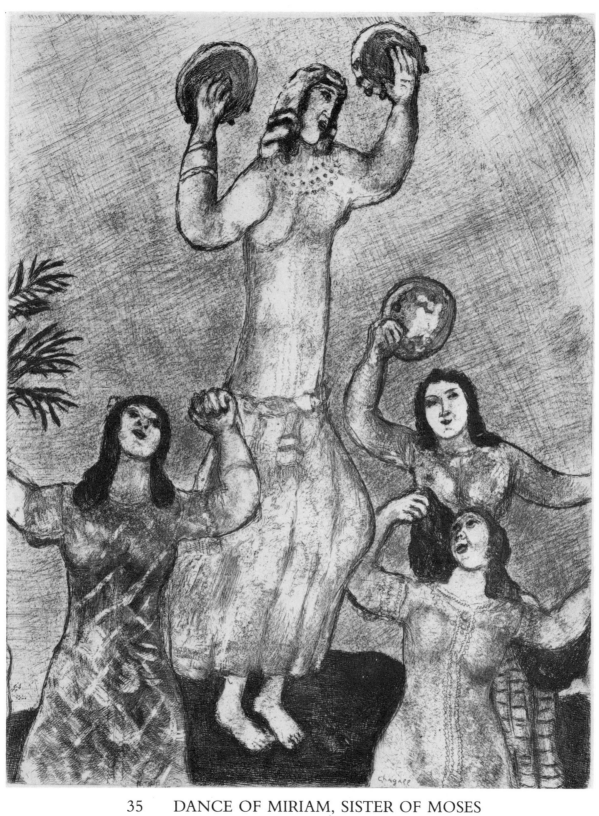

35 DANCE OF MIRIAM, SISTER OF MOSES

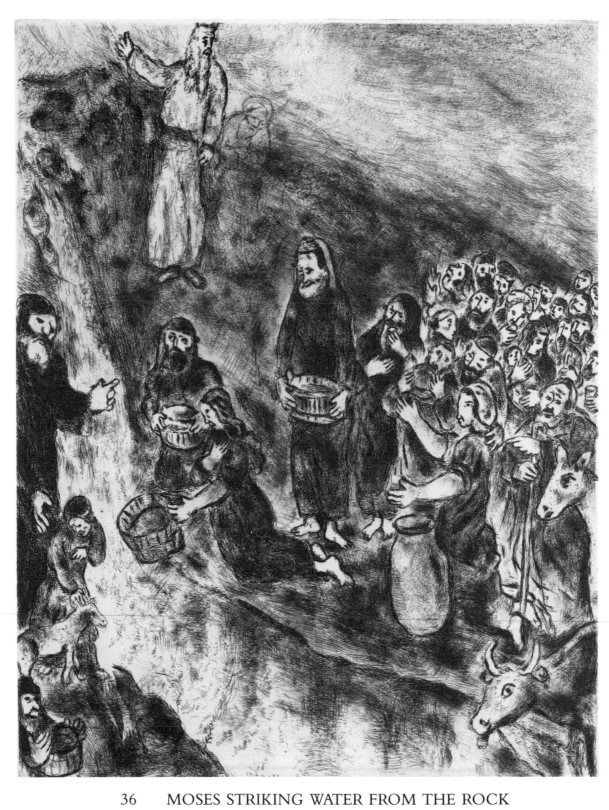

36 MOSES STRIKING WATER FROM THE ROCK

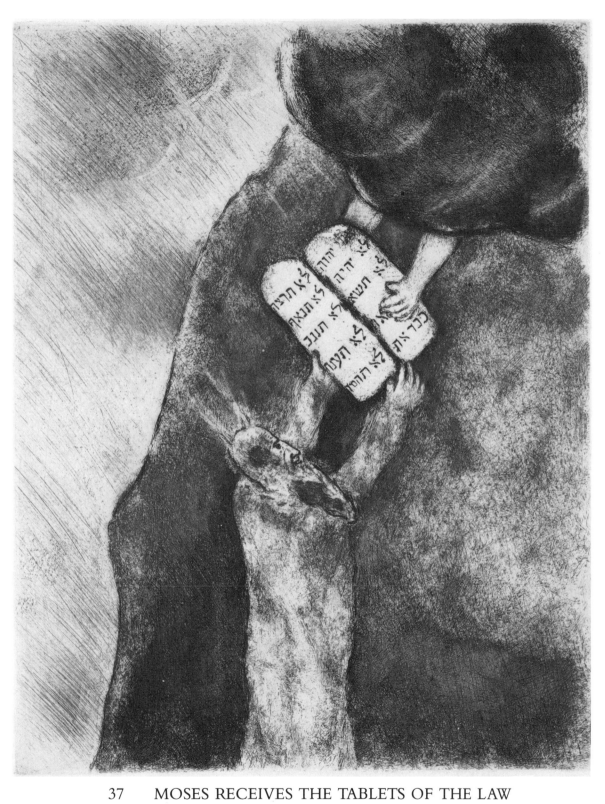

37 MOSES RECEIVES THE TABLETS OF THE LAW

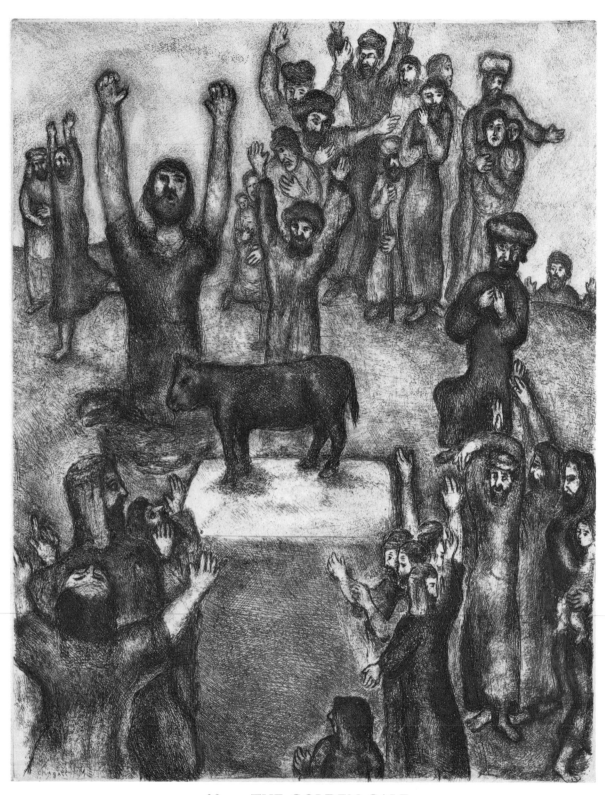

38 THE GOLDEN CALF

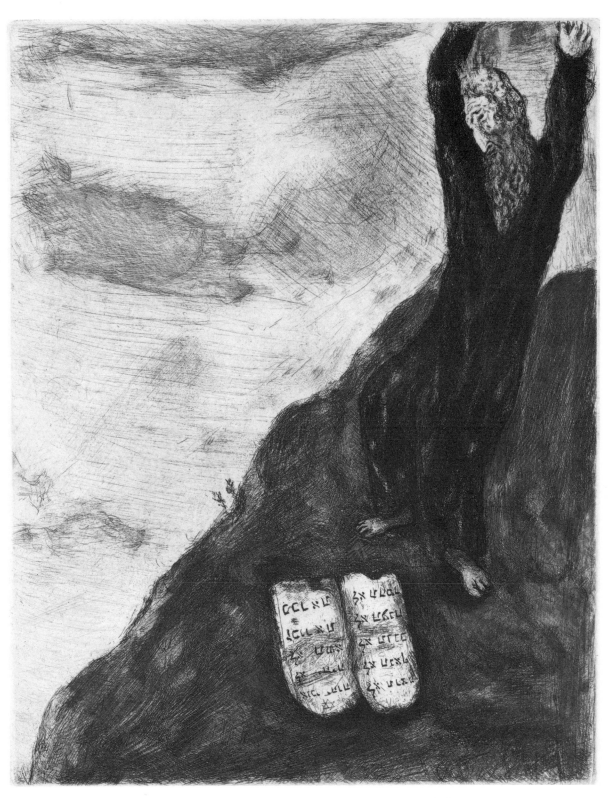

39 MOSES BREAKS THE TABLETS

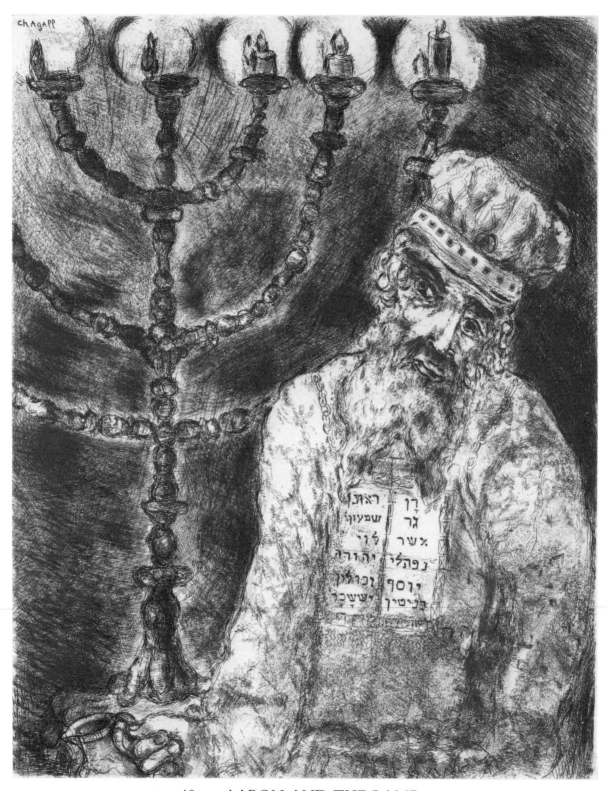

40 AARON AND THE LAMP

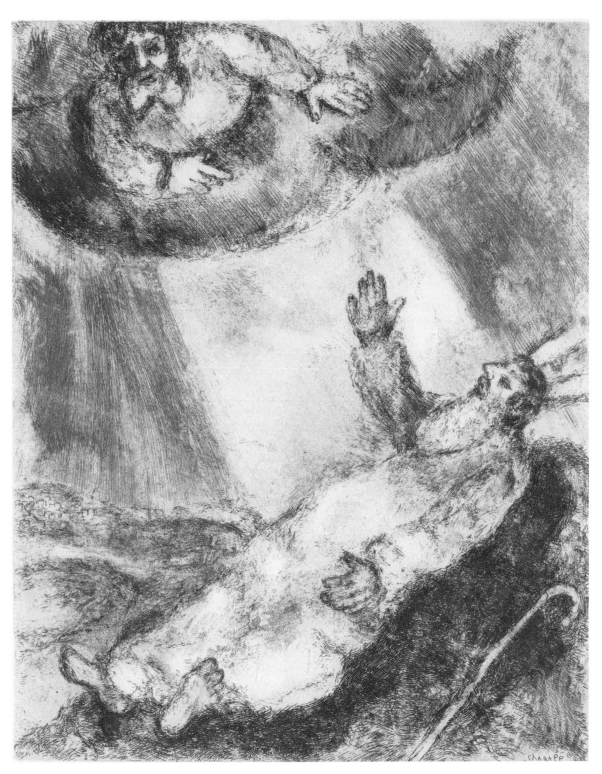

41 DEATH OF MOSES

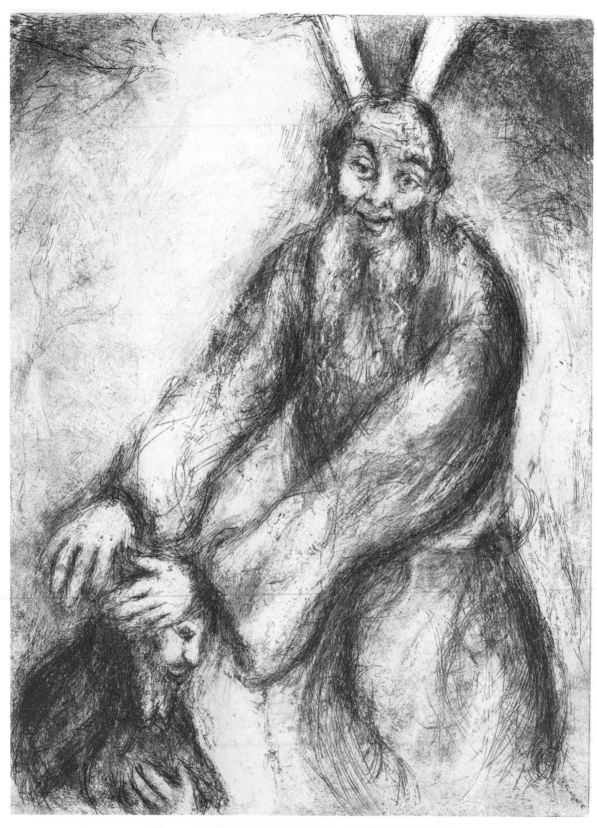

42 MOSES' BLESSING OVER JOSHUA

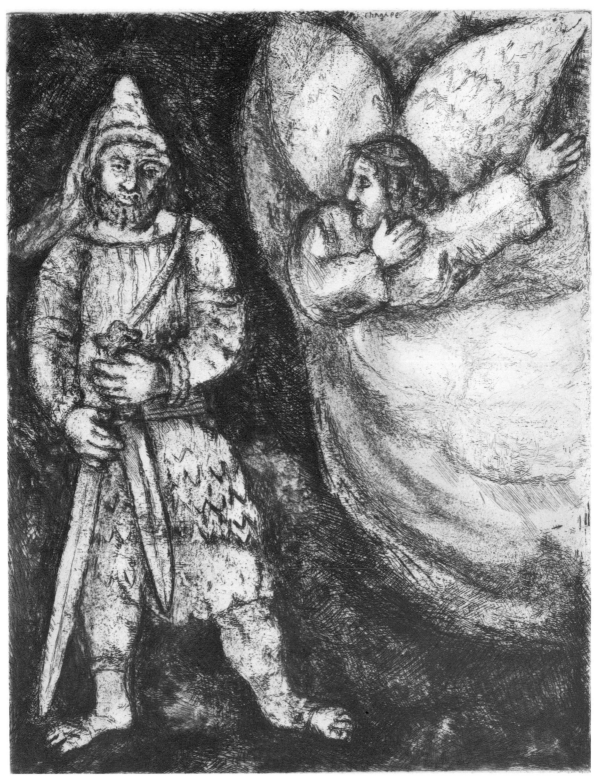

43 JOSHUA ARMED BY GOD

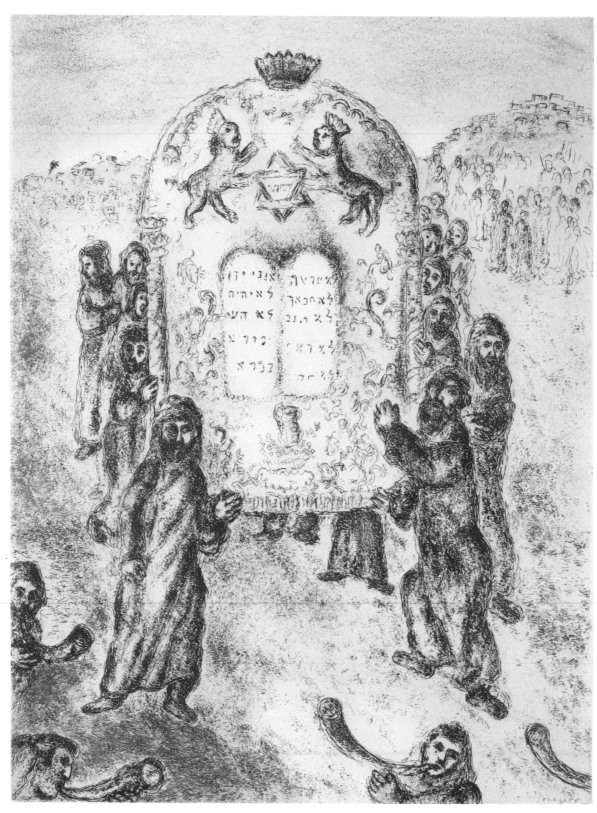

44 CROSSING OF THE JORDAN

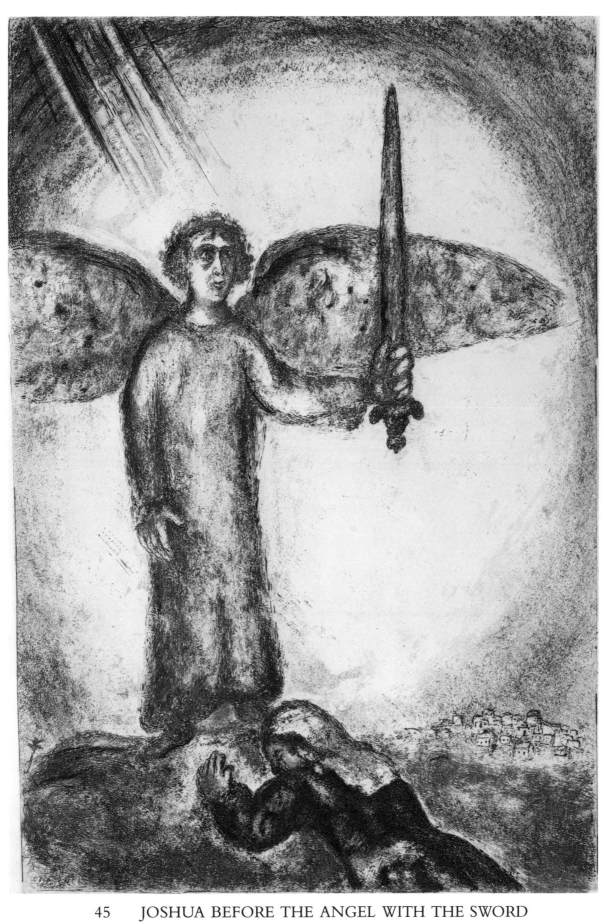

45 JOSHUA BEFORE THE ANGEL WITH THE SWORD

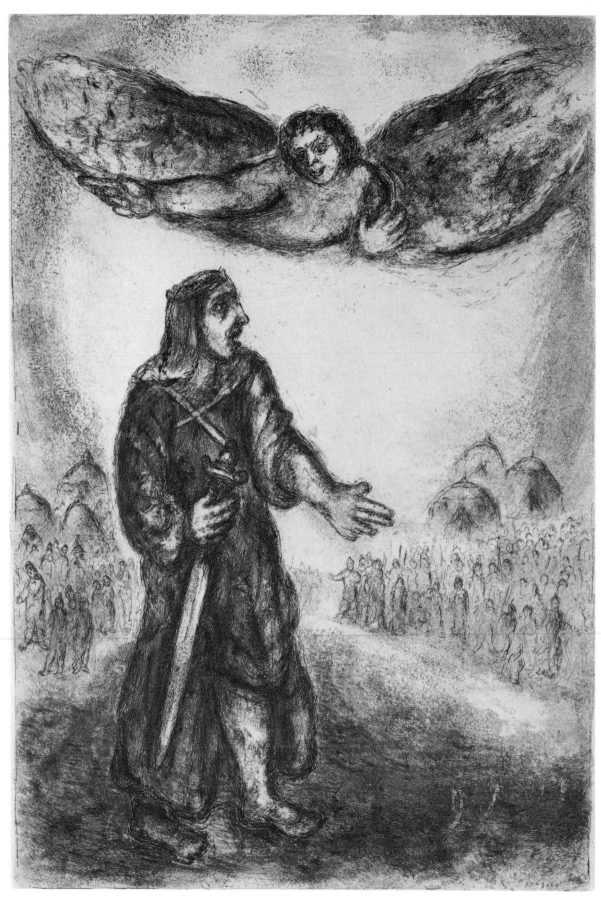

46 JOSHUA BEFORE JERICHO

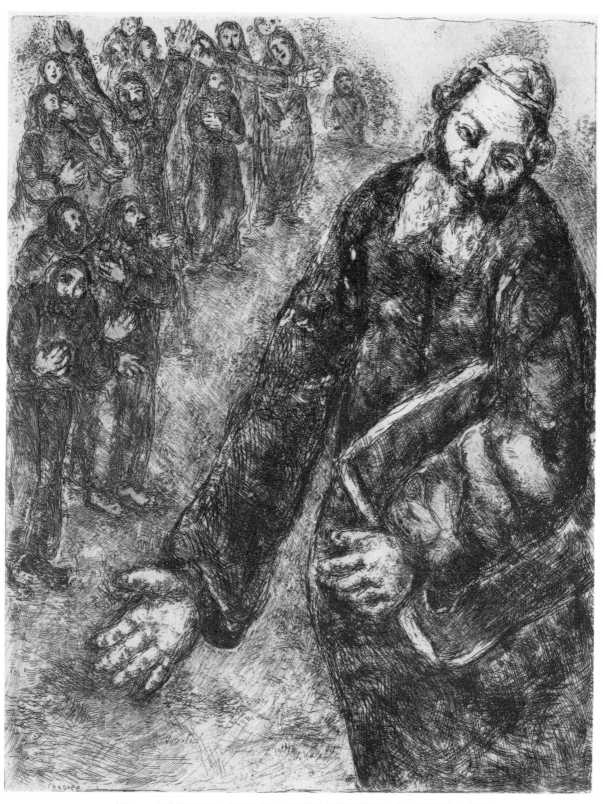

47 JOSHUA READS THE WORDS OF THE LAW

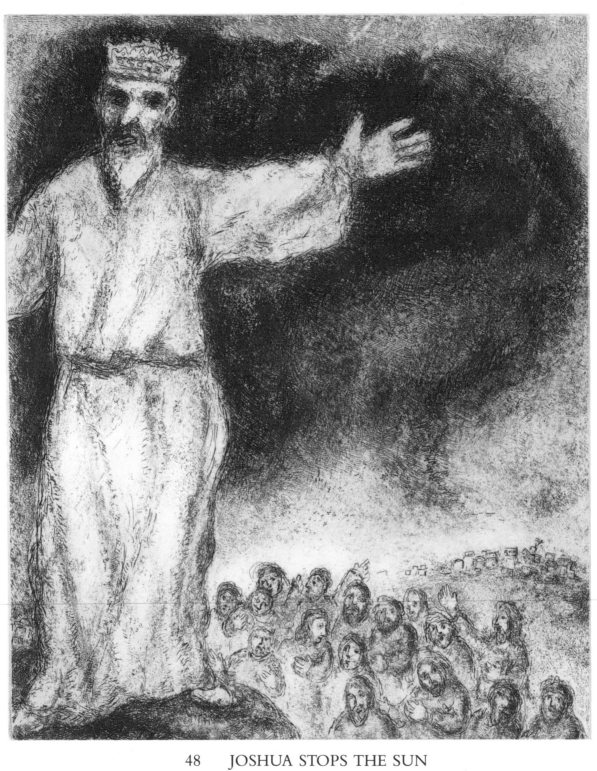

48 JOSHUA STOPS THE SUN

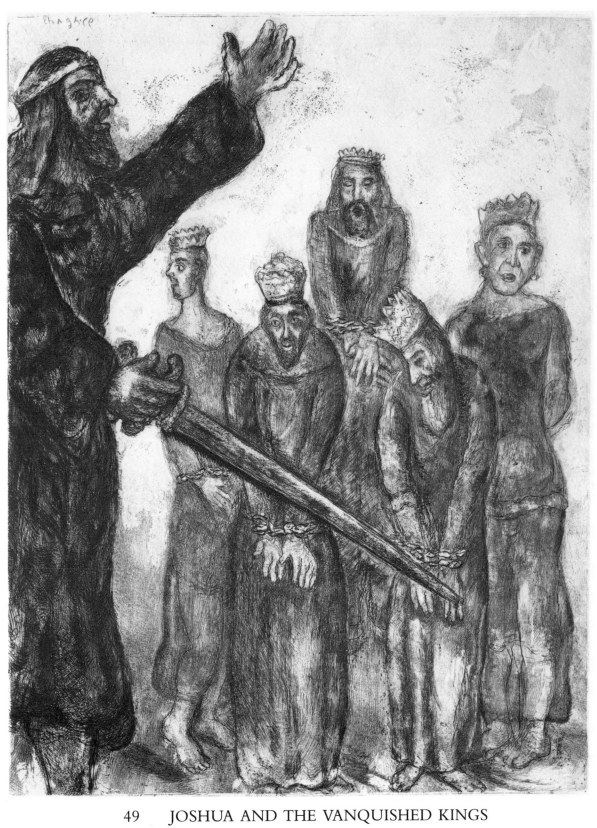

49 JOSHUA AND THE VANQUISHED KINGS

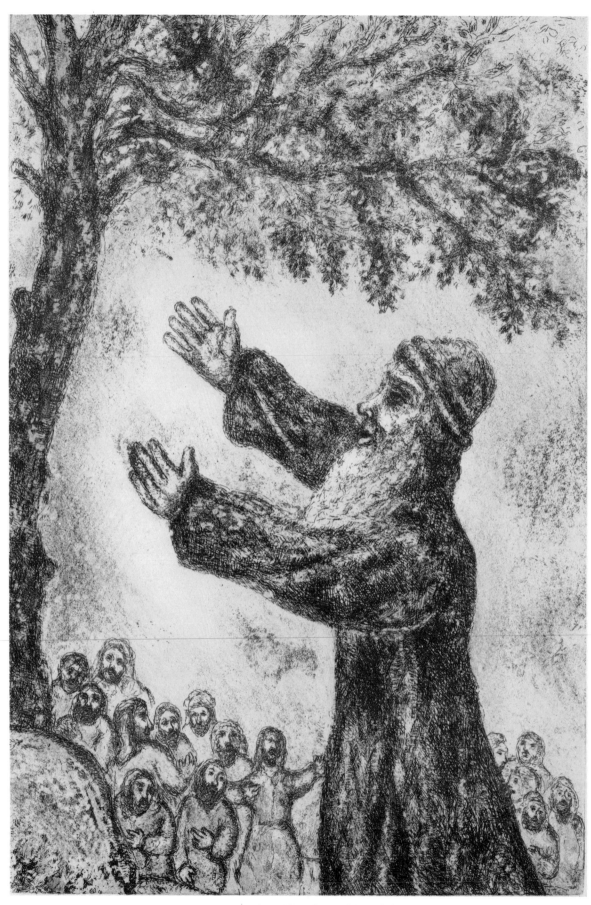

50 EXHORTATION OF JOSHUA

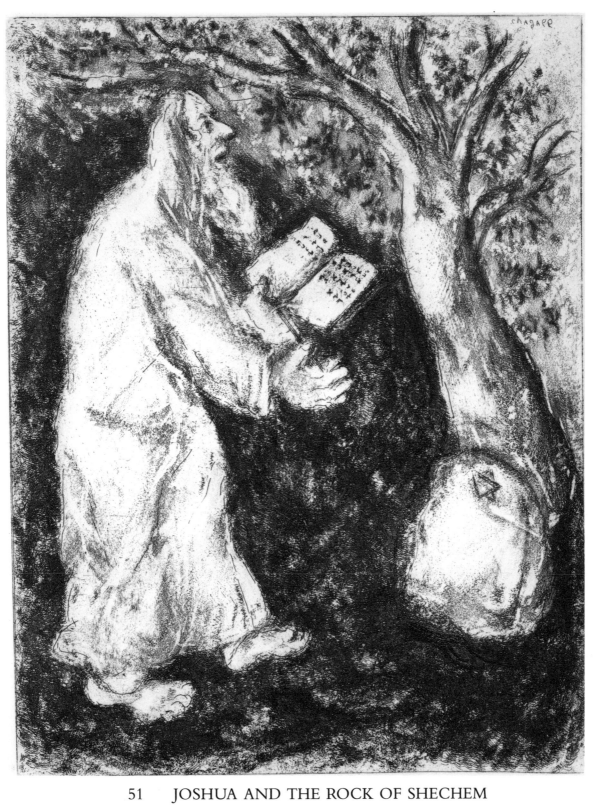

51 JOSHUA AND THE ROCK OF SHECHEM

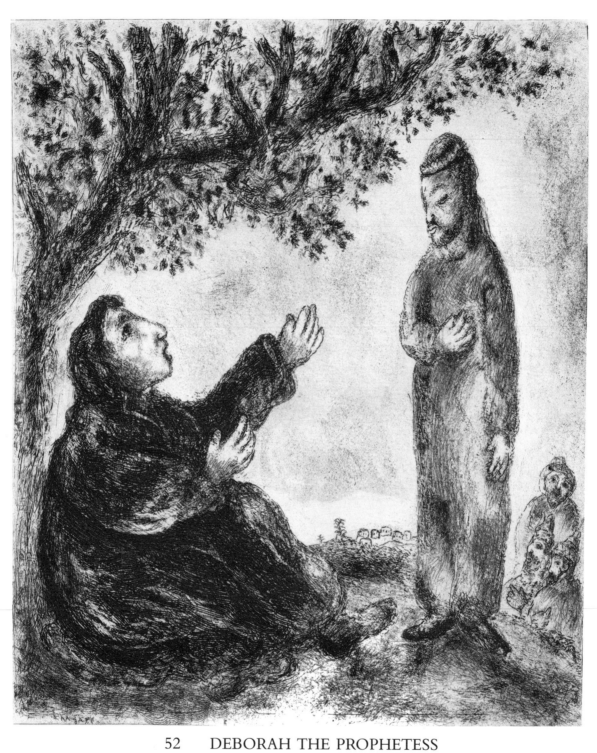

52 DEBORAH THE PROPHETESS

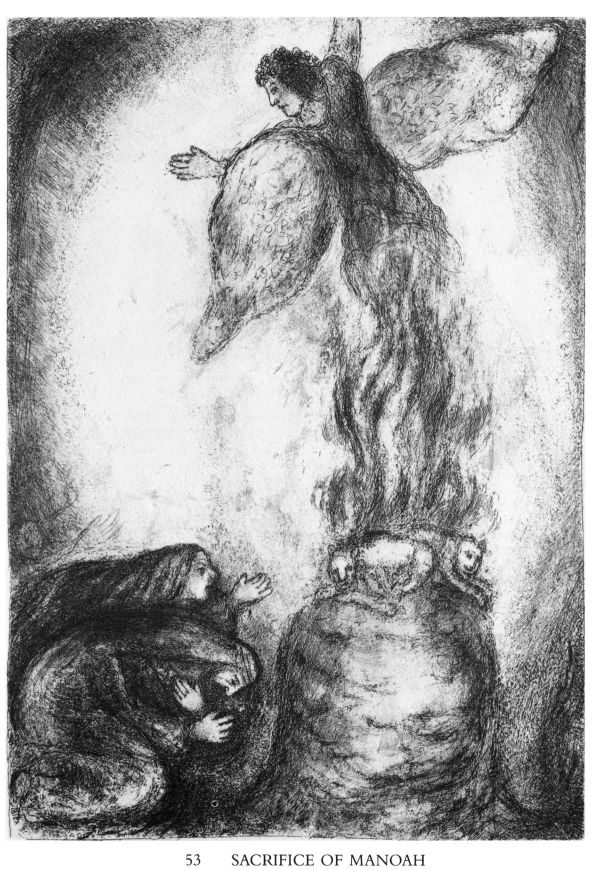

53 SACRIFICE OF MANOAH

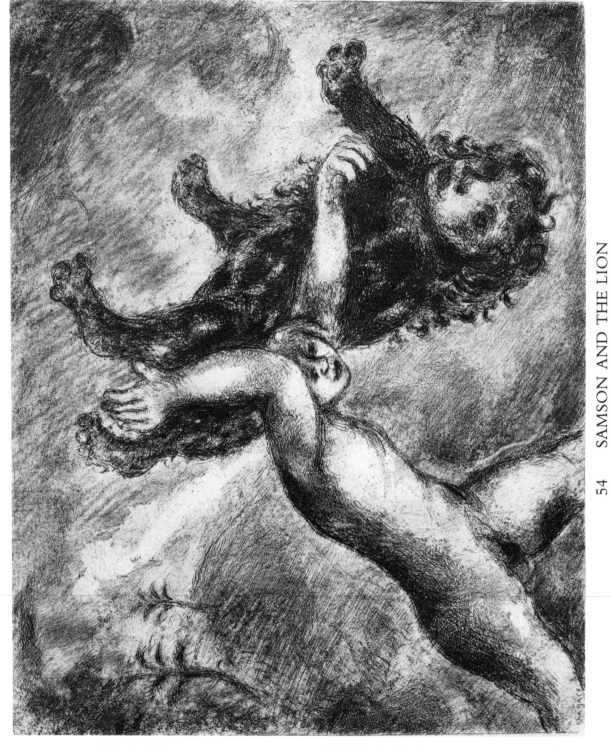

54 SAMSON AND THE LION

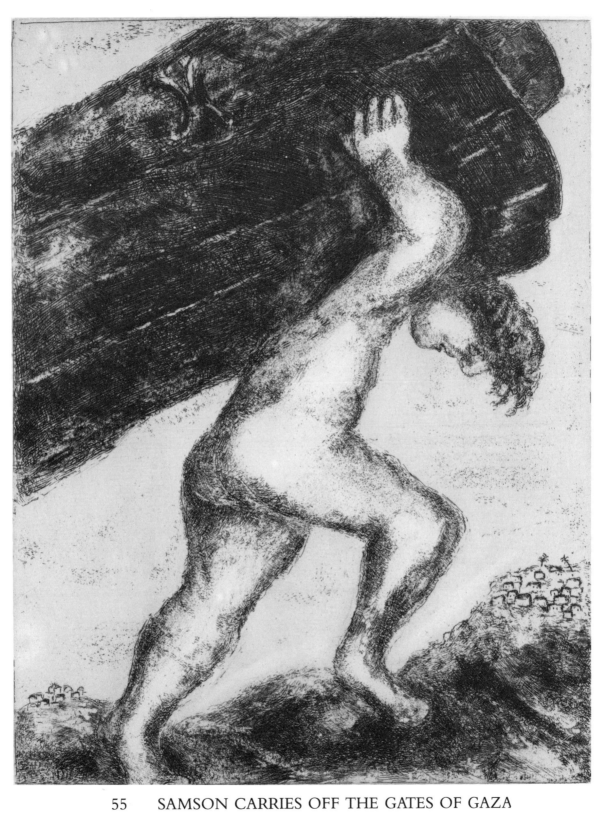

55 SAMSON CARRIES OFF THE GATES OF GAZA

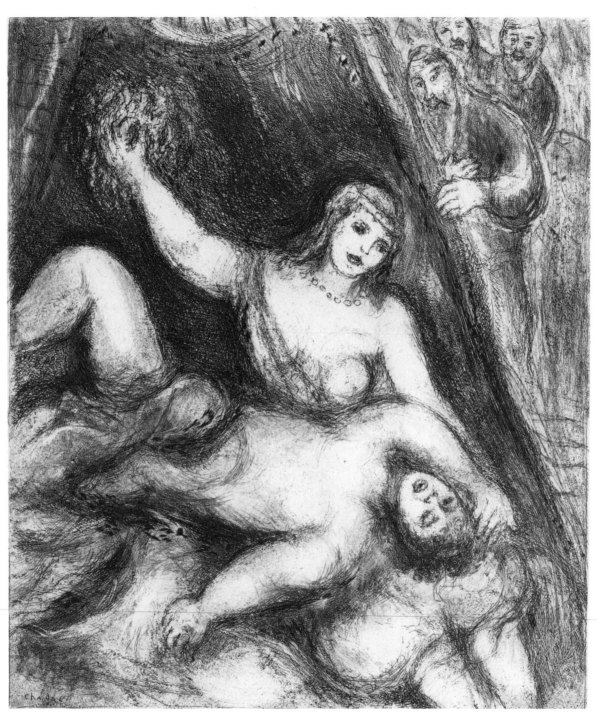

56 SAMSON AND DELILAH

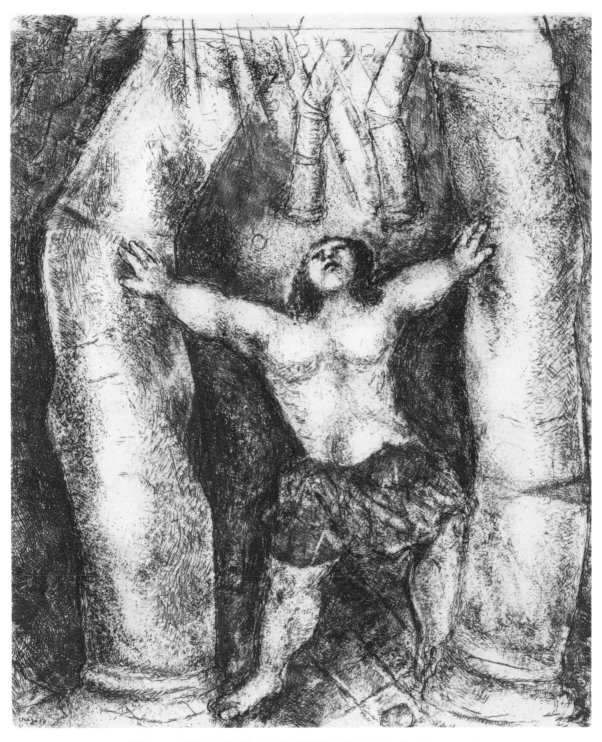

57 SAMSON OVERTURNS THE COLUMNS

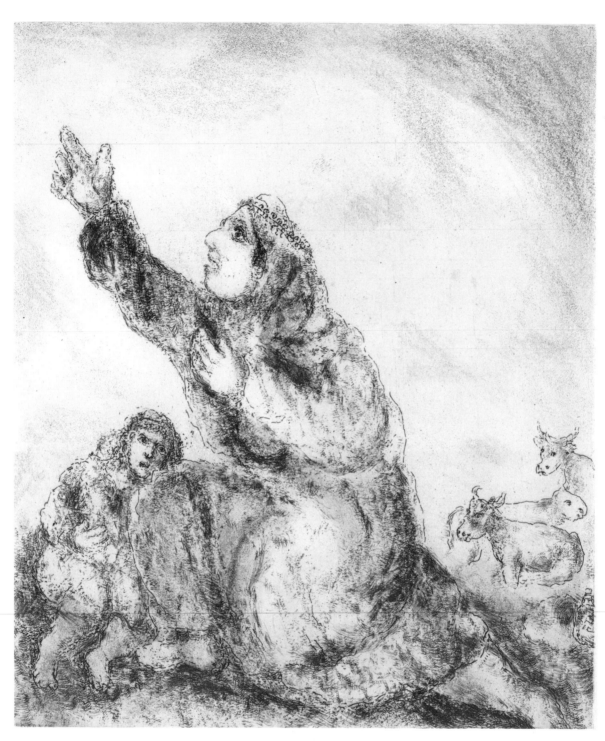

58 ANNA INVOKES GOD

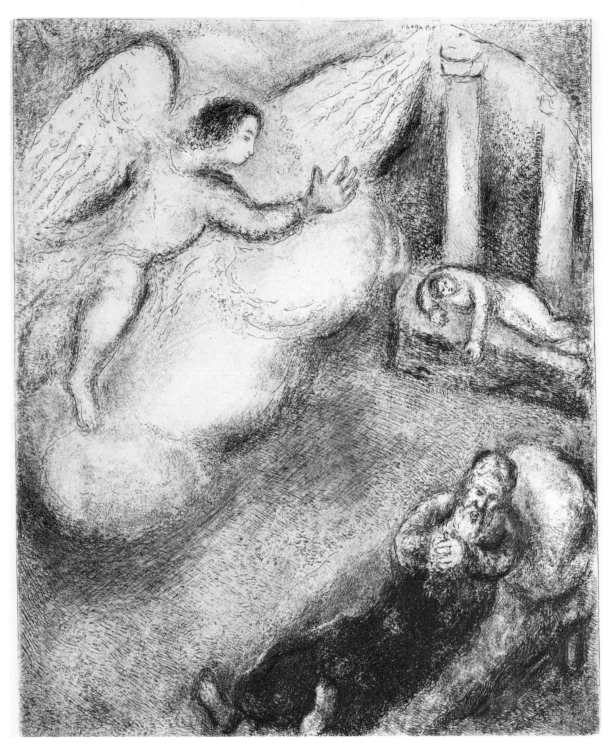

59 SAMUEL CALLED BY GOD

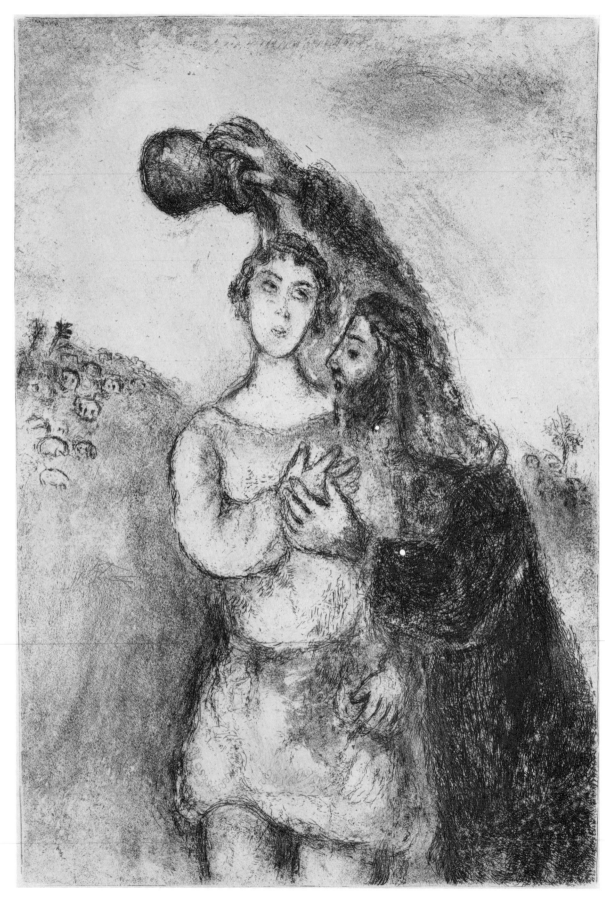

60 ANOINTING OF SAUL

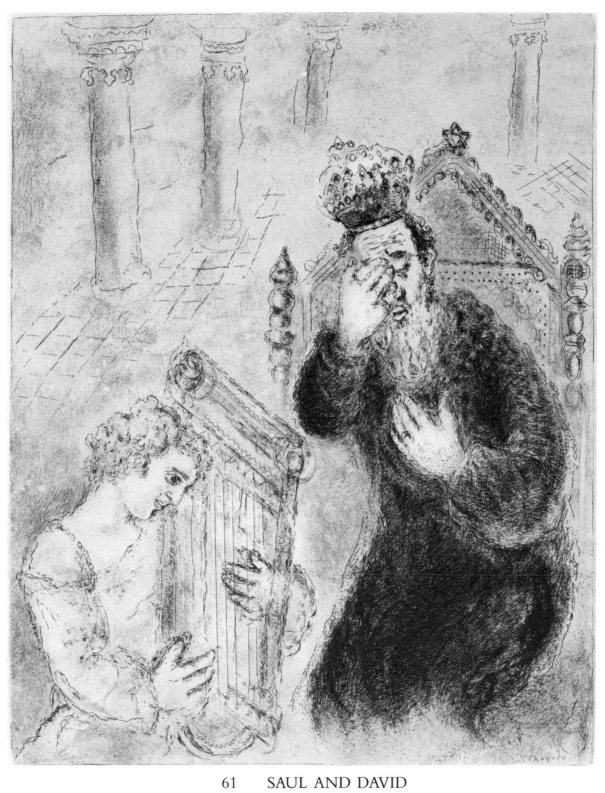

61 SAUL AND DAVID

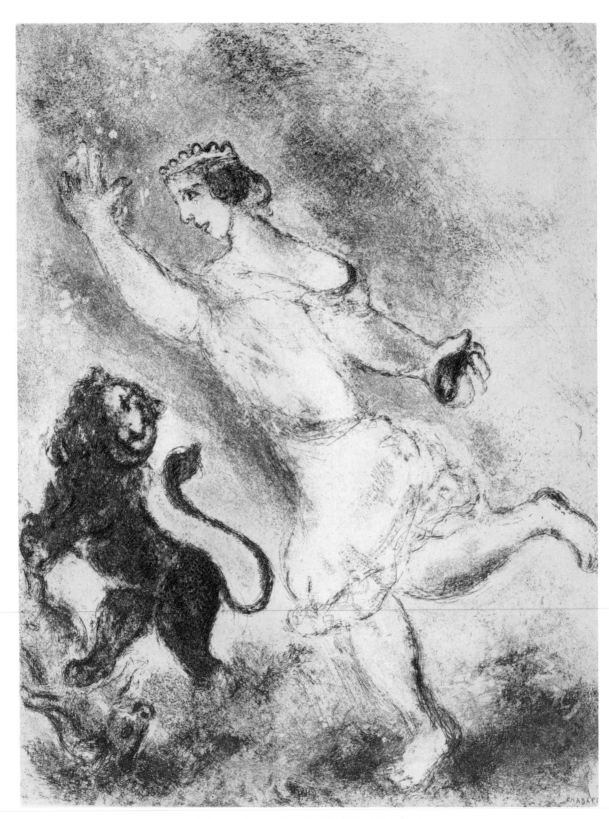

62 DAVID AND THE LION

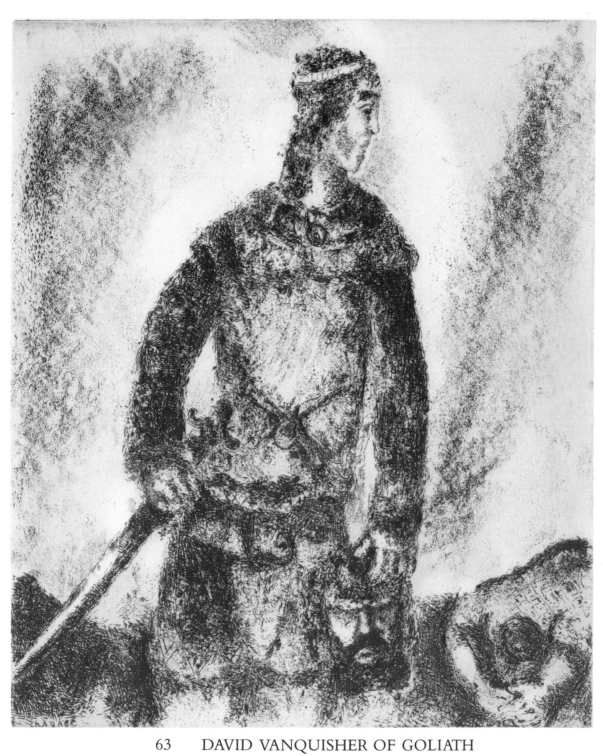

63 DAVID VANQUISHER OF GOLIATH

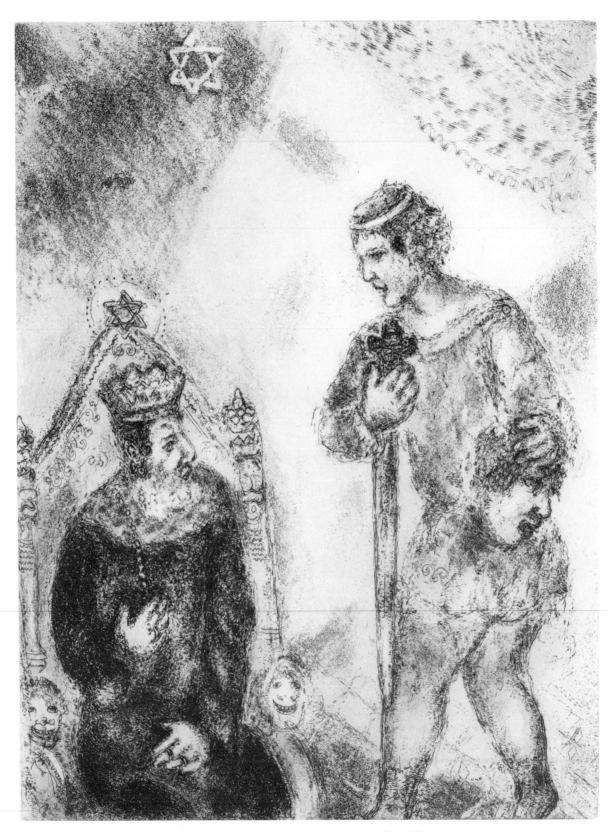

64 DAVID BEFORE SAUL

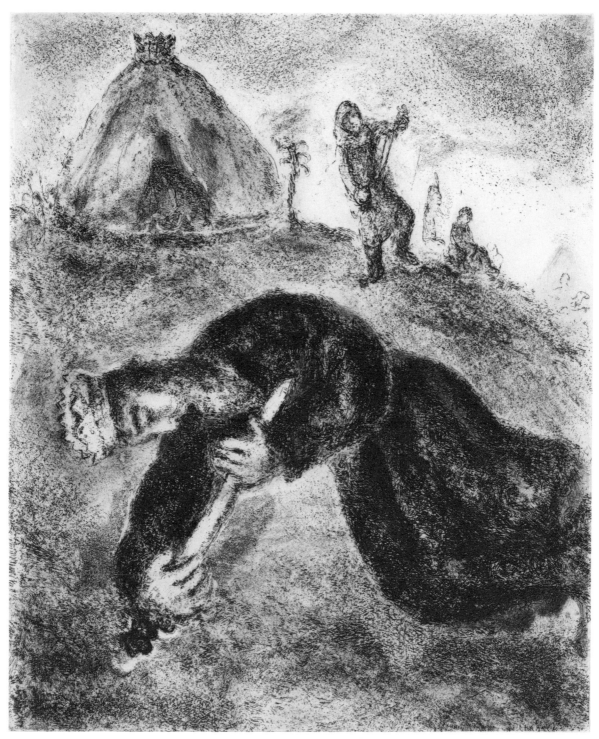

65 DEATH OF SAUL

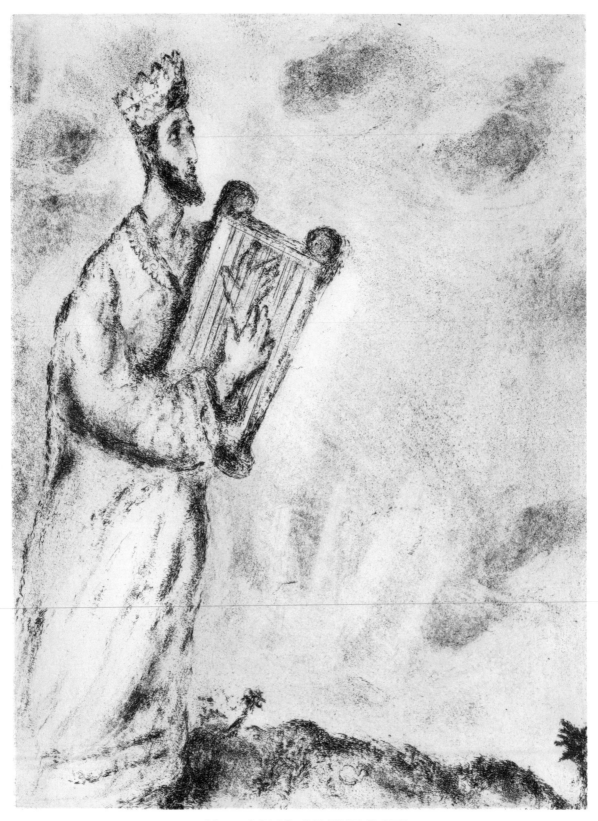

66 SONG OF THE BOW

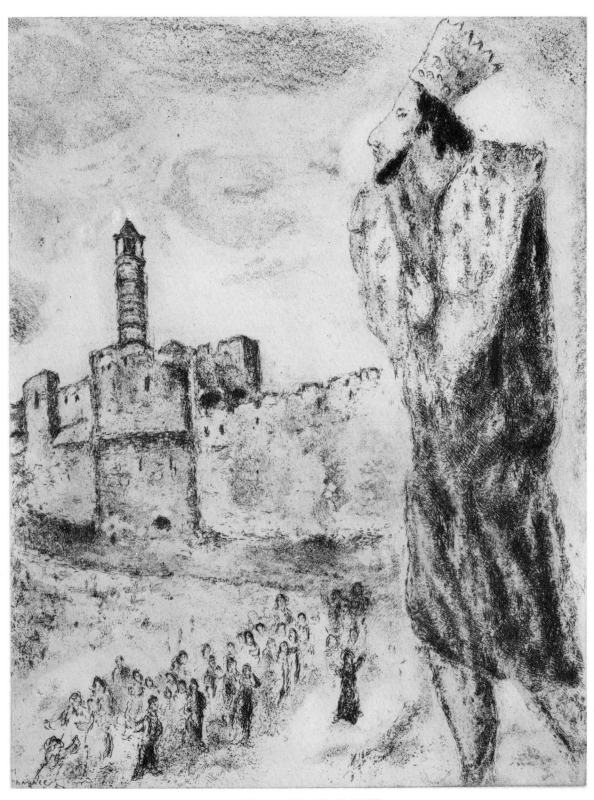

67 KING DAVID

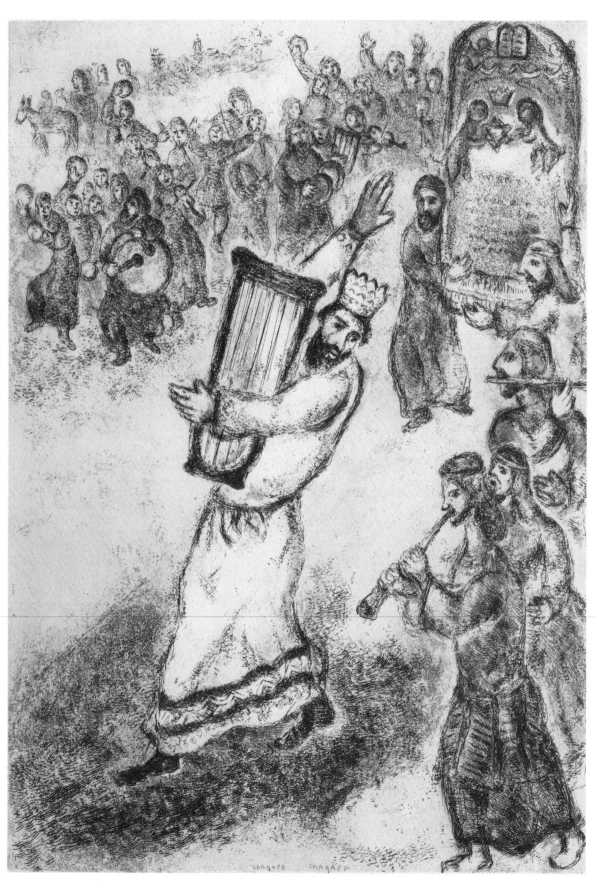

68 THE ARK CARRIED TO JERUSALEM

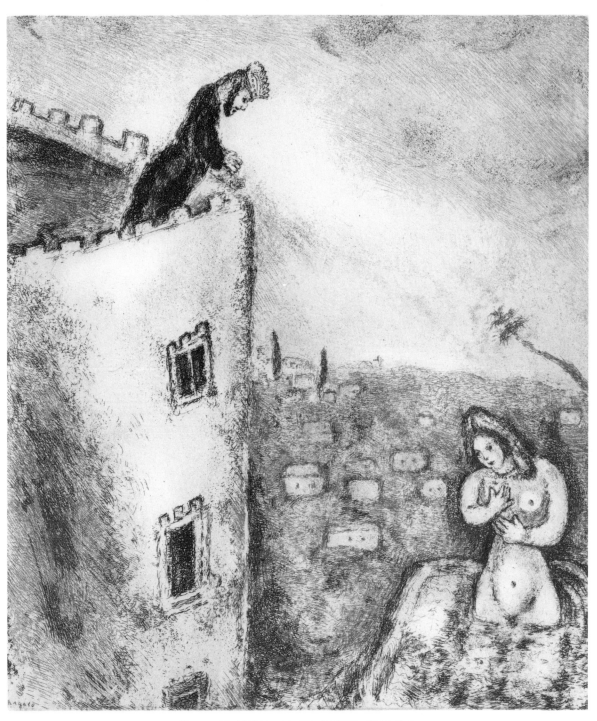

69 DAVID AND BATHSHEBA

70 DAVID AND ABSALOM

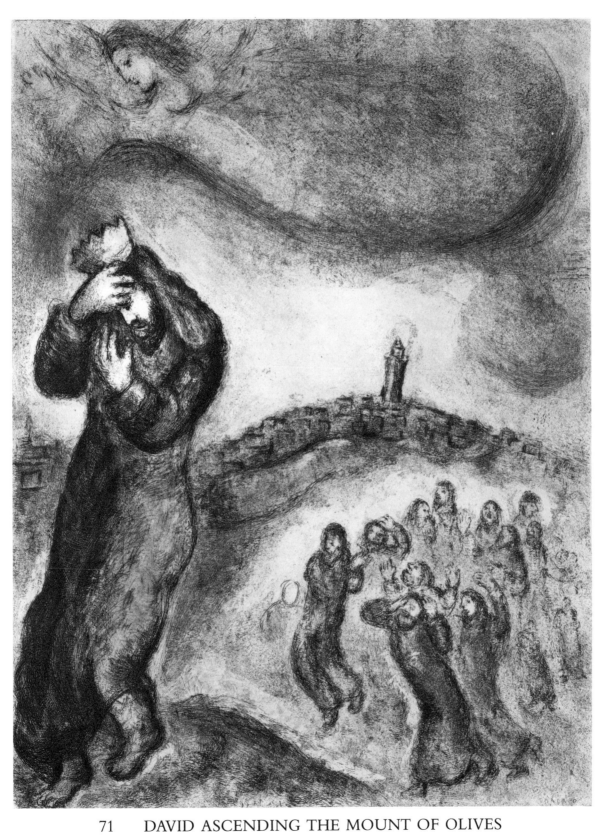

71 DAVID ASCENDING THE MOUNT OF OLIVES

72 END OF ABSALOM

73 DAVID MOURNS ABSALOM

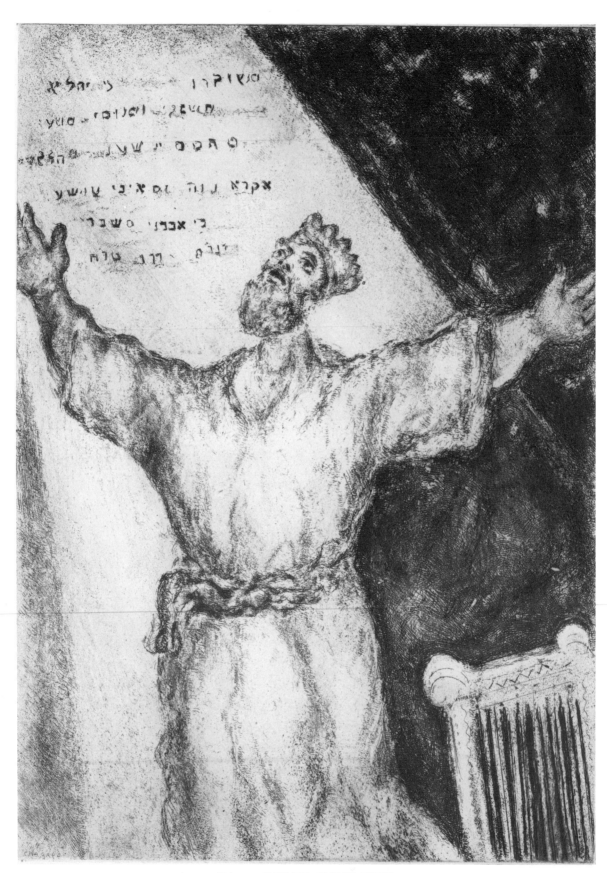

74 SONG OF DAVID

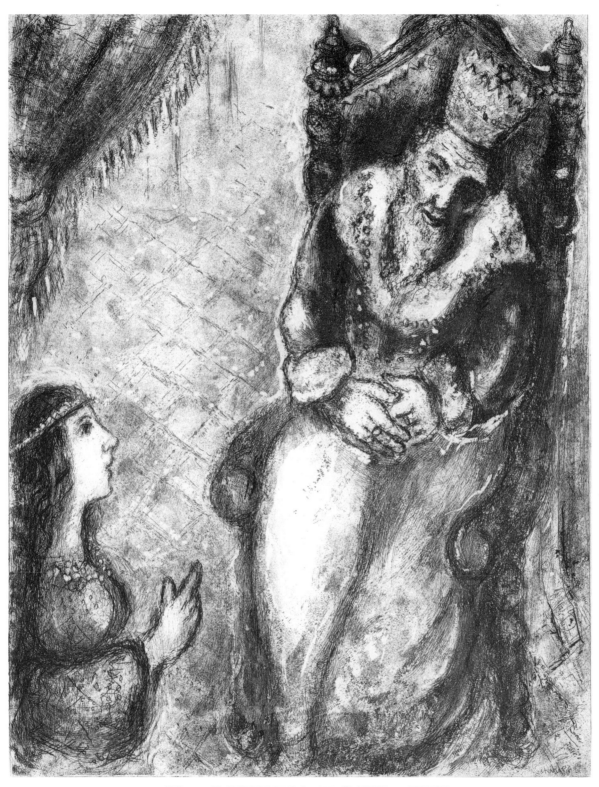

75 BATHSHEBA AT DAVID'S FEET

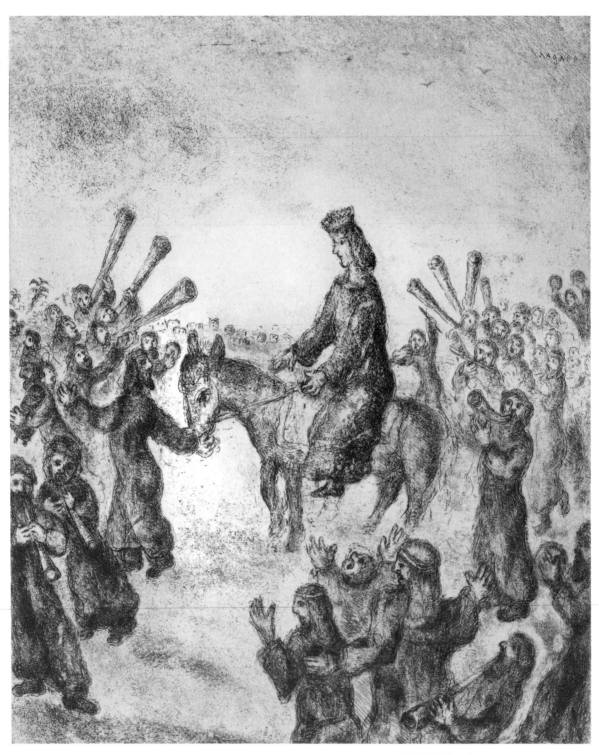

76 ANOINTING OF KING SOLOMON

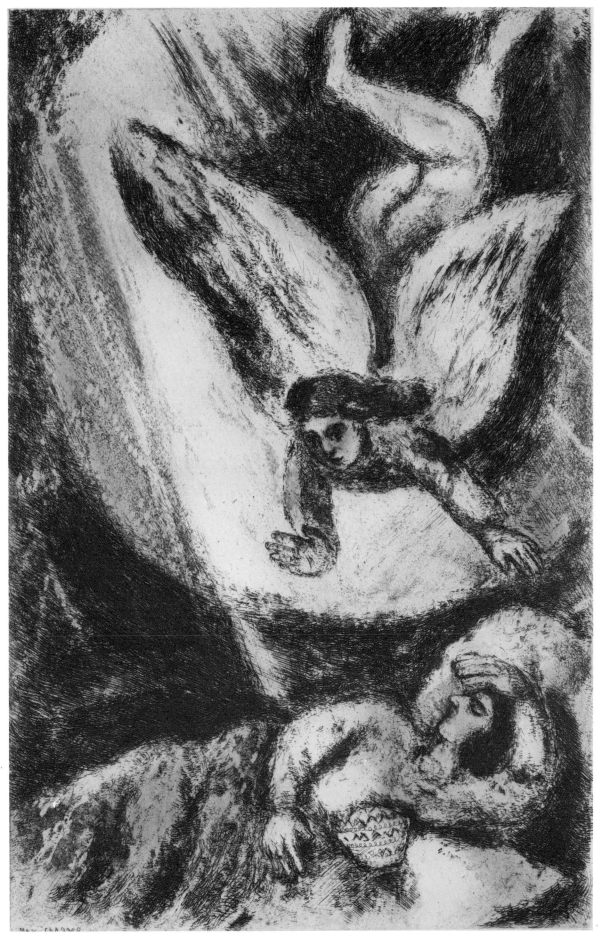

77 SOLOMON'S DREAM

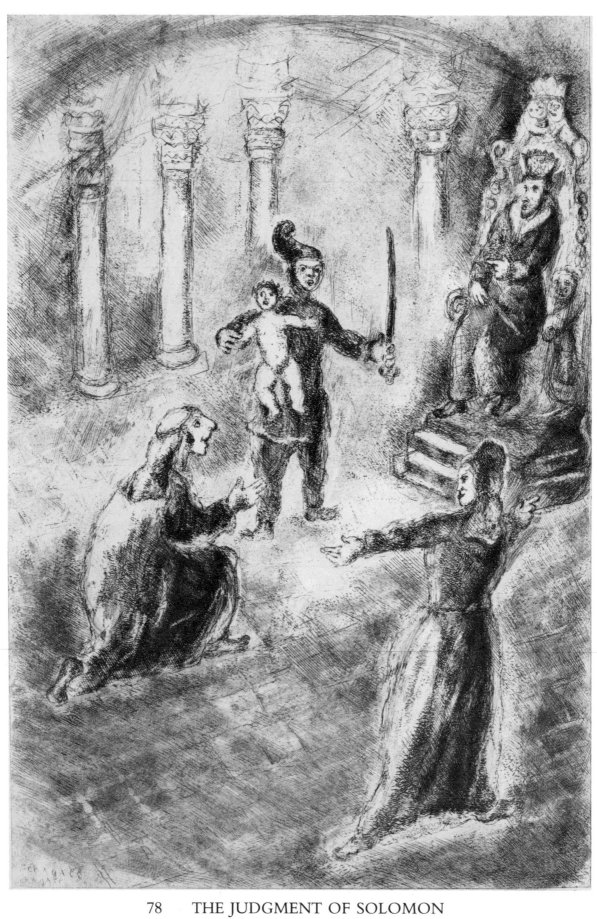

78 THE JUDGMENT OF SOLOMON

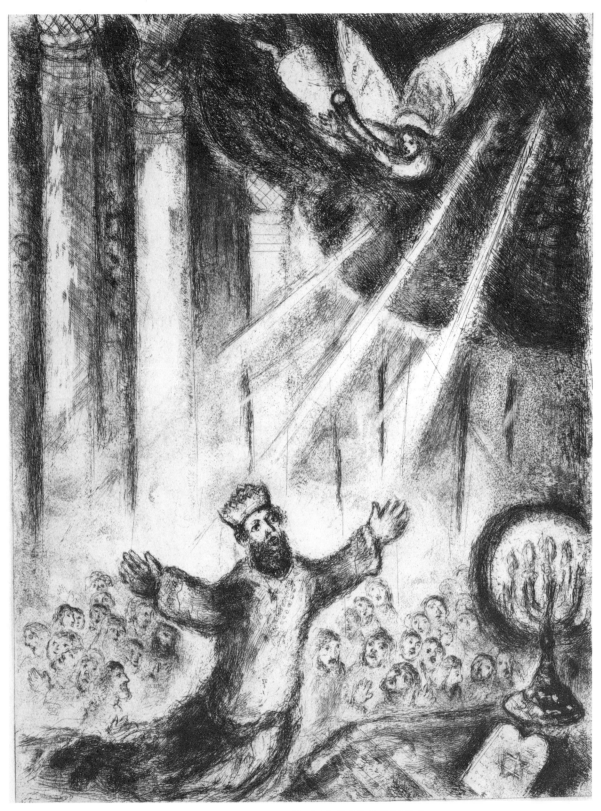

79 PRAYER OF SOLOMON

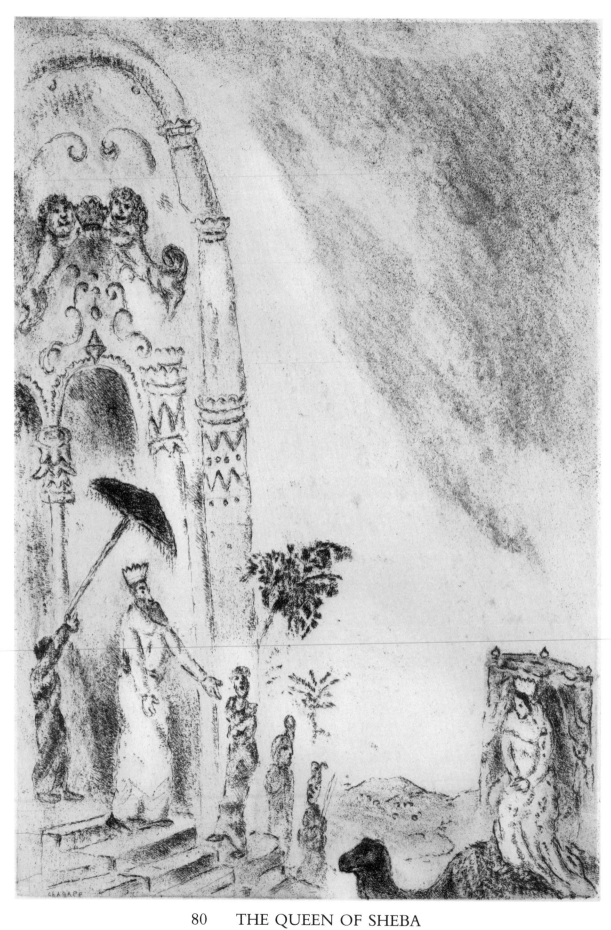

80 THE QUEEN OF SHEBA

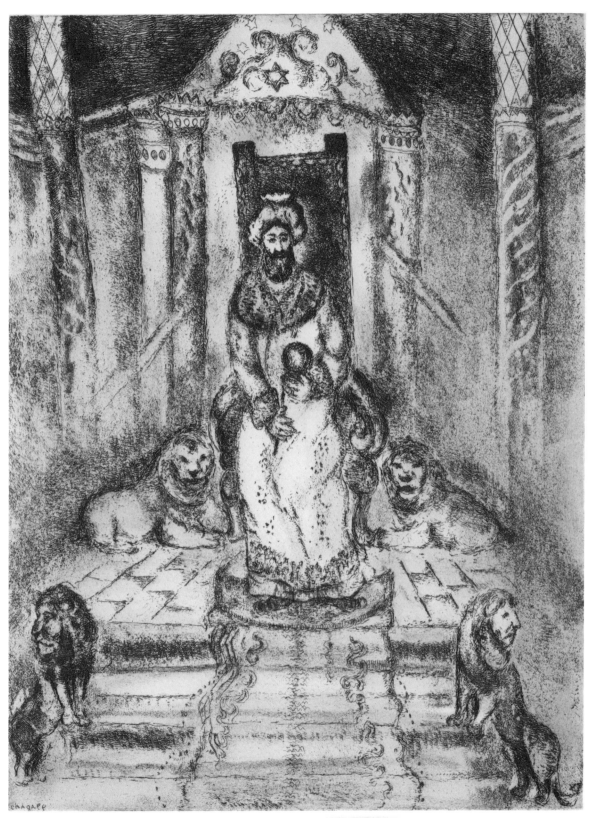

81 SOLOMON ON HIS THRONE

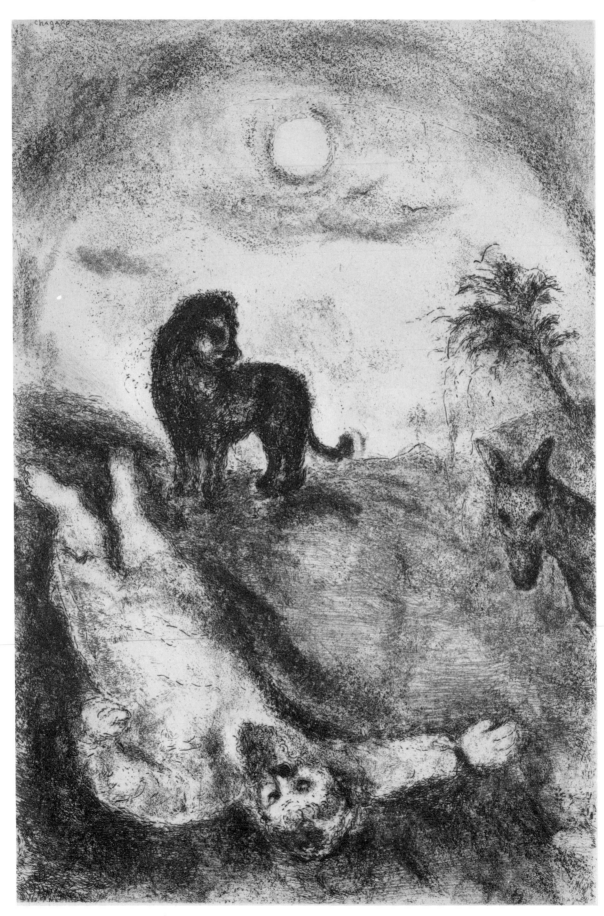

82 PROPHET KILLED BY A LION

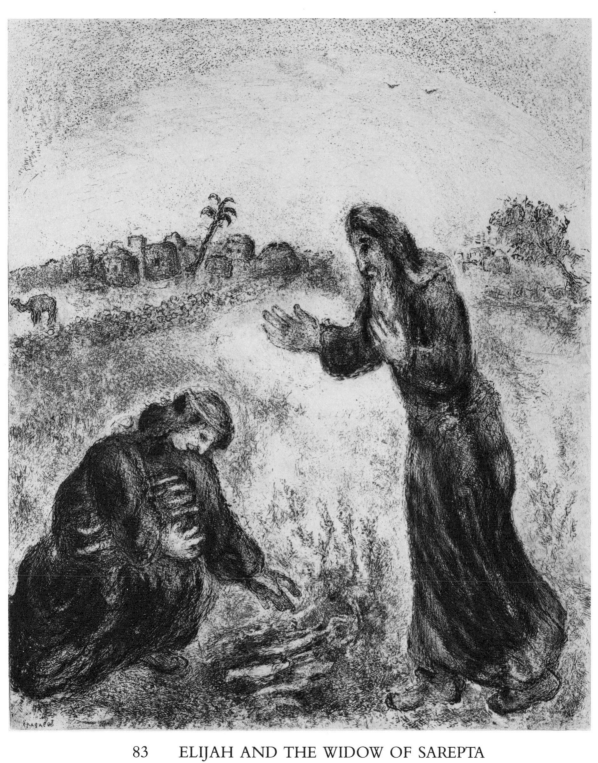

83 ELIJAH AND THE WIDOW OF SAREPTA

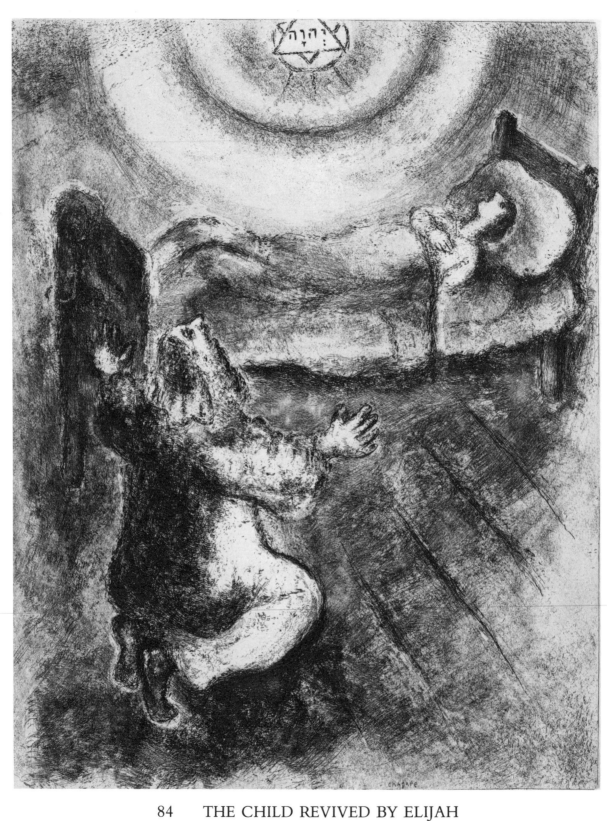

84 THE CHILD REVIVED BY ELIJAH

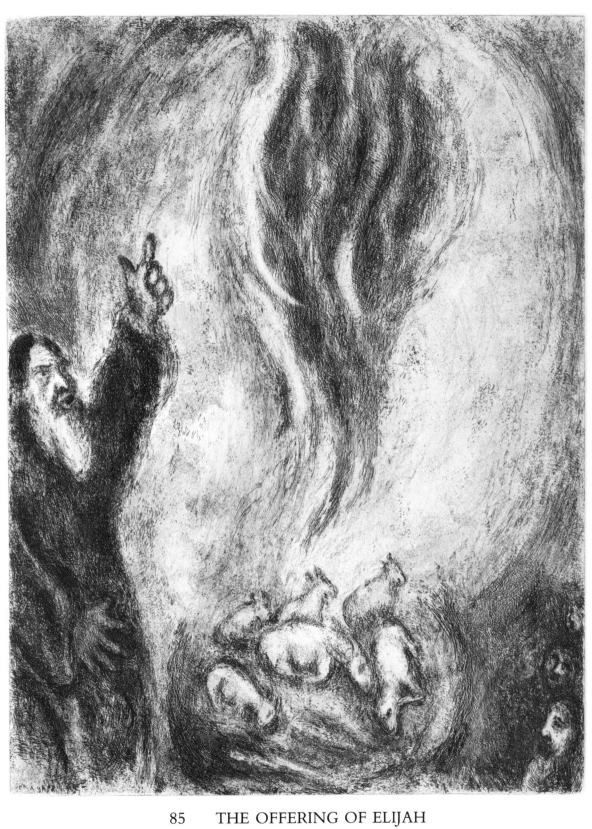

85 THE OFFERING OF ELIJAH

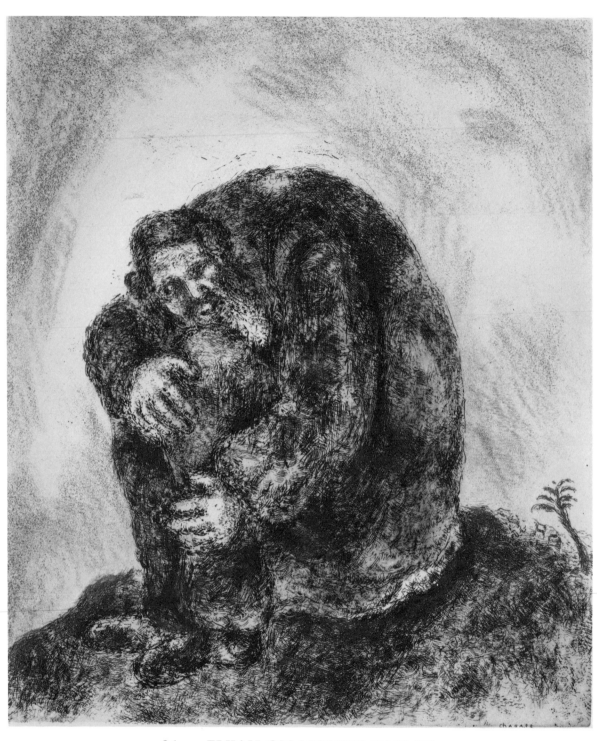

86 ELIJAH ON MOUNT CARMEL

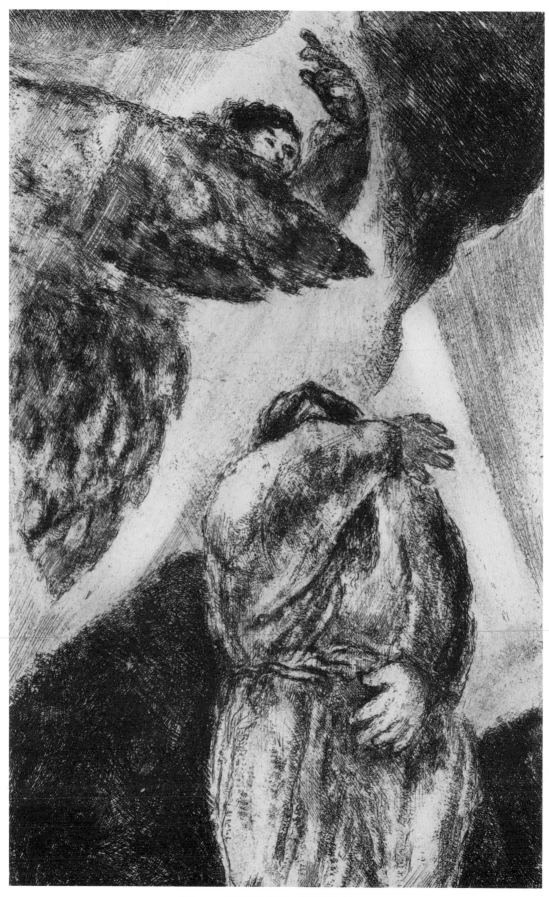

88 ELIJAH'S VISION

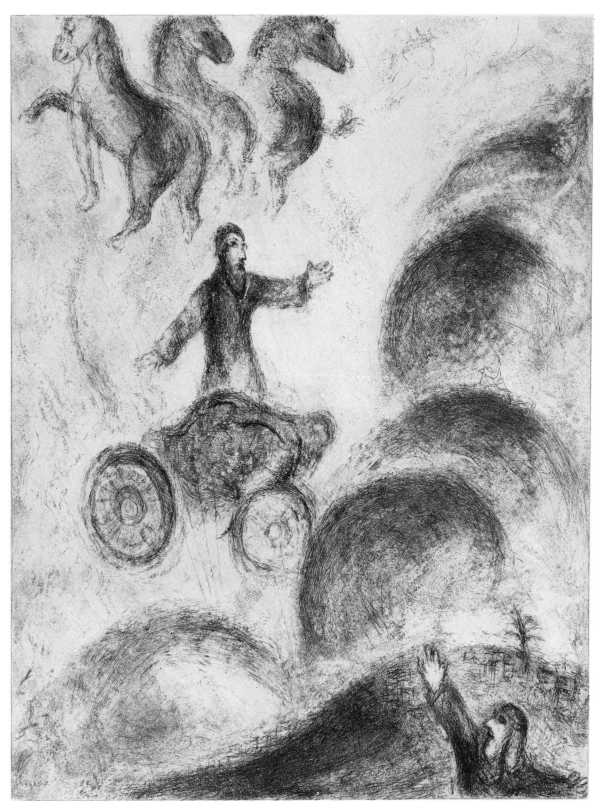

89 ELIJAH CARRIED OFF TO HEAVEN

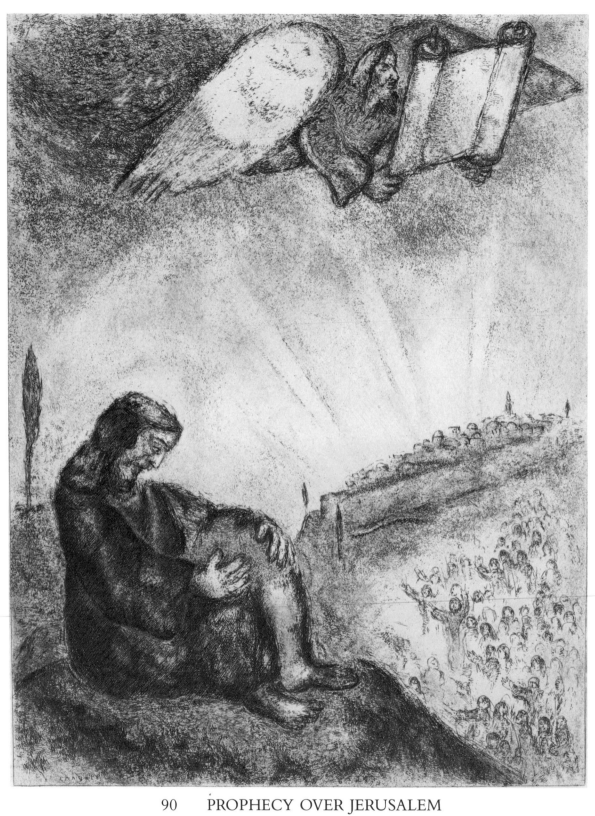

90 PROPHECY OVER JERUSALEM

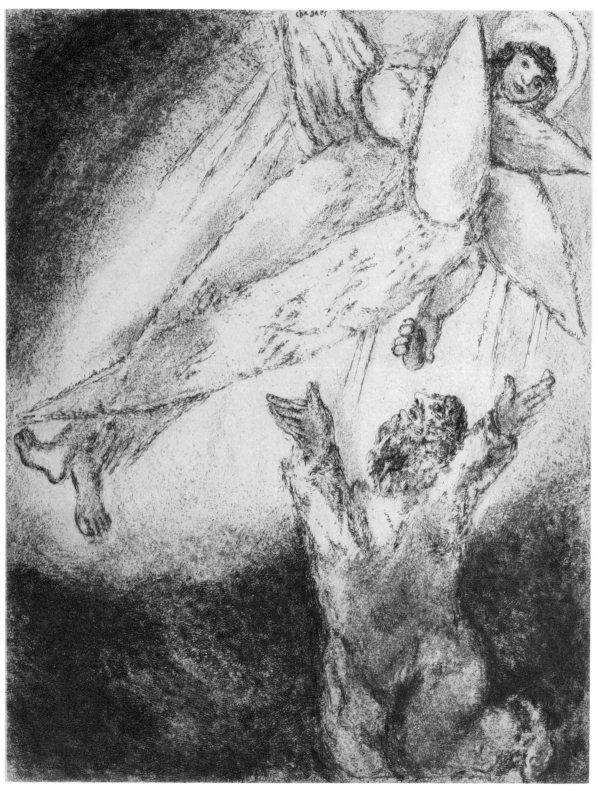

91 VISION OF ISAIAH

92 MESSIANIC TIMES

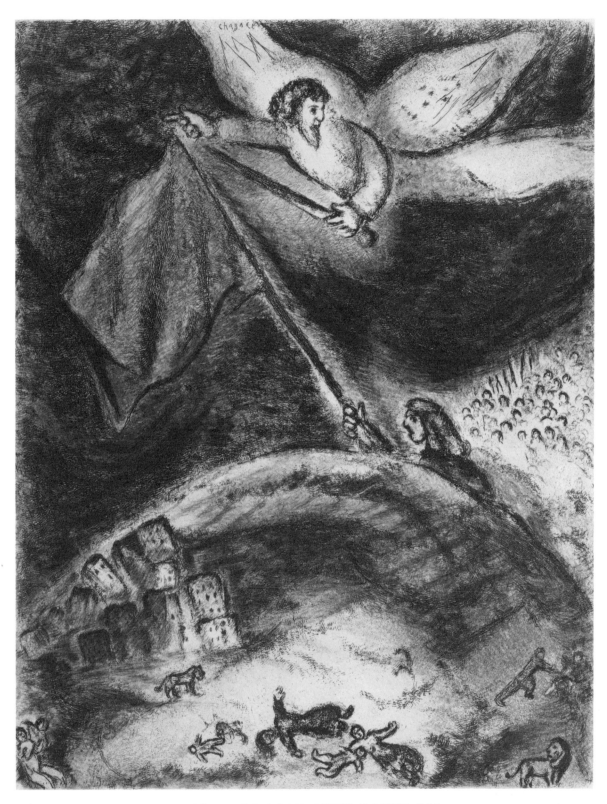

93 ORACLE OVER BABYLON

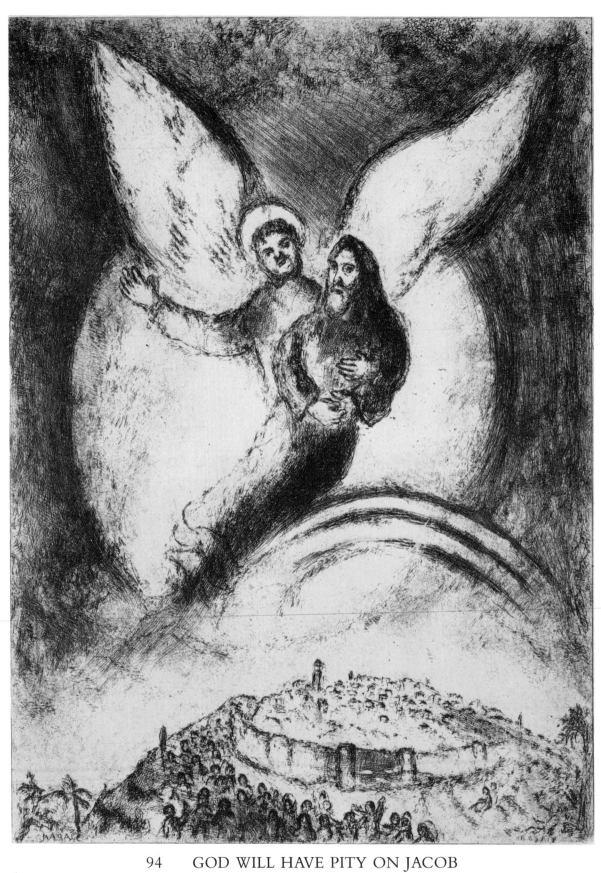

94 GOD WILL HAVE PITY ON JACOB

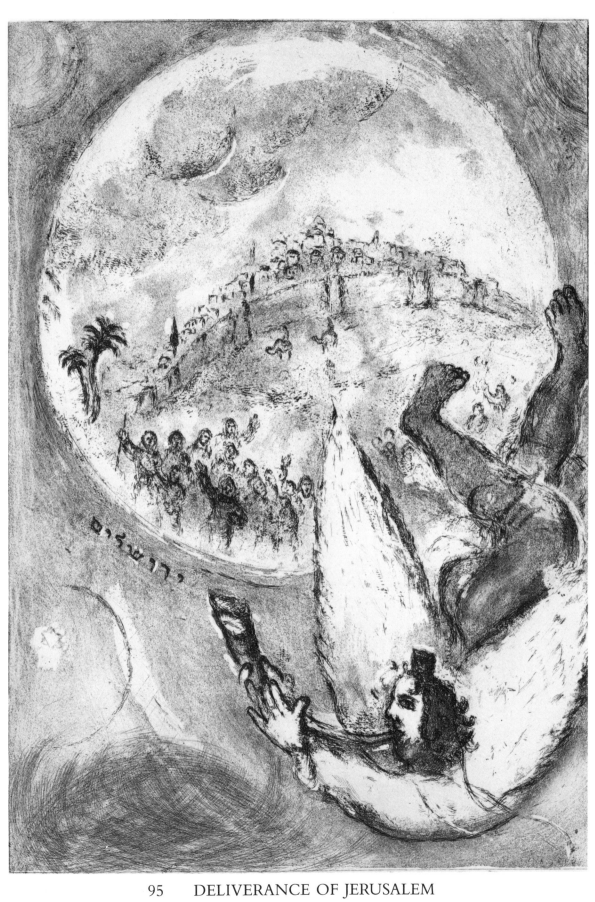

95 DELIVERANCE OF JERUSALEM

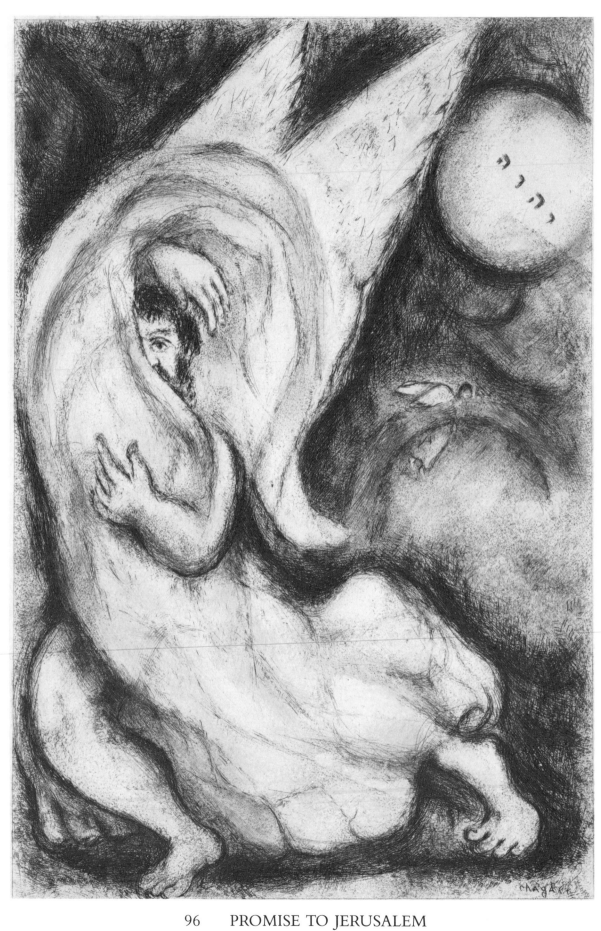

96 PROMISE TO JERUSALEM

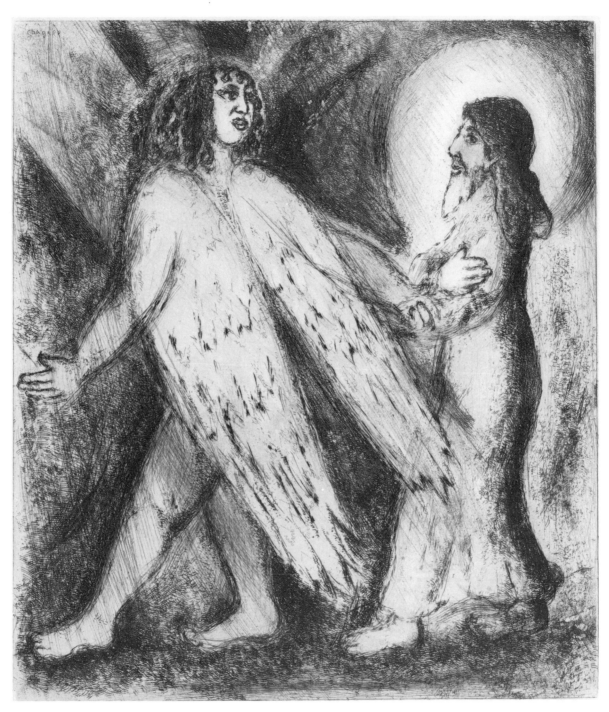

97 MAN GUIDED BY GOD

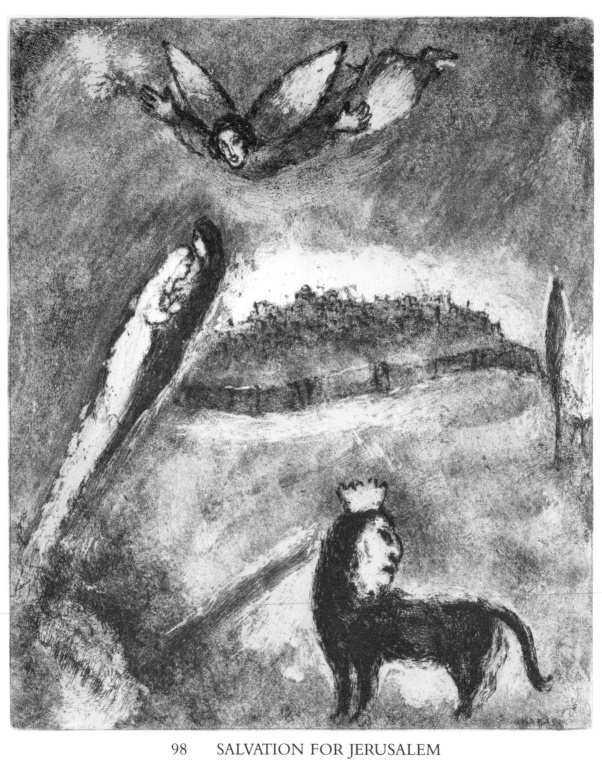

98 SALVATION FOR JERUSALEM

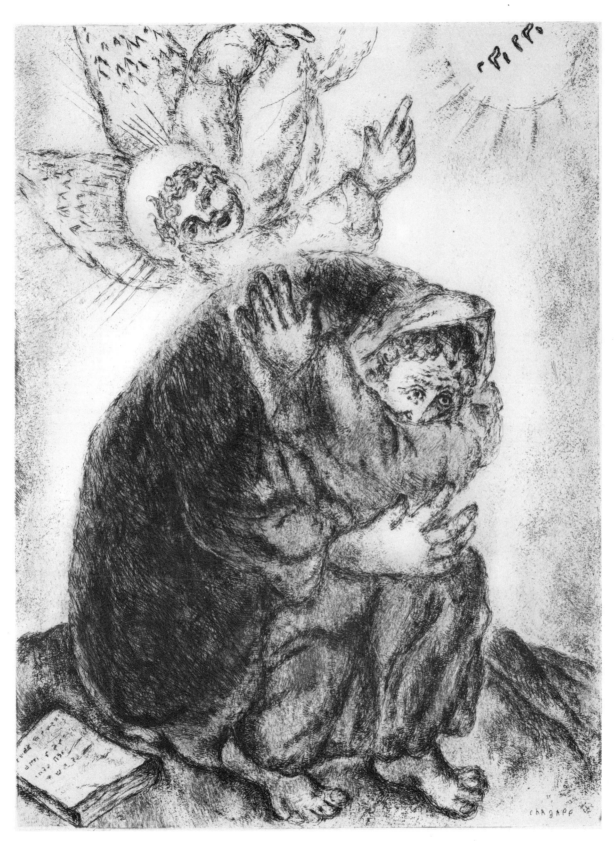

99 ISAIAH'S PRAYER

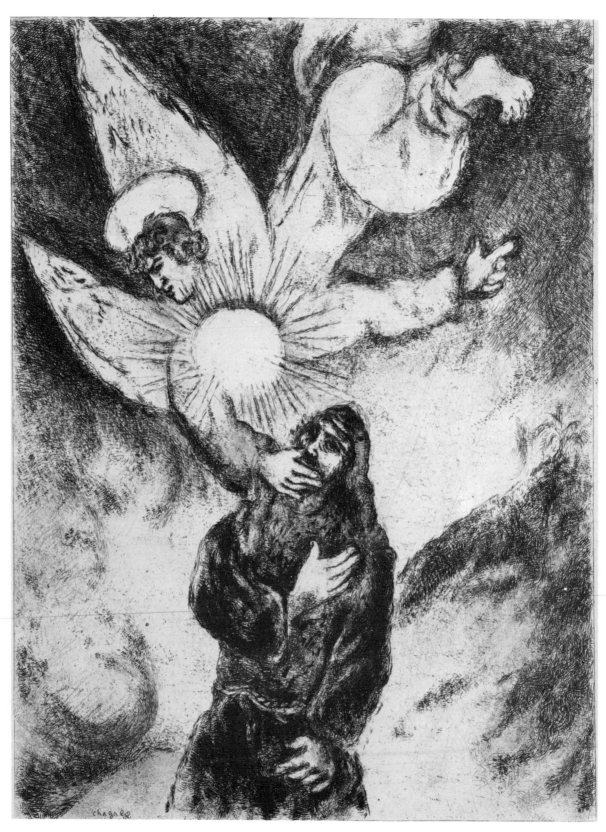

100 CALLING OF JEREMIAH

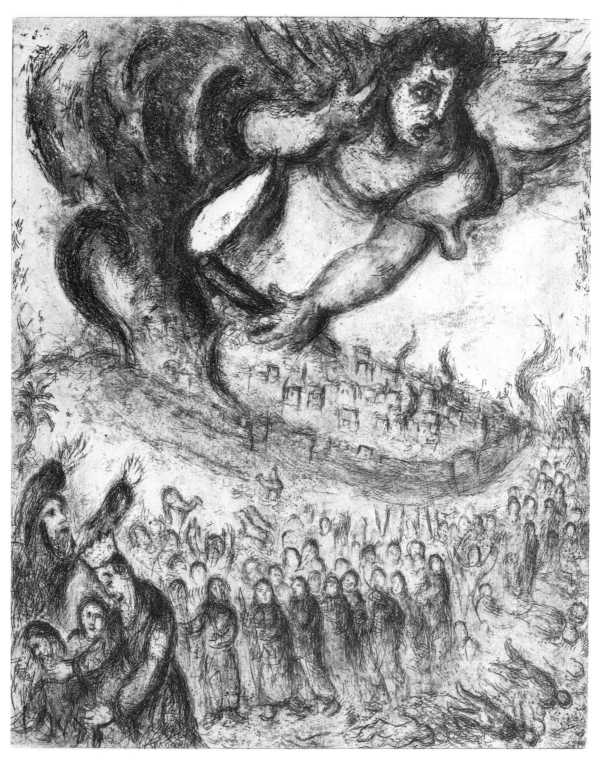

101 CAPTURE OF JERUSALEM

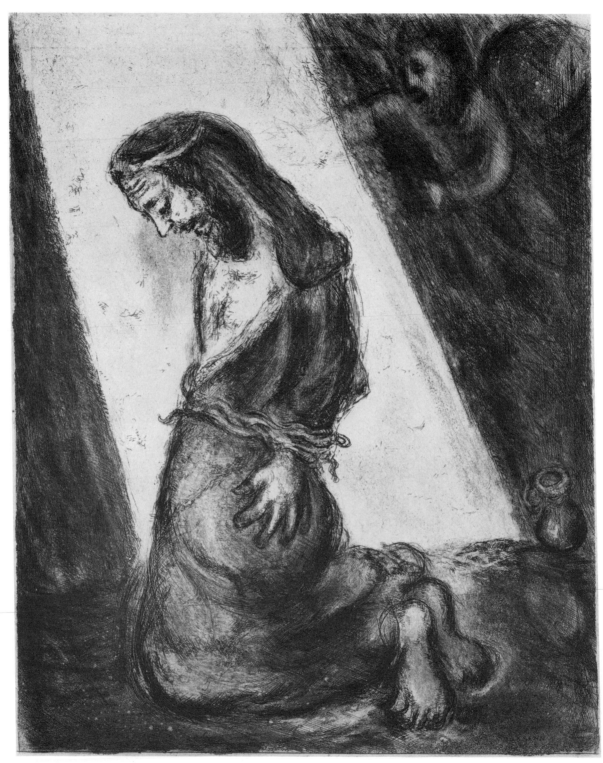

102 JEREMIAH IN THE PIT

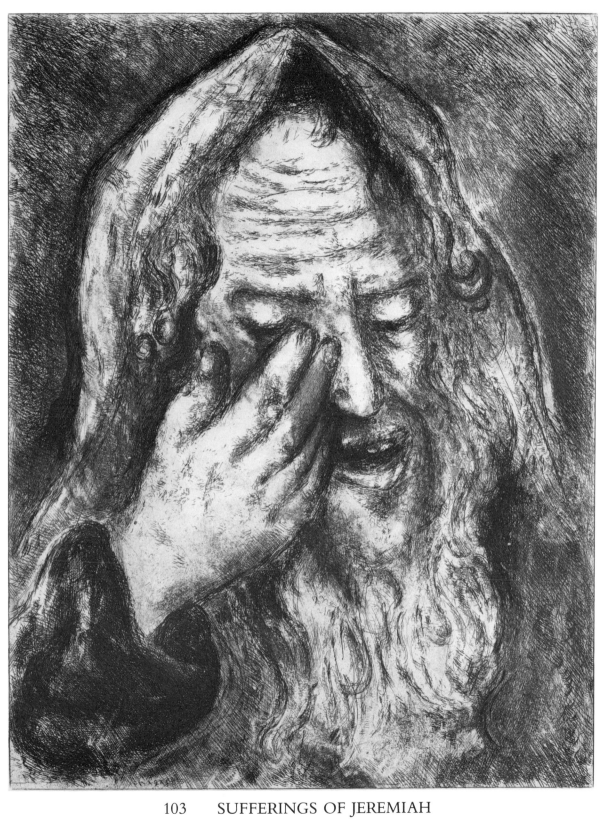

103 SUFFERINGS OF JEREMIAH

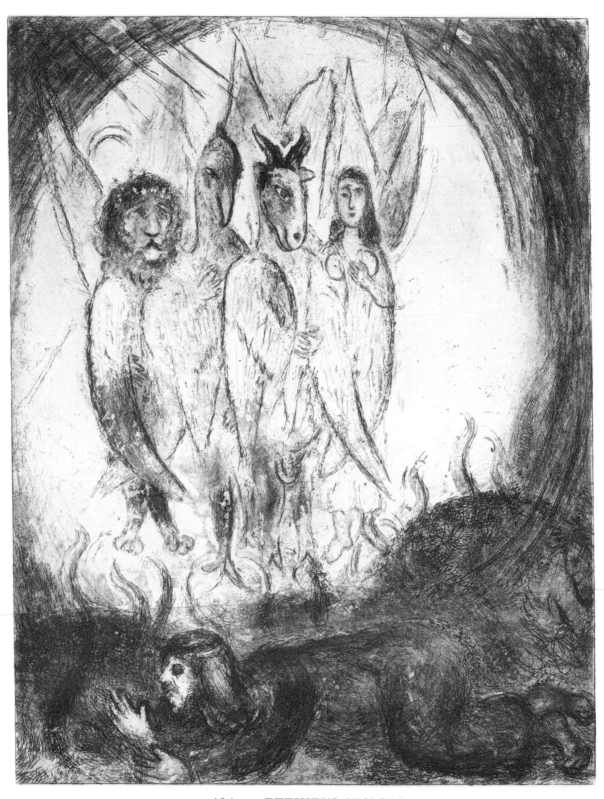

104 EZEKIEL'S VISION

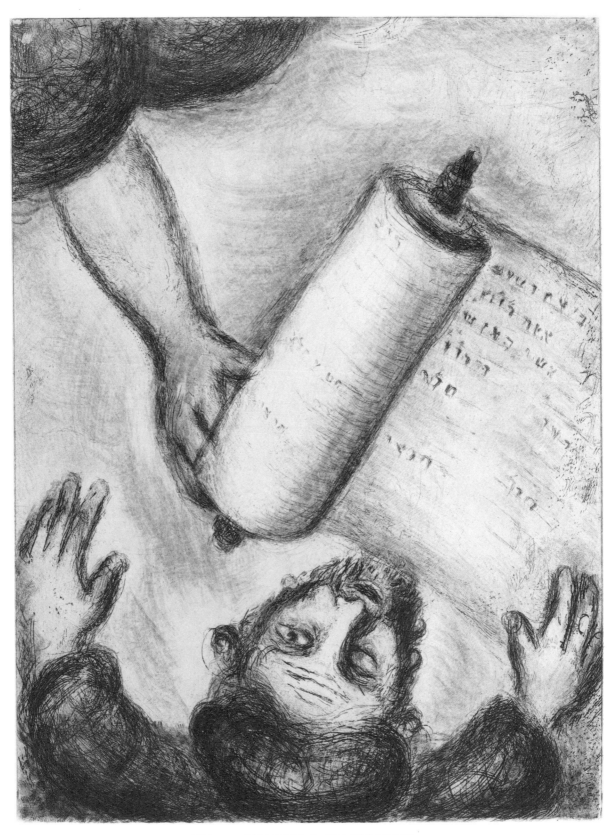

105 CALLING OF EZEKIEL

BIBLICAL TEXTS
AND INTERPRETATIONS

Note:

The original French verses in Chagall's *Bible* are excerpts of the translation established according to the Hebrew text by the pastors and professors of the Church of Geneva, published in 1638 in Geneva. The composition and printing of these texts were executed under the guidance of Georges Arnoult. The printing on the presses of the Imprimerie Nationale took place December 14, 1956.

The English translation for this catalogue of the texts cited by Chagall is taken from *Tanakh, A New Translation of the Holy Scriptures According to the Traditional Hebrew Text,* Philadelphia-NY-Jerusalem: Jewish Publication Society, 1985. This material is copyrighted by and used through the courtesy of the The Jewish Publication Society.

1. CREATION OF MAN

. . . the LORD GOD formed man from the dust of the earth. He blew into his nostrils the breath of life, and man became a living being .

<div align="right">Genesis, II, 7</div>

Chagall begins his cycle with the creation of man—introducing man's dialogue with God as the humanist focus of his personal interpretation of the *Bible*.[66] Heeding the traditional prohibition in Judaism against graven imagery depicting God, Chagall suggests divinity in the abstract form of a circle of light inscribed in Hebrew with God's name. This circle, suggesting the infinite and the eternal, becomes one of the three symbolic means Chagall utilizes to suggest God's presence in the *Bible*. The agent of God's creation is the angel, a dynamic winged creature which supports the gracefully inert body of Adam in his arms and whose arm merges with Adam's neck and breast.[67] A brilliant light highlights the floating triad of God, angel and man amidst the dense darkness of the surrounding void, somewhere between heaven and earth. Through this stark contrast, Chagall accentuates the miracle of life born out of dust. The dynamic process of creation is suggested by the angel's diagonal, downward sweep across the void and by the centrifugal force of outspread wings and limbs. The artful cropping of the dominant circle of God's light and of the feet of Adam and the angel remind us that Chagall has captured a transitory moment of a process that extends beyond time and space.

2. THE DOVE OF THE ARK

At the end of forty days, Noah opened the window of the ark that he had made and sent out the raven; it went to and fro until the waters had dried up from the earth. Then he sent out the dove to see whether the waters had decreased from the surface of the ground. But the dove could not find a resting place for its foot, and returned to him to the ark, for there was water over all the earth. So putting out his hand, he took it into the ark with him.

<div align="right">Genesis, VIII, 6-9</div>

Departing from the tradition in western art of depicting dramatic, external views of the flood and its devastation, Chagall chooses to represent the moment of deliverance as experienced from within the Ark.[68] Cramped into the dark hold of the vessel are Noah, a mother and her baby, a heifer and a cock. This compressed space is relieved by the open window, through which the dove is launched and through which brilliant sunlight illuminates the anxious, yet hopeful, passengers. The promise of new life is overtly expressed by the juxtaposition of the elderly Noah and the youthful mother and her newborn child. The presence of the cock and the young cow, familiar domestic animals of Chagall's Vitebsk youth, also carry deeper significance for the artist. The cock and cow are the innocent victims of slaughter by the traditional *schochets* (Jewish butchers) so vividly recalled by Chagall in *My Life*.[69] Furthermore, the symbolic meaning of the cock, which for thousands of years has played a part in religious rites as the embodiment of the forces of sun and fire, frequently appears in Chagall's works to represent elementary spiritual power.[70] The heifer is symbolically linked with Israel by the Biblical verse from the *Book of Hosea*: "Since Israel has run wild, wild as a heifer" (Hosea, IV, 16).[71] Thus, these two symbolic animals reinforce the dream of the salvation of the Jewish people so poignantly expressed in this etching.

3. SACRIFICE OF NOAH

Then Noah built an altar to the LORD and, taking of every clean animal and of every clean bird, he offered burnt offerings on the altar. The LORD smelled the pleasing odor, and the LORD said to Himself: "Never again will I doom the earth because of man, since the devisings of man's mind are evil from his youth; nor will I ever again destroy every living being, as I have done.
So long as the earth endures,
Seedtime and harvest,
Cold and heat,
Summer and winter,
Day and night
Shall not cease."

<div align="right">Genesis, VIII, 20-22</div>

This scene depicting Noah's gratitude to God is filled with Chagall's unique warmth and joy. Noah humbly embraces the dark barren earth. His sacrifice of beatific animals is enveloped in a circle of pure light, reminiscent of God's presence in Plate 1 and symbolic of God's acceptance of this pleasing offering. The presence on the right margin of Noah's son regarding the offering reminds us of God's salvation of future generations.

4. THE RAINBOW

And God said to Noah and to his sons with him, "I now establish My covenant with you and your offspring to come, and with every living thing that is with you—birds, cattle, and every wild beast as well—all that have come out of the ark, every living thing on earth. I will maintain My covenant with you: never again shall all flesh be cut off by the waters

of a flood, and never again shall there be a flood to destroy the earth."

God further said, "This is the sign that I set for the covenant between Me and you, and every living creature with you, for all ages to come. I have set My bow in the clouds, and it shall serve as a sign of the covenant between Me and the earth. When I bring clouds over the earth, and the bow appears in the clouds, I will remember My covenant between Me and you and every living creature among all flesh, so that the waters shall never again become a flood to destroy all flesh. When the bow is in the clouds, I will see it and remember the everlasting covenant between God and all living creatures, all flesh that is on earth."

Genesis, IX, 8-16

The dim and clouded landscape just emerging from the flood is illuminated by the brilliant white rainbow, symbol of God's covenant with Noah. Its reflected light seeps between the dark linear striations of earth and sky and accents the contours of the landlocked Ark. Amidst the rainbow, a light-filled angel gestures down to the reclining Noah. The harmony between God and man is expressed by their shared glance and their mirrored uplifted hands. The delicate shrub behind Noah's head and the three small animals etched into the landscape remind us that God's covenant extends not only to Noah, but to every living creature and to the earth.

5. THE MANTLE OF NOAH

Noah, the tiller of the soil, was the first to plant a vineyard. He drank of the wine and became drunk, and he uncovered himself within his tent. Ham, the father of Canaan, saw his father's nakedness and told his two brothers outside. But Shem and Japheth took a cloth, placed it against both their backs and, walking backward, they covered their father's nakedness; their faces were turned the other way, so that they did not see their father's nakedness.

Genesis, IX, 20-23

The noble visage and frail body of the venerable Noah, seen in Plates 2-4, is transformed in this scene to that of a younger, bulkier man with dark beard and features coarsened by his inebriation. Unlike the graceful, innocent nudity of Adam in Plate 1, Noah's reclining body is ungainly and disproportioned. Chagall departs from a strict illustration of the text by placing Noah in the lush, grape-laden vineyard he has cultivated, which has supplied the wine in the bottles around him. Only one son (rather than the text's Shem and Japheth) cloaks his father's nakedness, while averting his gaze.

The four Noah etchings [Plates 2-5] reflect Chagall's

ability to express a range of characterizations for a single personality, with facial features and body types radically altered to suit each individual scene. Noah is depicted as monumental [Plate 1], humble [Plate 2], inspired [Plate 3], yet vulnerable [Plate 5]. The cumulative depictions convey the strengths and weaknesses of his humanity.

6. THE CIRCUMCISION

Such shall be the covenant between Me and you and your offspring to follow which you shall keep: every male among you shall be circumcised.

Genesis, XVII, 10

Chagall's memories of his younger brother's birth and circumcision in Vitebsk may, perhaps, have inspired his depiction of this act of Covenant.

Mama, half naked, pale, with a faint pink flush on her cheeks is in bed. My younger brother had just been born . . . An old man, murmuring his prayer, cuts with a sharp knife the little bit of skin below the newborn baby's belly. He . . . stifles the babe's cries and moans with his beard.[72]

Earlier depictions of circumcision scenes appear in Chagall's Russian paintings and drawings of 1908–1910. In these works, ambiguous references to New Testament iconography have been interpreted as Chagall's expression of the Jewishness of Jesus.[73]

7. ABRAHAM AND THE THREE ANGELS

The LORD appeared to him by the terebinths of Mamre; he was sitting at the entrance of the tent as the day grew hot. Looking up, he saw three men standing near him. As soon as he saw them, he ran from the entrance of the tent to greet them and, bowing to the ground, he said, "My lords, if it please you, do not go on past your servant. Let a little water be brought; bathe your feet and recline under the tree. And let me fetch a morsel of bread that you may refresh yourselves; then go on — seeing that you have come your servant's way." They replied, "Do as you have said."

Abraham hastened into the tent to Sarah, and said, "Quick, three seahs of choice flour! Knead and make cakes!" Then Abraham ran to the herd, took a calf, tender and choice, and gave it to a servant-boy, who hastened to prepare it. He took curds and milk and the calf that had been prepared and set these before them; and he waited on them under the tree as they ate.

Genesis, XVIII, 1-8

This extraordinary visit by three angels to announce Sarah's impending pregnancy has been portrayed by Chagall as a charming genre scene. The angels dine out-of-doors at a picnic table under a tree, served by the hospitable Abraham and his wife. The brilliant, clear sky of Palestine beats down on the scene and is reflected in the blinding whiteness of the Angel's luxuriant wings. Chagall's depiction of the aged Sarah seems close to his description of his grandmother Batsheva: "All there was to that little old woman was a scarf around her head, a little skirt and a wrinkled face."[74]

A precedent for Chagall's depiction of this scene is Andre Roubliev's icon at Moscow's Tretiakov Gallery which was well known to Chagall and which shows three angels at the table, without Abraham, in a symbolic prefiguration of the Trinity.[75]

8. THE DESCENT TOWARDS SODOM

The men set out from there and looked down toward Sodom, Abraham walking with them to see them off.

Genesis, XVIII, 16

Chagall follows the angels' announcement of new life in the preceding etching with this depiction of the angels' mission of death. As Abraham escorts the three angels down the precipitous slope of the mountainside, his face is sobered and shoulders are weighted by the destructive purpose of their journey. The foremost angel points downward to their distant destination—a bird's eye view of Sodom. The abrupt shift in scale between these weighty figures and the minute city below describes not only the physical distance to be travelled, but the moral distance between righteousness and Sodom's depravity.

9. LOT AND HIS DAUGHTERS

And the older one said to the younger, "Our father is old, and there is not a man on earth to consort with us in the way of all the world. Come, let us make our father drink wine, and let us lie with him, that we may maintain life through our father." That night they made their father drink wine, and the older one went in and lay with her father; he did not know when she lay down or when she rose. The next day the older one said to the younger, "See, I lay with Father last night; let us make him drink wine tonight also, and you go and lie with him, that we may maintain life through our father." That night also they made their father drink wine, and the younger one went and lay with him;

he did not know when she lay down or when she rose.

Genesis, XIX, 31–35

Lot's daughters' initiative to perpetuate their people is sensitively portrayed as sensible and natural by Chagall.[76] Lot's features, contorted by drink, convey his insensibility. His daughters are depicted as fresh-faced and innocent. The kindred relationship between father and daughter is underscored by their similar body proportions and reclining poses. Outside the shelter of their cave, the promise of new life is indicated by the tiny tree emerging out of the hilltop and the spray of leaves at the right margin.

10. THE SACRIFICE OF ABRAHAM

They arrived at the place of which God had told him. Abraham built an altar there; he laid out the wood; he bound his son Isaac; he laid him on the altar, on top of the wood. And Abraham picked up the knife to slay his son. Then an angel of the LORD called to him from heaven: "Abraham! Abraham!" And he answered, "Here I am." And he said, "Do not raise your hand against the boy, or do anything to him. For now I know that you fear God, since you have not withheld your son, your favored one, from Me." When Abraham looked up, his eye fell upon a ram, caught in the thicket by its horns. So Abraham went and took the ram and offered it up as a burnt offering in place of his son. And Abraham named that site Adonai-yireh, whence the present saying, "On the mount of the LORD there is vision."

Genesis, XXII, 9–14

Chagall's expression of man's faith in God reaches a climax in this dramatic scene. Young Isaac is bound and horizontally posed across the altar, his head hanging downward to accentuate his vulnerability. Abraham gently holds Isaac's leg with one hand and lifts the knife with the other. The sudden descent of the angel arrests his movement and Abraham's submissive eyes are locked onto God's messenger. The small white ram which will replace Isaac as the offering emerges from the dense thicket on the left. The subtlety of Chagall's composition can be seen in the way he has adjusted the angle of the knife to the kindling on the altar and echoed the angle created by Abraham's arm and knife in the angel's parted wings above.[77] In describing his childhood nightmares, Chagall alludes to the frightening imagery of this sacrifice. "[In his mother's arms] . . . no hand towel will be changed into a ram and an old man, and no sepulchral figure will glide across the frozen windowpanes."[78]

11. ABRAHAM WEEPING FOR SARAH

Sarah's lifetime—the span of Sarah's life—came to one hundred and twenty-seven years. Sarah died in Kiriath-arba—now Hebron—in the land of Canaan; and Abraham proceeded to mourn for Sarah and to bewail her.

<div align="right">Genesis, XXIII, 1–2</div>

Chagall evokes Abraham's profound grief in this simple yet monumental composition. With bowed head and covered face, Abraham's bereavement is discrete and contained in his massive solidity. Sarah is laid out horizontally before him, her insubstantial body emanating an ethereal light. The weight of Abraham's loneliness is accentuated by the jagged darkness pressing down on his shoulders.

12. REBECCA AT THE WELL

Then the servant took ten of his master's camels and set out, taking with him all the bounty of his master; and he made his way to Aramnaharaim, to the city of Nahor. He made the camels kneel down by the well outside the city, at evening time, the time when women come out to draw water. And he said, "O LORD, God of my master Abraham; grant me good fortune this day, and deal graciously with my master Abraham: Here I stand by the spring as the daughters of the townsmen come out to draw water; let the maiden to whom I say, 'Please, lower your jar that I may drink,' and who replies, 'Drink, and I will also water your camels'—let her be the one whom You have decreed for Your servant Isaac. Thereby shall I know that You have dealt graciously with my master."

<div align="right">Genesis, XXIV, 10–14</div>

The impact of Chagall's trip to Palestine, Egypt and Syria in 1931 in preparation for the *Bible* can be seen in this etching. The Bedouin garb of Abraham's servant, his elegant camel and its cloaked driver, the archaic pottery carried by Rebecca and the pervasive, brilliant sunlight over the desert landscape were all observed and recorded by Chagall during his sojourn. Rebecca's unselfconscious beauty and grace are carefully studied by the servant. In the far distance, at the horizon, a lone palm shades the well outside the city.

13. JACOB BLESSED BY ISAAC

Then his father Isaac said to him, "Come close and kiss me, my son"; and he went up and kissed

him. And he smelled his clothes and he blessed him, saying, "Ah, the smell of my son is like the smell of the fields that the LORD has blessed.
"May God give you
Of the dew of heaven and the fat of the earth,
Abundance of new grain and wine.
Let peoples serve you,
And nations bow to you;
Be master over your brothers,
And let your mother's sons bow to you.
Cursed be they who curse you,
Blessed they who bless you."*

<div align="right">Genesis, XXVII, 26–29</div>

The dramatic deception is brilliantly evoked by Chagall. Short, quivering lines describe the blind Isaac and evoke his trembling frailty. Through densely woven strokes, Chagall conveys the hairy tactility of the fleece used to cover Jacob's head, neck and body for this impersonation of his brother Esau. In the middleground, an anxious Sarah has laid out the meal prepared from Jacob's hunted game. In the distant background, a figure (perhaps Esau, the outdoorsman) rests beneath a palm. Anecdotal details of sheep, camel and still life relieve the intensity of the scene.

14. JACOB'S LADDER

He had a dream; a stairway was set on the ground and its top reached to the sky, and angels of God were going up and down on it. And the LORD was standing beside him and He said, "I am the LORD, the God of your father Abraham and the God of Isaac: the ground on which you are lying I will assign to you and to your offspring. Your descendants shall be the dust of the earth; you shall spread out to the west and to the east, to the north and to the south. All the families of the earth shall bless themselves by you and your descendants. Remember, I am with you: I will protect you wherever you go and will bring you back to this land. I will not leave you until I have done what I have promised you."

<div align="right">Genesis, XXVIII, 12–15</div>

Chagall's close identification with this subject, depicted frequently in his oeuvre, is reflected in a verse of a poem written by the artist: "Lying down like Jacob asleep/I have dreamed a dream/An angel seizes me and hoists me up onto a ladder,/The souls of the dead are singing."[79]
Chagall's playful imagination animates this etching with wit and whimsy. Jacob reclines across the horizontal foreground, grinning in his sleep. The

undulating horizon line echoes the relaxed and rounded contours of his curved arm and bent legs. Although the sun has set, the lightly stippled sky is brilliantly illuminated by a triangular shaft of pure light inscribed at its apex with God's name. Amidst this divine light, a tall ladder rises with two angels ascending and descending. Introducing the dreamer to his dream is an acrobatic Hasid who floats upside down, pointing downward to the visionary and upward to his vision.

There is a curious affinity between Chagall's depiction of the sleeping Jacob and Ribera's treatment of the same subject, which Chagall undoubtedly would have seen in Madrid's Prado Museum during his 1934 trip to Spain. Chagall's treatment of the ladder in this etching as a road to heaven presents a positive image of hope. By the late 1930's, the ladder takes on a negative connotation in Chagall's crucifixion paintings.[80]

15. MEETING OF JACOB AND RACHEL

He said, "It is still broad daylight, too early to round up the animals; water the flock and take them to pasture." But they said, "We cannot, until all the flocks are rounded up; then the stone is rolled off the mouth of the well and we water the sheep."

While he was still speaking with them, Rachel came with her father's flock; for she was a shepherdess. And when Jacob saw Rachel, the daughter of his uncle Laban, and the flock of his uncle Laban, Jacob went up and rolled the stone off the mouth of the well, and watered the flock of his uncle Laban.

Genesis, XXIX, 7–10

The depiction of Jacob and Rachel's first encounter is imbued with Chagall's unique romanticism. Jacob recognizes and embraces the beautiful daughter of his uncle Laban, while she is not yet quite aware of his identity. Jacob is obviously smitten by love at first sight, just as Chagall recalls having fallen in love with Bella.[81] While a flock of young sheep cavort around the open well, the sky is filled with sharp broken lines that express Jacob's high-keyed emotion. Chagall returns to this biblical love story during the last years of his life in his decoration of the *Harpsichord* (1980) for the Museum of the Biblical Message—Marc Chagall in Nice and in the late work *Peasants by the Well* (1981).

16. WRESTLING WITH THE ANGEL

After taking them across the stream, he sent across all his possessions. Jacob was left alone. And

a man wrestled with him until the break of dawn. When he saw that he had not prevailed against him, he wrenched Jacob's hip at its socket, so that the socket of his hip was strained as he wrestled with him. Then he said, "Let me go, for dawn is breaking." But he answered, "I will not let you go, unless you bless me." Said the other, "What is your name?" He replied, "Jacob."

Genesis, XXXII, 24–28

Chagall has portrayed an older, more massive Jacob than in the three prior plates. As in Rembrandt's painting of the same subject, Chagall has chosen to depict the moment of the struggle when the Angel has wrenched Jacob's hip at the socket by the pressure of his knee.[82] There is a baroque dynamism in the fleshy, overlapping limbs and the emphatic diagonal movement of the weighted adversaries. Chagall indicates the dawn by contrasting the diagonally striated sky on the left with the lighter, stippled sky on the right.

17. RACHEL'S TOMB

Thus Rachel died. She was buried on the road to Ephrath—now Bethlehem. Over her grave Jacob set up a pillar; it is the pillar at Rachel's grave to this day.

Genesis, XXXV, 19–20

Chagall visited Rachel's Tomb during his trip to Palestine in 1931 and enjoyed working out-of-doors while he painted this view.[83] The etching replicates the painting, capturing the vivid sensation of the landscape and light. Rachel's Tomb stands alone in the hilly landscape, bereft of human presence. The foreground landscape is animated by alternating horizontal stripes of rocky and smooth ground. The arches and domes of the monument are echoed in the rounded hills and camel. Unique in the *Bible* suite for its lack of human figuration, this etching exudes the poignancy of Rachel's death and her solitary resting place—left behind during the course of Jacob's journey.

18. YOUNG SHEPHERD JOSEPH

This, then, is the line of Jacob:
At seventeen years of age, Joseph tended the flocks with his brothers, as a helper to the sons of his father's wives Bilhah and Zilpah. And Joseph brought bad reports of them to their father.

Genesis, XXXVII, 2

Set against the clear, bright sky of Palestine, Joseph is represented as youthful, strong, yet gentle. His upright posture and the abrupt shift in scale between

his monumental figure and his distant brothers tending their flock can be seen as symbolic of the gulf between his righteousness and their weakness.

19. JOSEPH AND HIS BROTHERS

When Joseph came up to his brothers, they stripped Joseph of his tunic, the ornamented tunic that he was wearing, and took him and cast him into the pit. The pit was empty; there was no water in it.

Genesis, XXXVII, 23–24

The presence of only ten of Joseph's eleven brothers and the view of the caravan along the horizon would suggest that a slightly later verse has actually been illustrated by Chagall: the moment when Judah convinces his brothers to sell Joseph to the passing Midranite traders. Absent from the scene is the eleventh brother, Benjamin, who had prevented Joseph's murder and had planned to retrieve him from the pit. Brilliant sunlight illuminates the brothers' complicity in their evil deed. Joseph's anguished face and pose are reminiscent of traditional depictions of Christ's deposition from the cross.

20. JACOB WEEPING FOR JOSEPH

Then they took Joseph's tunic, slaughtered a kid, and dipped the tunic in the blood. They had the ornamented tunic taken to their father, and they said, "We found this. Please examine it; is it your son's tunic or not?" He recognized it, and said, "My son's tunic! A savage beast devoured him! Joseph was torn by a beast!" Jacob rent his clothes, put sackcloth on his loins, and observed mourning for his son many days. All his sons and daughters sought to comfort him, but he refused to be comforted, saying, "No, I will go down mourning to my son in Sheol." Thus his father bewailed him.

Genesis, XXXVII, 31–35

As in *Abraham Weeping for Sarah* [Plate 11], extreme grief is depicted through Jacob's hunched form and covered face. He clutches Joseph's tattered coat while his duplicitous sons pretend to comfort him. Dense blacks and grays dominate the composition, echoing the darkness of the brothers' deed and the bleakness of Jacob's heart.

21. POTIPHAR'S WIFE

After a time, his master's wife cast her eyes upon Joseph and said, "Lie with me." But he refused. He said to his master's wife, "Look, with me here, my master gives no thought to anything in this house, and all that he owns he has placed in my hands. He wields no more authority in this house than I, and he has withheld nothing from me except yourself, since you are his wife. How then could I do this most wicked thing, and sin before God?"

Genesis, XXXIX, 7–9

Chagall's depiction of Potiphar's wife follows a celebrated tradition of seductive, reclining nudes by Giorgione, Titian and Goya. Details of the partly draped figure, the elaborate draperies surrounding the bed and the slippers in the foreground recall Rembrandt's *Danaë*, while the nude's high-breasted and long-waisted torso are reminiscent of Ingres' odalisques. Chagall crops Joseph's figure to accentuate his rush to escape Potiphar's wife's grasp. Joseph's uncanny resemblance to Chagall adds a humorous touch to this aborted seduction scene.

22. PHARAOH'S DREAM

And Joseph said to Pharaoh, "Pharaoh's dreams are one and the same! God has told Pharaoh what He is about to do. The seven healthy cows are seven years, and the seven healthy ears are seven years; it is the same dream. The seven lean and ugly cows that followed are seven years, as are also the seven empty ears scorched by the east wind; they are seven years of famine. It is just as I have told Pharaoh: God has revealed to Pharaoh what He is about to do. Immediately ahead are seven years of great abundance in all the land of Egypt. After them will come seven years of famine, and all the abundance in the land of Egypt will be forgotten. As the land is ravaged by famine, no trace of the abundance will be left in the land because of the famine thereafter, for it will be very severe. As for Pharaoh having had the same dream twice, it means that the matter has been determined by God, and that God will soon carry it out.

Genesis, XLI, 25–32

During his 1934 trip to Spain, Chagall was deeply impressed by the paintings of El Greco.[84] There is a strong affinity between the attenuated, mannerist figuration of Pharaoh with his elongated, bearded face framed by a white collar and El Greco's portraits of the Spanish clergy and nobility. Interpreting Pharaoh's dream, the young Joseph points up to the vision of six (out of the seven in the text) healthy cows, which are encapsulated in a cartoon-like bubble. Chagall accomplishes a remarkable manipulation of values in the subtle gradations between Pharaoh's black garb and his dark gray throne.

Through the limited means of black, white and gray, Chagall is nonetheless able to express his supreme talent as a colorist.

23. JOSEPH RECOGNIZED BY HIS BROTHERS

Joseph said to his brothers, "I am Joseph. Is my father still well?" But his brothers could not answer him, so dumbfounded were they on account of him.

Then Joseph said to his brothers, "Come forward to me." And when they came forward, he said, "I am your brother Joseph, he whom you sold into Egypt. Now, do not be distressed or reproach yourselves because you sold me hither; it was to save life that God sent me ahead of you."

Genesis, XLV, 3–5

As Jacob and Benjamin embrace, their brothers look on with clasped hands, covered faces, downcast eyes, stooped poses and stunted proportions expressive of their contrition. Joseph's elevated stature as lord of all Egypt is suggested by the elegance of his figure and the grandeur of the palace setting.

24. JACOB'S DEPARTURE FOR EGYPT

So Israel set out with all that was his, and he came to Beer-sheba, where he offered sacrifices to the God of his father Isaac. God called to Israel in a vision by night: "Jacob! Jacob!" He answered, "Here." And He said, "I am God, the God of your father. Fear not to go down to Egypt, for I will make you there into a great nation. I Myself will go down with you to Egypt, and I Myself will also bring you back; and Joseph's hand shall close your eyes."

So Jacob set out from Beer-sheba. The sons of Israel put their father Jacob and their children and their wives in the wagons that Pharaoh had sent to transport him; and they took along their livestock and the wealth that they had amassed in the land of Canaan. Thus Jacob and all his offspring with him came to Egypt: he brought with him to Egypt his sons and grandsons, his daughters and granddaughters — all his offspring.

Genesis, XLVI, 1–7

Of the seventy members of Jacob's multi-generational household who travelled to Egypt, approximately forty are depicted in this caravan scene. The elderly patriarch is elevated above the crowds upon a stately camel. Chagall illustrates the dense multitude of his offspring with great detail in the foreground and reduces their figures and livestock to

schematic line drawings at the horizon. Chagall initiates the subject of the mass procession in this etching as an important theme of his oeuvre. Processions appear several times in the *Bible*, albeit more often to describe tragic events. They figure significantly in his war-time Crucifixion compositions and in his many monumental Biblical paintings and tapestries of the 1950s and 1960s.

25. BLESSING OF EPHRAIM AND MANASSEH

When Joseph saw that his father was placing his right hand on Ephraim's head, he thought it wrong; so he took hold of his father's hand to move it from Ephraim's head to Manasseh's. "Not so, Father," Joseph said to his father, "for the other is the firstborn; place your right hand on his head." But his father objected, saying "I know, my son, I know. He too shall become a people, and he too shall be great. Yet his younger brother shall be greater than he, and his offspring shall be plentiful enough for nations." So he blessed them that day, saying, "By you shall Israel invoke blessings, saying: God make you like Ephraim and Manasseh." Thus he put Ephraim before Manasseh.

Genesis, XLVIII, 17–20

The composition of *Jacob Blessed by Isaac* [Plate 13] is recalled in this etching where, again, the younger son receives the blessing due the elder. Close to death, Jacob's shrunken figure is almost dematerialized by light, as was that of the deceased Sarah [Plate 11]. Chagall's portrayal of the seated, blind Jacob crossing his arms to bless his two grandsons is close to Rembrandt's depiction of the same scene.

26. MOSES SAVED FROM THE WATER

A certain man of the house of Levi went and married a Levite woman. The woman conceived and bore a son; and when she saw how beautiful he was, she hid him for three months. When she could hide him no longer, she got a wicker basket for him and caulked it with bitumen and pitch. She put the child into it and placed it among the reeds by the bank of the Nile. And his sister stationed herself at a distance, to learn what would befall him.

Exodus, II, 1–4

Chagall devotes seventeen etchings of the *Bible* to Moses, illustrating his life from infancy to death. Through these etchings, Chagall celebrates Moses'

unique leadership, strength and wisdom. The scenes depicted extoll Moses' face-to-face relationship with God, his skill in representing the Israelites before Pharaoh, his efficacy as the agent of God's wrath over Egypt, and his leadership in bringing his people out of bondage and instilling in them God's commandments. These etchings provide a corpus of imagery that Chagall will draw upon for major painting cycles, ceramics, stained glass windows and tapestries for the duration of his career.

In addition to Chagall's skills in characterization and narration in this suite, Chagall is adept at capturing multiple textures through his varied etching techniques. In this plate, densely woven and deeply bitten lines provide the dark cloth of Pharaoh's daughter's gown, her servant's robe, Moses' pitch-covered wicker basket and the thick overhanging foliage. Short vertical lines describe the reeds at the river's edge, while choppy parallel and cross-hatched strokes suggest the grass underfoot. The Nile's swift current is conveyed by the movement of fine horizontal slashes across the white ground. These details reflect the direct impact of the Egyptian landscape on Chagall during his 1931 trip.

27. THE BURNING BUSH

Now Moses, tending the flock of his father-in-law Jethro, the priest of Midian, drove the flock into the wilderness, and came to Horeb, the mountain of God. An angel of the LORD appeared to him in a blazing fire out of a bush. He gazed, and there was a bush all aflame, yet the bush was not consumed. Moses said, "I must turn aside to look at this marvelous sight; why doesn't the bush burn up?" When the LORD saw that he had turned aside to look, God called to him out of the bush: "Moses! Moses!" He answered, "Here I am." And He said, "Do not come closer. Remove your sandals from your feet, for the place on which you stand is holy ground.

Exodus, III, 1–5

God's presence in the burning bush is described by three concentric circles of light inscribed at their center with God's name. This divine light illuminates Moses' lined and bearded face and is reflected in the rays emanating from his head (prematurely granted to Moses by Chagall before Sinai).[85]

28. MOSES AND THE SERPENT

But Moses spoke up and said, "What if they do not believe me and do not listen to me, but say: The

LORD did not appear to you?" The LORD said to him, "What is that in your hand?" And he replied, "A rod." He said, "Cast it on the ground." He cast in on the ground and it became a snake; and Moses recoiled from it. Then the LORD said to Moses, "Put out your hand and grasp it by the tail"— he put out his hand and seized it, and it became a rod in his hand —"that they may believe that the LORD, the God of their fathers, the God of Abraham, the God of Issac, and the God of Jacob, did appear to you."

Exodus, IV, 1–5

Moses' marvel of the rod transformed into a snake provides Chagall with the opportunity to depict another crowd scene full of anecdotal detail. While Pharaoh calmly looks on, his courtiers express their amazement in exaggerated gestures and poses. The deployment of these small figures across the middle-ground lends a Breughelian animation to this scene.

29. MEETING OF MOSES AND AARON

The LORD said to Aaron, "Go to meet Moses in the wilderness." He went and met him at the mountain of God, and he kissed him. Moses told Aaron about all the things that the LORD had committed to him and all the signs about which He had instructed him.

Exodus, IV, 27–28

On the slope of God's mountain, set against the darkened sky, Moses reveals God's instructions to Aaron. Drawn close together, as if their two heads grew out of one body, their physical proximity symbolizes their shared task and Aaron's designated role as Moses' spokesman. Moses is distinguished by the two rays of light emanating from his head and the tall rod which he will use as a sign to convince the Pharaoh of God's will.

30. MOSES AND AARON BEFORE PHARAOH

Afterward Moses and Aaron went and said to Pharaoh, "Thus says the LORD, the God of Israel: Let My people go that they may celebrate a festival for Me in the wilderness." But Pharaoh said, "Who is the LORD that I should heed Him and let Israel go? I do not know the LORD, nor will I let Israel go." They answered, "The God of the Hebrews has manifested Himself to us. Let us go, we pray, a distance of three days into the wilderness to sacrifice to the LORD our God, lest He strike us with

pestilence or sword." But the king of Egypt said to them, "Moses and Aaron, why do you distract the people from their tasks? Get to your labors!" And Pharaoh continued, "The people of the land are already so numerous, and you would have them cease from their labors!"

Exodus, V, 1–5

Within the dim interior of the palace, the light-filled figures of Moses and Aaron plead before the enthroned Pharaoh. Chagall accentuates the God-granted luminosity of the Israelite leaders with the black shadows cast behind them on the already darkened floor. The remote distance separating Moses and Aaron from Pharaoh and his courtiers conveys the futility of their plea and Pharaoh's insensitivity to their plight.

31. DARKNESS OVER EGYPT

Then the LORD said to Moses, "Hold out your arm toward the sky that there may be darkness upon the land of Egypt, a darkness that can be touched." Moses held out his arm toward the sky and thick darkness descended upon all the land of Egypt for three days.

Exodus, X, 21–22

Of the ten plagues cast over Egypt, Chagall omits to illustrate the initial eight and chooses to begin with the ninth plague, darkness. Moses' upraised rod causes darkness to descend over the earth and sky. Amidst the heavily etched and inked sky, clouded and textured in the painterly manner of El Greco, God's presence is illuminated by the bright white letters of His name and by an angel pointing to the chaos and devastation below. Chagall's supreme skills as a colorist are well represented in his treatment of the darkness as a palpable substance in this etching. Chagall curiously depicts a horned Moses in this etching in the style of medieval renderings of the patriarch based on Saint Jerome's mistranslation of the Hebrew word for ray.[86]

32. THE PASSOVER MEAL

This is how you shall eat it: your loins girded, your sandals on your feet, and your staff in your hand; and you shall eat it hurriedly: it is a passover offering to the LORD. For that night I will go through the land of Egypt and strike down every first-born in the land of Egypt, both man and beast; and I will mete out punishments to all the gods of Egypt, I the LORD. And the blood on the houses

where you are staying shall be a sign for you: when I see the blood I will pass over you, so that no plague will destroy you when I strike the land of Egypt.

This day shall be to you one of remembrance: you shall celebrate it as a festival to the LORD throughout the ages; you shall celebrate is as an institution for all time.

Exodus, XII, 11–14

In this depiction of the tenth, and final, plague—death of the first-born—the darkness of night reaches a black intensity. The vengeful angel of death, floating across the sky, brandishes its sharp knife and slaughtered humans and beasts drop beneath it. Sheltered by the striated roof, the Israelites partake of the Pascal lamb. Their meal is a unique admixture of scenes of the holiday and sabbath meals of Chagall's Vitebsk with echoes of traditional depictions of *The Last Supper*.

33. THE EXODUS FROM EGYPT

So God led the people roundabout, by way of the wilderness at the Sea of Reeds.

Now the Israelites went up armed out of the land of Egypt. And Moses took with him the bones of Joseph, who had exacted an oath from the children of Israel, saying, "God will be sure to take notice of you: then you shall carry up my bones from here with you."

They set out from Succoth, and encamped at Etham, at the edge of the wilderness. The LORD went before them in a pillar of cloud by day, to guide them along the way, and in a pillar of fire by night, to give them light, that they might travel day and night. The pillar of cloud by day and the pillar of fire by night did not depart from before the people.

Exodus, XIII, 18–22

Unlike the vertical format preferred for most of the etchings in the *Bible*, Chagall works this plate horizontally to accentuate the processional quality of the scene. Moses leads the Israelites out of Egypt, guided by the pillar of cloud and an angel inscribed with God's name. Chagall individualizes each figure to accentuate the human experience of this Exodus: mothers carrying, leading or nursing their young; men bearing their rods and leading their livestock. Amidst the sea of bodies and faces, Chagall depicts the bearers of Joseph's remains. While Chagall depicted Jacob's journey to Egypt [Plate 24] as moving to the right, he now presents this exodus from Egypt as moving in the reverse direction. The comparatively small crowd which accompanied Jacob has now grown to the multitude following Moses.

Chagall's evocation of the Exodus is inflected by his memories of the first World War:

Each setback to the Army was an excuse for its chief, the Grand Duke Nicholas Nicolaevich, to blame the Jews. "Get them all out in twenty-four hours. Or have them shot. Or both at once." The army was advancing, and as they advanced, the Jewish population retreated *en masse*, abandoning cities and villages. I longed to put them down on my canvas, to get them out of harm's way.[87]

34. CROSSING OF THE RED SEA

The angel of God, who had been going ahead of the Israelite army, now moved and followed behind them; and the pillar of cloud shifted from in front of them and took up a place behind them, and it came between the army of the Egyptians and the army of Israel. Thus there was the cloud with the darkness, and it cast a spell upon the night, so that the one could not come near the other all through the night.

Then Moses held out his arm over the sea and the LORD drove back the sea with a stong east wind all that night, and turned the sea into dry ground. The waters were split, and the Israelites went into the sea on dry ground, the waters forming a wall for them on their right and on their left. The Egyptians came in pursuit after them into the sea, all of Pharaoh's horses, chariots, and horsemen. At the morning watch, the LORD looked down upon the Egyptian army from a pillar of fire and cloud, and threw the Egyptian army into panic. He locked the wheels of their chariots so that they moved forward with difficulty. And the Egyptians said, "Let us flee from the Israelites, for the LORD is fighting for them against Egypt."

Exodus, XIV, 19–25

Chagall's depiction is faithful to the text: the angel leading the orderly procession of Israelites over dry land and the billowing pillar of cloud shielding their escape while Moses' upraised rod unleashes the sea's water and the Egyptian soldiers, chariots and horses are engulfed.

Chagall is fully aware of the growing threat of Nazism during the 1930s while he is working on this suite. His own pictures were destroyed in Mannheim in 1933 by Goebbels' orders.[88] Chagall's depiction of the salvation of the Jews and the destruction of their oppressors in antiquity takes on a contemporary significance.

This etching initiates an important image in Chagall's oeuvre, which he transforms into such monumentally scaled works as his painting for the Biblical Message Museum and his ceramic mural for Eglise Notre-Dame de Toute Grâce, Plateau d'Assy during the 1950s.

35. DANCE OF MIRIAM, SISTER OF MOSES

Then Miriam the prophetess, Aaron's sister, took a timbrel in her hand, and all the women went out after her in dance with timbrels. And Miriam chanted for them:
 Sing to the LORD, for He has triumphed gloriously; Horse and driver He has hurled into the sea.

Exodus, XV, 20–21

The spontaneity and fervor expressed in Miriam's dance and song evoke Chagall's Hasidic roots and his understanding that music and movement can express religious ecstasy.

36. MOSES STRIKING WATER FROM THE ROCK

Moses cried out to the LORD, saying, "What shall I do with this people? Before long they will be stoning me!" Then the LORD said to Moses, "Pass before the people; take with you some of the elders of Israel, and take along the rod with which you struck the Nile, and set out. I will be standing there before you on the rock at Horeb. Strike the rock and water will issue from it, and the people will drink." And Moses did so in the sight of the elders of Israel. The place was named Massah and Meribah, because the Israelites quarreled and because they tried the LORD, saying, "Is the LORD present among us or not?"

Exodus, XVII, 4–7

Moses appears dematerialized by light as he stands isolated, and perhaps alienated, from the doubting Israelites. Aaron stands behind him as a shadow. Chagall infuses a supernatural luminosity into the miraculous water spilling down the banks crowded with figures and livestock.

37. MOSES RECEIVES THE TABLETS OF THE LAW

When Moses had ascended the mountain, the cloud covered the mountain. The Presence of the LORD abode on Mount Sinai, and the cloud hid it for six days. On the seventh day He called to Moses from the midst of the cloud. Now the Presence of the LORD appeared in the sight of the Israelites as a consuming fire on the top of the mountain. Moses went inside the cloud and ascended the mountain; and Moses remained on the mountain forty days and forty nights.

Exodus, XXIV, 15–18

Chagall depicts Moses on Sinai, engulfed by the concealing clouds. He reaches diagonally upward to grasp the tablets handed down by the two hands of God emerging from a dark cloud. The steep precipice of the mountain accentuates the descent of the tablets from God to man. God's light has been imbued in the tablets, which gleam as a beacon in this somber composition.

38. THE GOLDEN CALF

When the people saw that Moses was so long in coming down from the mountain, the people gathered against Aaron and said to him, "Come, make us a god who shall go before us, for that man Moses, who brought us from the land of Egypt—we do not know what has happened to him." Aaron said to them, "Take off the gold rings that are on the ears of your wives, your sons, and your daughters, and bring them to me." And all the people took off the gold rings that were in their ears and brought them to Aaron. This he took from them and cast in a mold, and made it into a molten calf. And they exclaimed, "This is your god, O Israel, who brought you out of the land of Egypt!" When Aaron saw this, he built an altar before it; and Aaron announced: "Tomorrow shall be a festival of the LORD!" Early next day, the people offered up burnt offerings and brought sacrifices of well-being; they sat down to eat and drink, and then rose to dance.

Exodus, XXXII, 1–6

Unlike the divine light emitted by God's tablets [Plate 37], the golden calf gleams darkly. Crowds of figures with mesmerized faces and uplifted arms express their adoration towards this symbol of Israel's lack of faith. Chagall's psychological insight into the consequences of such mass hysteria grows out of his personal experience of the pogroms of Czarist Russia as well as his awareness of the growing Nazi idolatry during the 1930s.

39. MOSES BREAKS THE TABLETS

Thereupon Moses turned and went down from the mountain bearing the two tablets of the Pact, tablets inscribed on both their surfaces: they were inscribed on the one side and on the other. The tablets were God's work, and the writing was God's writing, incised upon the tablets. When Joshua heard the sound of the people in its boisterousness, he said to Moses, "There is a cry of war in the camp." But he answered,

"It is not the sound of the tune of triumph, Or the sound of the tune of defeat; It is the sound of song that I hear!"
As soon as Moses came near the camp and saw the calf and the dancing, he became enraged; and he hurled the tablets from his hands and shattered them at the foot of the mountain.

Exodus, XXXII, 15–19

Moses' dark robes and uplifted arms (echoing the prior depiction of the idolatrous Israelites) express his black anger. Too respectful of the tablets to shatter them completely,[89] Chagall depicts them as only slightly chipped. Their discarded state is also expressed by their darkened tonality—no longer do they emit light as they did atop Sinai [Plate 37] and they are now etched with the anachronistic detail of the star of David.

40. AARON AND THE LAMP

The LORD spoke to Moses, saying: Speak to Aaron and say to him, "When you mount the lamps, let the seven lamps give light at the front of the lampstand." Aaron did so; he mounted the lamps at the front of the lampstand, as the LORD had commanded Moses.—Now this is how the lampstand was made: it was hammered work of gold, hammered from base to petal. According to the pattern that the LORD had shown Moses, so was the lampstand made.

Numbers, VIII, 1–4

In this portrait of Aaron, Chagall portrays the ritual objects and garments whose designs have been specified by God and which have been fabricated by the first Jewish artist, Bezalel:[90] the golden, seven-branched menorah,[91] the breastplate engraved with the names of the twelve tribes,[92] Aaron's robe,[93] frontlet and headress.[94] Aaron holds the small vessel of oil with which he tends the menorah. In depicting the elaborate artistry of Bezalel's craft, Chagall establishes the biblical precedent for Jewish art and Jewish artists, as prescribed by God.

41. DEATH OF MOSES

Moses went up from the steppes of Moab to Mount Nebo, to the summit of Pisgah, opposite Jericho, and the LORD showed him the whole land: Gilead as far as Dan; all Naphtali; the land of Ephraim and Manasseh; the whole land of Judah as far as the Western Sea; the Negeb; and the Plain— the Valley of Jericho, the city of palm trees—as far

as Zoar. And the LORD said to him, "This is the land of which I swore to Abraham, Isaac, and Jacob, 'I will assign it to your offspring.' I have let you see it with your own eyes, but you shall not cross there."

So Moses the servant of the LORD died there, in the land of Moab, at the command of the LORD. He buried him in the valley in the land of Moab, near Beth-peor; and no one knows his burial place to this day. Moses was a hundred and twenty years old when he died; his eyes were undimmed and his vigor unabated. And the Israelites bewailed Moses in the steppes of Moab for thirty days.

The period of wailing and mourning for Moses came to an end.

Deuteronomy, XXXIV, 1–8

Moses reclines on the elevated ground and raises his arm in a vigorous gesture of farewell. His fading body is dematerialized (as were Sarah [Plate 11] and Jacob [Plate 25]) by the diagonal shaft of light emitted by the angel/cloud form above. Lightly etched in the left background is a distant view of the hills and buildings of the Promised Land, which he was deprived from entering.

42. MOSES' BLESSING OVER JOSHUA

Now Joshua son of Nun was filled with the spirit of wisdom because Moses had laid his hands upon him; and the Israelites heeded him, doing as the LORD had commanded Moses.

Deuteronomy, XXXIV, 9

Moses is depicted as upright and powerful as he blesses his successor, Joshua. Rays of light emanate from his head and envelop his being as he transfers the spirit of wisdom to the Israelites' new leader.

43. JOSHUA ARMED BY GOD

After the death of Moses the servant of the LORD, the LORD said to Joshua son of Nun, Moses' attendant:

"My servant Moses is dead. Prepare to cross the Jordan, together with all this people, into the land that I am giving to the Israelites. Every spot on which your foot treads I give to you, as I promised Moses. Your territory shall extend from the wilderness and the Lebanon to the Great River, the River Euphrates [on the east]—the whole Hittite country—and up to the Mediterranean Sea on the west. No one shall be able to resist you as long as you live. As I was with Moses, so I will be with you; I will not fail you or forsake you.

"Be strong and resolute, for you shall apportion to this people the land that I swore to their fathers to assign to them.

Joshua, I, 1–6

Chagall devotes nine etchings to the complex personality of Joshua as the victorious warrior and spiritual teacher who leads his people into the Promised Land. In this etching, Joshua is depicted as strong and resolute, his feet planted firmly on the ground, as God's winged messenger exhorts him to cross the Jordan.

44. CROSSING OF THE JORDAN

Three days later, the officials went through the camp and charged the people as follows: "When you see the Ark of the Covenant of the LORD your God being borne by the levitical priests, you shall move forward. Follow it—but keep a distance of some two thousand cubits from it, never coming any closer to it—so that you may know by what route to march, since it is a road you have not traveled before." And Joshua said to the people, "Purify yourselves, for tomorrow the LORD will perform wonders in your midst."

Then Joshua ordered the priests, "Take up the Ark of the Covenant and advance to the head of the people." And they took up the Ark of the Covenant and marched at the head of the people.

Joshua, III, 2–6

Ram's horns herald the advancing ark led by the priests and followed by the long procession of Israelites. Chagall's anachronistic depiction of the Ark is based on the European Arks and Torah curtains of his Vitebsk youth, his visits to the synagogues of Safed during his 1931 trip to Palestine and his renewed contact with Eastern European synagogues during his 1935 trip to Vilna and Warsaw. Thus, rampant, crowned lions and the star of David appear in the midst of biblical antiquity.

45. JOSHUA BEFORE THE ANGEL WITH THE SWORD

Once when Joshua was near Jericho, he looked up and saw a man standing before him, drawn sword in hand. Joshua went up to him and asked him, "Are you one of us or of our enemies?" He replied, "No, I am captain of the LORD's host. Now I have come!" Joshua threw himself face down to the ground and, prostrating himself, said to him, "What does my lord command his servant?" The captain of the LORD's

*host answered Joshua, "Remove your sandals from
your feet, for the place where you stand is holy."
And Joshua did so.*

<div align="right">Joshua, V, 13–15</div>

A fierce angel whose raised sword points upward to heaven evokes the awesomeness of God as Joshua's ally in battle. A surprising resemblance to Chagall's own features can be detected in the face of the angel.[95]

46. JOSHUA BEFORE JERICHO

*Now Jericho was shut up tight because of the
Israelites; no one could leave or enter.
 The LORD said to Joshua, "See, I will deliver
Jericho and her king [and her] warriors into your
hands. Let all your troops march around the city and
complete one circuit of the city. Do this six days,
with seven priests carrying seven ram's horns
preceding the Ark. On the seventh day, march
around the city seven times, with the priests blowing
the horns. And when a long blast is sounded on the
horn—as soon as you hear that sound of the horn—
all the people shall give a mighty shout. Thereupon
the city wall will collapse, and the people shall
advance, every man straight ahead."
 Joshua son of Nun summoned the priests and said
to them, "Take up the Ark of the Covenant, and let
seven priests carrying seven ram's horns precede the
Ark of the LORD." And he instructed the people,
"Go forward, march around the city, with the
vanguard marching in front of the Ark of the LORD."*

<div align="right">Joshua, VI, 1–7</div>

Chagall depicts Joshua as a mighty warrior, massive in scale and girded with sword for battle. Framing this central figure, Chagall has schematically sketched in two flanks of his army and the rounded tents of their camp. The angel/messenger appears in the circle of God's light, his wings outspread as a canopy above Joshua's head.

47. JOSHUA READS THE WORDS OF THE LAW

*All Israel—stranger and citizen alike—with their
elders, officials, and magistrates, stood on either side
of the Ark, facing the levitical priests who carried
the Ark of the LORD's Covenant. Half of them
faced Mount Gerizim and half of them faced
Mount Ebal, as Moses the servant of the LORD had
commanded them of old, in order to bless the people*

*of Israel. After that, he read all the words of the
Teaching, the blessing and the curse, just as is
written in the Book of the Teaching. There was not
a word of all that Moses had commanded that
Joshua failed to read in the presence of the entire
assembly of Israel, including the women and
children and the strangers who accompanied them.*

<div align="right">Joshua, VIII, 33–35</div>

Thus far seen primarily as the valiant military leader of the Israelites, Chagall now offers another side of Joshua's persona. Chagall portrays Joshua's role as the spiritual leader and educator of his people. His heretofore fierce posture and facial features are transformed completely in this etching. His body is softened and his face is gentled with introspection. As in his depictions of Noah [Plates 2–5], Chagall utilizes a variety of body and facial types for the same character. His forms and expression are adapted to best convey each individual scene without any need to restrict his depiction to a consistent type.

48. JOSHUA STOPS THE SUN

*On that occasion, when the LORD routed the
Amorites before the Israelites, Joshua addressed the
LORD; he said in the presence of the Israelites:
 "Stand still, O sun, at Gibeon,
 O moon, in the Valley of Aijalon!"
 And the sun stood still
 And the moon halted,
 While a nation wreaked judgment on its foes
—as is written in the Book of Jashar. Thus the sun
halted in midheaven, and did not press on to set, for
a whole day; for the LORD fought for Israel.
Neither before nor since has there ever been such a day,
when the LORD acted on words spoken by a man.*

<div align="right">Joshua, X, 12–14</div>

To Joshua's talents as military leader and teacher, Chagall adds this portrayal of his ability to effect miracles. The sun and moon's simultaneous presence are suggested by the light and dark zones in the sky. Joshua dominates the scene as he towers over the amazed Israelites and his robes emit a heavenly light.

49. JOSHUA AND THE VANQUISHED KINGS

*And now Joshua ordered, "Open the mouth of
the cave, and bring those five kings out of the cave to
me." This was done. Those five kings—the king of
Jerusalem, the king of Hebron, the king of Jarmuth,*

the king of Lachish, and the king of Eglon—were brought out to him from the cave. And when the kings were brought out to Joshua, Joshua summoned all the men of Israel and ordered the army officers who had accompanied him, "Come forward and place your feet on the necks of these kings." They came forward and placed their feet on their necks. Joshua said to them, "Do not be frightened or dismayed; be firm and resolute. For this is what the LORD is going to do to all the enemies with whom you are at war." After that, Joshua had them put to death and impaled on five stakes, and they remained impaled on the stakes until evening. At sunset Joshua ordered them taken down from the poles and thrown into the cave in which they had hidden. Large stones were placed over the mouth of the cave, [and there they are] to this very day.

Joshua, X, 22–27

The five defeated kings appear shackled before Joshua, who is again portrayed as the monumental, ferocious warrior. Diagonally cutting across the plate is the instrument of his vengeance—his long, sharp sword.

50. EXHORTATION OF JOSHUA

"Now, therefore, revere the LORD and serve Him with undivided loyalty; put away the gods that your forefathers served beyond the Euphrates and in Egypt, and serve the LORD. Or, if you are loath to serve the LORD, choose this day which ones you are going to serve—the gods that your forefathers served beyond the Euphrates, or those of the Amorites in whose land you are settled; but I and my household will serve the LORD."
In reply, the people declared, "Far be it from us to forsake the LORD and serve other gods!"

Joshua, XXIV, 14–16

The aged Joshua is again depicted as the teacher [see Plate 47] and moral guide of his people. The tall trees' overhanging branches create a sanctuary for this final delivery of his instructions.

51. JOSHUA AND THE ROCK OF SHECHEM

On that day at Shechem, Joshua made a covenant for the people and he made a fixed rule for them. Joshua recorded all this in a book of divine instruction. He took a great stone and set it up at the foot of the oak in the sacred precinct of the LORD; and Joshua said to all the people, "See, this very stone shall be a witness against us, for it heard all the words that the LORD spoke to us; it shall be a witness against you, lest you break faith with your God."

Joshua, XXIV, 25–27

Joshua's body is dematerialized by light, signifying his impending death [see Plates 11, 25 and 41]. The prophet holds the book in which he has recorded divine instruction. The stone marker is carved with an anachronistic star of David, symbolizing for Chagall the Israelites' covenant with God. Resembling a gravestone, this marker recalls Chagall's visits to the graves of his grandparents and mother, which he describes in words and depicts in the etching *Beside My Mother's Tombstone* in *My Life*.[96]

52. DEBORAH THE PROPHETESS

She summoned Barak son of Abinoam, of Kedesh in Naphtali, and said to him, "The LORD, the God of Israel, has commanded: Go, march up to Mount Tabor, and take with you ten thousand men of Naphtali and Zebulun. And I will draw Sisera, Jabin's army commander, with his chariots and his troops, toward you up to the Wadi Kishon; and I will deliver him into your hands." But Barak said to her, "If you will go with me, I will go; if not, I will not go." "Very well, I will go with you," she answered. "However, there will be no glory for you in the course you are taking, for then the LORD will deliver Sisera into the hands of a woman." So Deborah went with Barak to Kedesh.

Judges, IV, 6–9

The singular women that Chagall has chosen to depict in the *Bible* thusfar have represented a diversity of characters and personalities, ranging from the sensibility of Lot's Daughters, the fortitude of Sarah, the generosity of Rebecca and the ideal beauty of Rachel to the sensuality of Potiphar's wife and the gaiety of Miriam. With Deborah, Chagall adds a portrait of wisdom. Under the sanctuary of her palm, she sits rooted to the earth. Barak's respectful pose before her denotes her dignified stature as a prophetess of her people.

53. SACRIFICE OF MANOAH

So Manoah said to the angel of the LORD, "What is your name? We should like to honor you when your words come true." The angel said to him,

"You must not ask for my name, it is unknowable!"

Manoah took the kid and the meal offering and offered them up on the rock to the LORD; and a marvelous thing happened while Manoah and his wife looked on. As the flames leaped up from the altar toward the sky, the angel of the LORD ascended in the flames of the altar, while Manoah and his wife looked on; and they flung themselves on their faces to the ground.

<div align="right">Judges, XIII, 17–20</div>

A possible source of inspiration for Chagall's composition can be found in Rembrandt's painting in the Louvre of the *Angel Leaving Tobias.*[97] The pose of the kneeeling figure of Manoah is close to that of Rembrandt's prostrated Tobias, while Chagall's feather-winged angel ascending from the flames bears a strong resemblance to Rembrandt's departing archangel. The familiar motif of the circle of light again envelops the sacrifice, signifying God's acceptance of this offering.

54. SAMSON AND THE LION

So Samson and his father and mother went down to Timnah.

When he came to the vineyards of Timnah [for the first time], a full-grown lion came roaring at him. The spirit of the LORD gripped him, and he tore him asunder with his bare hands as one might tear a kid asunder; but he did not tell his father and mother what he had done.

<div align="right">Judges, XIV, 5–6</div>

Chagall depicts Samson as a young, awkwardly proportioned youth unconscious of his own strength. His encounter with the lion is depicted as a playful wrestling match, of the kind Chagall enjoyed at the Russian circus,[98] rather than the dangerous act of killing a wild beast. Chagall's energetic and painterly treatment of the sky and ground enliven this dramatic scene.

55. SAMSON CARRIES OFF THE GATES OF GAZA

Once Samson went to Gaza; there he met a whore and slept with her. The Gazites [learned] that Samson had come there, so they gathered and lay in ambush for him in the town gate the whole night; and all night long they kept whispering to each other, "When daylight comes, we'll kill him." But Samson lay in bed only till midnight. At midnight he got up, grasped the doors of the town

gate together with the two gateposts, and pulled them out along with the bar. He placed them on his shoulders and carried them off to the top of the hill that is near Hebron.

<div align="right">Judges, XVI, 1–3</div>

Chagall continues to depict Samson's brute strength [see Plate 53]. He expresses the palpable weight of the gates by their enormous size and by the deeply etched and darkly inked treatment of the plate to simulate the tactility of grained wood. An effective foil to accentuate Samson's bulk are the minutely detailed views of distant hilltop towns.

56. SAMSON AND DELILAH

Then she said to him, "How can you say you love me, when you don't confide in me? This makes three times that you've deceived me and haven't told me what makes you so strong." Finally, after she had nagged him and pressed him constantly, he was wearied to death and he confided everything to her. He said to her, "No razor has ever touched my head, for I have been a nazirite to God since I was in my mother's womb. If my hair were cut, my strength would leave me and I should become as weak as an ordinary man."

Sensing that he had confided everything to her, Delilah sent for the lords of the Philistines, with this message: "Come up once more, for he has confided everything to me." And the lords of the Philistines came up and brought the money with them.

<div align="right">Judges, XVI, 15–18</div>

Chagall actually depicts the following verse (Judges, XVI, 19) when Samson has fallen asleep on Delilah's lap and seven locks of his hair have been cut off. Baroque lines animate Delilah's voluptuousness and Samson's sensual relaxation. Samson's shorn locks seem to flame in Delilah's upraised arm. Four Philistine voyeurs peer around the curtains at Samson's defeat as a consequence of his physical excesses.

57. SAMSON OVERTURNS THE COLUMNS

Then Samson called to the LORD, "O LORD GOD! Please remember me, and give me strength just this once, O God, to take revenge of the Philistines, if only for one of my two eyes." He embraced the two middle pillars that the temple rested upon, one with his right arm and one with his left, and leaned against them; Samson cried, "Let me die with the Philistines!" and he pulled with all

<div align="center">142</div>

his might. The temple came crashing down on the lords and on all the people in it. Those who were slain by him as he died outnumbered those who had been slain by him when he lived.

<div align="right">Judges, XVI, 28–30</div>

Chagall depicts Samson pushing rather than pulling the two massive columns and causing them to buckle. His force is magical rather than forceful.[99] The cubistic device of rays of etched lines fanning out from the roof enhances the visual sensation of the movement of the collapsing rear columns.

58. ANNA INVOKES GOD

After they had eaten and drunk at Shiloh, Hannah rose.—The priest Eli was sitting on the seat near the doorpost of the temple of the LORD.—In her wretchedness, she prayed to the LORD, weeping all the while. And she made this vow: "O LORD of Hosts, if You will look upon the suffering of Your maidservant and will remember me and not forget Your maidservant, and if You will grant Your maidservant a male child, I will dedicate him to the LORD for all the days of his life; and no razor shall ever touch his head."

<div align="right">I Samuel, I, 9–11</div>

There is a lovely impressionist quality to Chagall's treatment of this scene. Small delicate touches and subtle flickering accents of light and shade build up the figures of Anna, Eli and the flock of cattle. Very fine, broken outlines define their contours. The brilliant light of Palestine which so overwhelmed Chagall illuminates this scene.

59. SAMUEL CALLED BY GOD

Young Samuel was in the service of the LORD under Eli. In those days the word of the LORD was rare; prophecy was not widespread. One day, Eli was asleep in his usual place; his eyes had begun to fail and he could barely see. The lamp of God had not yet gone out, and Samuel was sleeping in the temple of the LORD where the Ark of God was. The LORD called out to Samuel, and he answered, "I'm coming."

<div align="right">I Samuel, III, 1–4</div>

The object of the angel's visit is the young Samuel, asleep in the Temple, who mistakes God's awakening call for Eli's summons. It is the elderly priest Eli who will enlighten him that he is being called by God.

60. ANOINTING OF SAUL

They then descended from the shrine to the town, and [Samuel] talked with Saul on the roof.
Samuel took a flask of oil and poured some on Saul's head and kissed him, and said, "The LORD herewith anoints you ruler over His own people."

<div align="right">I Samuel, IX, 25; X, 1</div>

Chagall depicts the young Saul as described in the *Bible*—handsome and a head taller than any of the people.[100] As Samuel anoints Saul, he also places the latter's hand against his heart, foretelling that when Saul will leave Samuel, God will give the young ruler a new heart.[101]

61. SAUL AND DAVID

Whenever the [evil] spirit of God came upon Saul, David would take the lyre and play it; Saul would find relief and feel better, and the evil spirit would leave him.

<div align="right">I Samuel, XVI, 23</div>

Chagall portrays the young David as described in the Bible: ruddy-cheeked, handsome[102] and skilled in music.[103] Chagall's rendering seems to be a reversed view of Rembrandt's great painting of the same scene.[104] David's simple robe is filled with light, symbolizing God's spirit in him. Saul, however, is shrouded in black, symbolizing the darkness of evil spirits besetting him. Chagall embellishes the composition with the decorative details of Saul's jewelled crown, elaborately carved throne (with the anachronistic star of David) and the elegantly carved columns and tiles of Saul's court.

Chagall's loving treatment of David in this etching evokes his love for his younger brother, whom he also portrayed as a musician in *David in Profile* (1914). About the young David, who died of tuberculosis in the Crimea, Chagall wrote: "His name is sweeter than a line of horizons and to me it breathes the perfume of my native land."[105]

Chagall devotes fourteen etchings in the *Bible* to David, the prophet nearest to Chagall's heart because he was an artist.[106] This cycle describes David's complex personality, full of virtues and flaws. These images of David become the prototypes for many of Chagall's works during the 1950s and 1960s: his Biblical Message paintings, his stained glass windows for Metz Cathedral and his tapestries for Israel's Knesset. Chagall occasionally combines the persona of David with the tragic mythical musician Orpheus during these decades in his mural *The Source of Music* (1965–66)[107] for New York's Metropolitan Opera House, in his monumental painting *The Concert* (1957)[108] and in the Nef Collection mosaic in Washington, D.C.

62. DAVID AND THE LION

David replied to Saul, "Your servant has been tending his father's sheep, and if a lion or a bear came and carried off an animal from the flock, I would go after it and fight it and rescue it from its mouth. And if it attacked me, I would seize it by the beard and strike it down and kill it. Your servant has killed both lion and bear; and that uncircumcised Philistine shall end up like one of them, for he has defied the ranks of the living God.

II Samuel, XVII, 34–36

As in Samson's killing of a lion [Plate 54], David's attack of the lion is depicted playfully by Chagall. Indeed, the young shepherd seems to be gracefully chasing the smiling lion. Only the presence of the large rock in David's hand and the fact that the happy lion is actually pawing a small sheep allude to the potential violence underlying this scene.

63. DAVID VANQUISHER OF GOLIATH

When the Philistine began to advance toward him again, David quickly ran up the battle line to face the Philistine. David put his hand into the bag; he took out a stone and slung it. It struck the Philistine in the forehead; the stone sank into his forehead, and he fell face down on the ground. Thus David bested the Philistine with sling and stone; he struck him down and killed him. David had no sword; so David ran up and stood over the Philistine, grasped his sword and pulled it from its sheath; and with it he dispatched him and cut off his head.

I Samuel, XVII, 48–51

David's persona takes on a heroic dimension as he grasps Goliath's sword with one hand and the head of the Philistine with the other. Goliath's beheaded body can barely be discerned lying on the ground beside him. Deeply etched, cross-hatched strokes lend a mottled texture to the figures and ground. The stark contrast between the dark and light areas, echoed in the sky, adds an expressionist quality to the compositon.

64. DAVID BEFORE SAUL

When Saul saw David going out to assault the Philistine, he asked his army commander Abner, "Whose son is that boy, Abner?" And Abner replied, "By your life, Your Majesty, I do not know." "Then find out whose son that young fellow is," the king ordered. So when David returned after killing

the Philistine, Abner took him and brought him to Saul, with the head of the Philistine still in his hand. Saul said to him, "Whose son are you, my boy?" And David answered, "The son of your servant Jesse the Bethlehemite."

I Samuel, XVII, 55–58

This etching depicts the turning point in Saul and David's relationship, as the young shepherd is about to be transformed into a warrior and military commander whose celebrated successes will ultimately arouse Saul's envy. The elderly ruler, who once stood a head above all others, is now shrunken in his elaborate throne and it is David who looks down upon him. Even the anachronistic star on Saul's throne is dwarfed by the ascendant star (the star of David!) floating above.

65. DEATH OF SAUL

The Philistines pursued Saul and his sons, and the Philistines struck down Jonathan, Abinadab, and Malchi-shua, sons of Saul. The battle raged around Saul, and some of the archers hit him, and he was severely wounded by the archers. Saul said to his arms-bearer, "Draw your sword and run me through, so that the uncircumcised may not run me through and make sport of me." But his arms-bearer, in his great awe, refused; whereupon Saul grasped the sword and fell upon it. When his arm-bearer saw that Saul was dead, he too fell on his sword and died with him. Thus Saul and his three sons and his arms-bearer, as well as all his men, died together on that day.

I Samuel, XXXI, 2–6

The poignancy of Saul's tragic end is accentuated when one compares Chagall's depiction of his death with that of his anointment by Samuel [Plate 50]. The once tall and handsome youth chosen by God ends his life—fallen, broken and bereft of God's spirit. In the background, the arms bearer who had refused Saul's pleas to end his life, kills himself as well.

66. SONG OF THE BOW

O hills of Gilboa—
Let there be no dew or rain on you,
Or bountiful fields.
For there the shield of warriors lay rejected,
The shield of Saul
Polished with oil no more.

From the blood of slain,
From the fat of warriors—

The bow of Jonathan
Never turned back;
The sword of Saul
Never withdrew empty.

Saul and Jonathan,
Beloved and cherished,
Never parted
In life or in death.
They were swifter than eagles,
They were stronger than lions!

Daughters of Israel,
Weep over Saul,
Who clothed you in crimson and finery,
Who decked your robes with jewels of gold.

How have the mighty fallen
In the thick of battle —
Jonathan, slain on your heights!
I grieve for you,
My brother Jonathan,
You were most dear to me.
Your love was wonderful to me
More than the love of women.

How have the mighty fallen,
The weapons of war perished!

<div align="right">II Samuel, I, 21–27</div>

David the shepherd, musician and warrior is now depicted as the poet, mourning the loss of Jonathan and Saul with his dirge. Chagall poses the crowned David with lyre against the clear, sunlit sky. The once full-cheeked, stocky youth now appears as a lean, soulful personage.

67. KING DAVID

David was thirty years old when he became king, and he reigned forty years. In Hebron he reigned over Judah seven years and six months, and in Jerusalem he reigned over all Israel and Judah thirty-three years.

<div align="right">II Samuel, V, 4–5</div>

Chagall portrays the young king overlooking the ramparts of Jerusalem, the stronghold of Zion, which he will capture and rename the City of David.[109] The majesty of the monumental city is beautifully captured by Chagall who felt in Jerusalem the most profound impression of his life.[110]

68. THE ARK CARRIED TO JERUSALEM

David again assembled all the picked men of Israel, thirty thousand strong. Then David and all

the troops that were with him set out from Baalim of Judah to bring up from there the Ark of God to which the Name was attached, the name LORD of Hosts Enthroned on the Cherubim.

They loaded the Ark of God onto a new cart and conveyed it from the house of Abinadab, which was on the hill; and Abinadab's sons, Uzza and Ahio, guided the new cart. They conveyed it from Abinadab's house on the hill, [Uzzah walking] alongside the Ark of God and Ahio walking in front of the Ark. Meanwhile, David and all the House of Israel danced before the LORD to [the sound of] all kinds of cypress wood [instruments], with lyres, harps, timbrels, sistrums, and cymbals.

<div align="right">II Samuel, VI, 1–5</div>

Chagall continues to depict the Ark in the style of the synagogues of Vitebsk, Vilna, Safed and Warsaw. Even the musicians accompanying the procession and playing the specified ancient biblical instruments —lyres, harps, timbrels, sistrums and cymbals— are closer in spirit to the itinerant *klezmer* musicians of the Eastern European shtetls. The dancers move with the spontaneity and intensity of Hasidic fervor. Chagall transposes the joyous celebrations of his Russian-Jewish childhood to biblical antiquity.

69. DAVID AND BATHSHEBA

At the turn of the year, the season when kings go out [to battle], David sent Joab with his officers and all Israel with him, and they devastated Ammon and besieged Rabbah; David remained in Jerusalem. Late one afternoon, David rose from his couch and strolled on the roof of the royal palace; and from the roof he saw a woman bathing. The woman was very beautiful, and the king sent someone to make inquiries about the woman. He reported, "She is Bathsheba daughter of Eliam [and] wife of Uriah the Hittite."

<div align="right">II Samuel, XI, 1–3</div>

Chagall adds another dimension to David's cumulative portrait—the King as lover. The puppet-like King overhangs the parapet of his roof, much as the palm tree leans diagonally across the horizon. Just as the tree bends to the force of the wind, Chagall depicts David giving in to the powerful force of nature—his attraction to the beautiful Bathsheba.

70. DAVID AND ABSALOM

Absalom lived in Jerusalem two years without appearing before the king. Then Absalom sent for

Joab, in order to send him to the king; but Joab would not come to him, He sent for him a second time, but he would not come. So [Absalom] said to his servants, "Look, Joab's field is next to mine, and he has barley there. Go and set it on fire." And Absalom's servants set the field on fire. Joab came at once to Absalom's house and said to him, "Why did your servants set fire to my field?"

Absalom replied to Joab, "I sent for you to come here; I wanted to send you to the king to say [on my behalf]: 'Why did I leave Geshur? I would be better off if I were still there. Now let me appear before the king; and if I am guilty of anything, let him put me to death!'" Joab went to the king and reported to him; whereupon he summoned Absalom. He came to the king and flung himself face down to the ground before the king. And the king kissed Absalom.

<div align="right">II Samuel, XIV, 28–33</div>

Chagall now reveals yet another aspect of David's personality—the King as father. The poignant reunion between David and Absalom (the son who had fled for three years after killing his half-brother for raping his sister Tamar) seems to be blessed by the rays of pure white light shining down upon their embrace.

71. DAVID ASCENDING THE MOUNT OF OLIVES

David meanwhile went up the slope of the [Mount of] Olives, weeping as he went; his head was covered and he walked barefoot. And all the people who were with him covered their heads and wept as they went up.

<div align="right">II Samuel, XV, 30</div>

A grief-stricken David, betrayed by his rebellious son Absalom, leaves his beloved Jerusalem. In the sky, Chagall adds an angel who sweeps a cloud of darkness over the city. Chagall enhances the emotional upheaval of this scene by repeating the undulating curves of the unsteady ground beneath David's feet in the roiling mass of David's mournful followers, in the hilly rise of Jerusalem and in the enveloping cloud of darkness.

72. END OF ABSALOM

Absalom encountered some of David's followers. Absalom was riding on a mule, and as the mule passed under the tangled branches of a great terebinth, his hair got caught in the terebinth; he was held between heaven and earth as the mule under him kept going.

<div align="right">II Samuel, XVIII, 9</div>

Ironically, Absalom is ultimately doomed by his beautiful hair, which he had to cut every year because it grew too heavy for him.[111] Chagall compares Absalom's curls with the waving branches and foliage of the terebinth tree. The little mule, oblivious to his master's distress, departs from the scene. Shortly, David's followers will arrive to stab the trapped Absalom to death.

73. DAVID MOURNS ABSALOM

The king was shaken. He went up to the upper chamber of the gateway and wept, moaning these words as he went, "My son Absalom! O my son, my son Absalom! If only I had died instead of you! O Absalom, my son, my son!"

Joab was told that the king was weeping and mourning over Absalom. And the victory that day was turned into mourning for all the troops; for that day the troops heard that the king was grieving over his son. The troops stole into town that day like troops ashamed after running away in battle.

<div align="right">II Samuel, XIX, 1–4</div>

Chagall expresses the depth of a father's uncritical love for his child in David's grief for his errant son, Absalom. Despite his son's disaffection, David retains his love for him and bemoans his death. Behind the King's city, the lowered sun emits its last rays of brilliant light.

74. SONG OF DAVID

He said:

O LORD, my crag, my fastness, my deliverer!
O God, the rock wherein I take shelter:
My shield, my mighty champion,
my fortress and refuge!
My savior, You who rescue me from violence!

All praise! I called on the LORD,
And I was delivered from my enemies.

For the breakers of Death encompassed me,
The torrents of Belial terrified me;
The snares of Sheol encircled me,
The toils of Death engulfed me.

In my anguish I called on the LORD,
Cried out to my God;
In His Abode He heard my voice,
My cry entered His ears.

<div align="right">II Samuel, XXII, 2–7</div>

Chagall describes another facet of David's creativity—the King as psalmist. Bathed in a diagonal shaft of light in which the Hebrew letters dance, David is depicted in the throes of inspiration. His hymn is an expression of gratitude to God for deliverance from his enemies.

75. BATHSHEBA AT DAVID'S FEET

Then Nathan said to Bathsheba, Solomon's mother, "You must have heard that Adonijah son of Haggith has assumed the kingship without the knowledge of our lord David. Now take my advice, so that you may save your life and the life of your son Solomon. Go immediately to King David and say to him, 'Did not you, O lord king, swear to your maidservant: "Your son Solomon shall succeed me as king, and he shall sit upon my throne?" Then why has Adonijah become king?' While you are still there talking with the king, I will come in after you and confirm your words."

So Bathsheba went to the king in his chamber.— The king was very old, and Abishag the Shunammite was waiting on the king.— Bathsheba bowed low in homage to the king; and the king asked, "What troubles you?" She answered him, "My lord, you yourself swore to your maidservant by the LORD your God: 'Your son Solomon shall succeed me as king, and he shall sit upon my throne.' Yet now Adonijah has become king, and you, my lord the king, know nothing about it.

I Kings, I, 11–18

Chagall's last depiction of David in the suite portrays the once vigorous king as very old and weary. The still youthful and beautiful Bathsheba comes before him to implore that he designate their son Solomon as his successor. The etching scintillates with the spoils of David's success: the elaborately beaded clothing and headgear, the jewelled necklaces, the glittering draperies and the sparkling tiled floor.

Chagall devotes fourteen etchings of the *Bible* to David, from his youthful, musical consolation of Saul through the end of his forty year reign over Israel. With each etching, Chagall reveals another dimension of David's complex personality: the musician, shepherd, warrior, poet, liberator of Jerusalem, leader, lover, father and psalmist. As with Chagall's treatment of Moses, the David cycle provides a wellspring of imagery that will inspire Chagall's oeuvre for the succeeding five decades of his creativity.

76. ANOINTING OF KING SOLOMON

Then King David said, "Summon to me the priest Zadok, the prophet Nathan, and Benaiah son of Jehoiada." When they came before the king, the king said to them, "Take my loyal soldiers, and have my son Solomon ride on my mule and bring him down to Gihon. Let the priest Zadok and the prophet Nathan anoint him there king over Israel, whereupon you shall sound the horn and shout, 'Long live King Solomon!' Then march up after him, and let him come in and sit on my throne. For he shall succeed me as king; him I designate to be ruler of Israel and Judah." Benaiah son of Jehoiada spoke up and said to the king, "Amen! And may the LORD, the God of my lord the king, so ordain. As the LORD was with my lord the king, so may He be with Solomon; and may He exalt his throne even higher than the throne of my lord King David."

I Kings, I, 32–37

Chagall reprises the joyful processions of the Ark [Plates 44 and 68] for the announcement of Solomon's accession as King. Again, the musicians depicted hark back to the *klezmer* musicians of Chagall's youth. They flank the youthful King and their uptilted horns symmetrically frame Solomon's awkward seat atop David's mule. The ensuing cycle of six etchings portrays Solomon's psychological development from an insecure young man propelled into power to a wise and glorious leader of a mighty kingdom.

77. SOLOMON'S DREAM

At Gibeon the LORD appeared to Solomon in a dream by night; and God said, "Ask, what shall I grant you?" Solomon said, "You dealt most graciously with Your servant my father David, because he walked before You in faithfulness and righteousness and in integrity of heart. You have continued this great kindness to him by giving him a son to occupy his throne, as is now the case. And now, O LORD my God, You have made Your servant king in place of my father David; but I am a young lad, with no experience in leadership. Your servant finds himself in the midst of the people You have chosen, a people too numerous to be numbered or counted. Grant, then, Your servant an understanding mind to judge Your people, to distinguish between good and bad; for who can judge this vast people of Yours?"

I Kings, III, 5–9

Solomon is the third figure in the *Bible* depicted as being visited in his dreams by God [see Plates 14 and 59]. A large angel vertically plummets down to Solomon's horizontally reclining body. The angel is encircled by God's symbolic light. Chagall draws our attention to Solomon's request for wisdom by having the young King's arm shield his bare head, which is temporarily bereft of the crown set aside for the night. Chagall's depiction of Solomon's dream is close to his descripton of his own childhood dream: "Suddenly the ceiling opens and a winged creature comes down with flashing light and noise filling the room with movement and clouds. A rustling of dragging wings—I think: an angel! I can't open my eyes, the light is too bright, too luminous."[112]

78. THE JUDGMENT OF SOLOMON

The king said, "One says, 'This is my son, the live one, and the dead one is yours'; and the other says, 'No, the dead boy is yours, mine is the live one.' So the king gave the order, "Fetch me a sword."
A sword was brought before the king, and the king said, "Cut the live child in two, and give half to one and half to the other."
But the woman whose son was the live one pleaded with the king, for she was overcome with compassion for her son."Please, my lord," she cried, "give her the live child; only don't kill it!" The other insisted, "It shall be neither yours nor mine; cut it in two!" Then the king spoke up. "Give the live child to her," he said, "and do not put it to death; she is its mother."

I Kings, III, 23–27

Chagall depicts the decisive moment when the true mother is revealed by her love for her threatened child. Chagall contrasts the fair features of the supplicating mother with the angered features of the imposter. Centered in the composition is the object of their dispute—the innocent child dangling in the sworded attendant's grip. An aura of light illuminates the palace setting. Solomon is elevated on his throne. His calm posture expresses his confidence and wisdom to execute justice.

79. PRAYER OF SOLOMON

And now, O LORD God of Israel, keep the further promise that You made to Your servant, my father David: 'Your line on the throne of Israel shall never end, if only your descendants will look to their way and walk before Me as you have walked before Me.' Now therefore, O God of Israel, let the promise that You made to Your servant my father David be fulfilled.

"But will God really dwell on earth? Even the heavens to their uttermost reaches cannot contain You, how much less this House that I have built! Yet turn, O LORD my God, to the prayer and supplication of Your servant, and hear the cry and prayer which Your servant offers before You this day. May Your eyes be open day and night toward this House, toward the place of which You have said, 'My name shall abide there'; may You heed the prayers which Your servant will offer toward this place. And when You hear the supplications which Your servant and Your people Israel offer toward this place, give heed in Your heavenly abode—give heed and pardon.

I Kings, VIII, 25–30

Chagall depicts the dedication of Solomon's Temple. God's presence is indicated by the large cloud emitting rays of light and by the angel sounding the *shofar*. Upon the golden altar in the foreground are set the Tablets of the Law (inscribed with the anachronistic star of David) and the golden, seven-branched *menorah*. In the background, soaring columns indicate the monumental scale of the new sanctuary.

80. THE QUEEN OF SHEBA

The queen of Sheba heard of Solomon's fame, through the name of the LORD, and she came to test him with hard questions. She arrived in Jerusalem with a very large retinue, with camels bearing spices, a great quantity of gold, and precious stones. When she came to Solomon, she asked him all that she had in mind. Solomon had answers for all her questions; there was nothing that the king did not know, [nothing] to which he could not give her an answer. When the queen of Sheba observed all of Solomon's wisdom, and the palace he had built, the fare of his table, the seating of his courtiers, the service and attire of his attendants, and his wine service, and the burnt offerings that he offered at the House of the LORD, she was left breathless.

I Kings, X, 1–5

The figures, building and landscape seem to be dissolving under the glare of the intense light. This etching is filled with charming details of the encounter of these royal personages: the elaborate facade of Solomon's palace (anachronistically decorated in the style of the Torah Arks and curtains of Europe) and the Queen's elegant carriage perched on a camel. Chagall playfully echoes the diagonal of the dark umbrella shielding Solomon with the shade-giving tree next to the palace.

81. SOLOMON ON HIS THRONE

The king also made a large throne of ivory, and he overlaid it with refined gold. Six steps led up to the throne, and the throne had a back with a rounded top, and arms on either side of the seat. Two lions stood beside the arms, and twelve lions stood on the six steps, six on either side. No such throne was ever made for any other kingdom.

I Kings, X, 18–20

Chagall depicts Solomon on his throne with a Byzantine splendor, inflected by his familiarity with Russian icons. While Solomon's wisdom is extolled in Plate 73, here Chagall celebrates the riches and glory that God has promised him.[113]

82. PROPHET KILLED BY A LION

He set out, and a lion came upon him on the road and killed him. His corpse lay on the road, with the ass standing beside it, and the lion also standing beside the corpse. Some men who passed by saw the corpse lying on the road and the lion standing beside the corpse; they went and told it in the town where the old prophet lived. And when the prophet who had brought him back from the road heard it, he said, "That is the man of God who flouted the LORD's command; the LORD gave him over to the lion, which mauled him and killed him in accordance with the word that the LORD had spoken to him."

I Kings, XIII, 24–26

Chagall has chosen to illustrate a rarely depicted subject. The prophet relaxed as if merely asleep, the quiet lion poised by his body, the desert setting and the distinct disk of light in the sky — all bear a curious affinity with Rousseau's *Sleeping Gypsy* (1897). Chagall greatly admired Rousseau, "the painter of the people for the people. More innocent, more grandiose again than Courbet or Seurat."[114] Works by Chagall and Rousseau share a common metaphysical force and frequently use the same symbolic themes derived from the distant past and not borrowed from other painters.[115]

83. ELIJAH AND THE WIDOW OF SAREPTA

And the word of the LORD came to him: "Go at once to Zarephath of Sidon, and stay there; I have designated a widow there to feed you." So he went at once to Zarephath. When he came to the entrance of the town, a widow was there gathering wood. He called out to her, "Please bring me a little water in your pitcher, and let me drink,"

I Kings, XVII, 8–10

Chagall captures the sensation of the arid landscape which echoes Elijah's thirst and conveys the impending famine. A dome of light in the sky covers the scene, signifying God's presence.

Chagall devotes seven etchings in the *Bible* to Elijah, the prophet who has inspired him from his earliest youth. Chagall's childhood memories are filled with references to Elijah. On Yom Kippur: "Papa is all in white. Once a year, on the Day of Atonement, he seems to me the prophet Elijah."[116] On Passover:

My father, raising his glass, tells me to go and open the door, at such a late hour, to let in the Prophet Elijah? A cluster of white stars, silvered against the background of the blue velvet sky, force their way into my eyes and into my heart. But where is Elijah and his white chariot? Is he still lingering in the courtyard to enter the house in the guise of a sickly old man, a stooped beggar, with a sack on his back and a cane in his hand?[117]

The prophet disguised as a beggar first appears in Chagall's oeuvre in 1914 in *Over Vitebsk* and it is a motif that reappears periodically throughout his works. For Chagall, Elijah represents the ever present possibility for a miracle and for salvation.

84. THE CHILD REVIVED BY ELIJAH

After a while, the son of the mistress of the house fell sick, and his illness grew worse, until he had no breath left in him. She said to Elijah, "What harm have I done you, O man of God, that you should come here to recall my sin and cause the death of my son?" "Give me the boy," he said to her; and taking him from her arms, he carried him to the upper chamber where he was staying, and laid him down on his own bed. He cried out to the LORD and said, "O LORD my God, will You bring calamity upon this widow whose guest I am, and let her son die?" Then he stretched out over the child three times, and cried out to the LORD, saying, "O LORD my God, let this child's life return to his body!" The LORD heard Elijah's plea; the child's life returned to his body, and he revived.

I Kings, XVII, 17–22

Elijah's revival of the son of the widow of Sarepta (effected through a miraculous form of cardiopulmonary resuscitation as described in the text) is illuminated by the triple, concentric disks of light inscribed with a star of David and God's name.

The subject of the revived child has a personal meaning for Chagall, who recalls:

But first of all, I was born dead. I did not want to live. Imagine a white bubble that does not want to live. As if it had been stuffed with Chagall pictures. They pricked that bubble with needles, they plunged it into a pail of water. At last it emitted a feeble whimper. But the main thing was, I was born dead.[118]

85. THE OFFERING OF ELIJAH

When it was time to present the meal offering, the prophet Elijah came forward and said, "O LORD, God of Abraham, Isaac, and Israel! Let it be known today that You are God in Israel and that I am Your servant, and that I have done all these things at Your bidding. Answer me, O LORD, answer me, that this people may know that You, O LORD, are God; for You have turned their hearts backward."

Then fire from the LORD descended and consumed the burnt offering, the wood, the stones, and the earth; and it licked up the water that was in the trench.

I Kings, XVIII, 36–38

The circle of God's light, filled with flames, envelops Elijah's offering.

86. ELIJAH ON MOUNT CARMEL

Elijah said to Ahab, "Go up, eat and drink, for there is a rumbling of [approaching] rain," and Ahab went up to eat and drink. Elijah meanwhile climbed to the top of Mount Carmel, crouched on the ground, and put his face between his knees. And he said to his servant, "Go up and look toward the Sea." He went up and looked and reported, "There is nothing." Seven times [Elijah] said, "Go back," and the seventh time, [the servant] reported, "A cloud as small as a man's hand is rising in the west." Then [Elijah] said, "Go say to Ahab, 'Hitch up [your chariot] and go down before the rain stops you.' " Meanwhile the sky grew black with clouds; there was wind, and a heavy downpour fell; Ahab mounted his chariot and drove off to Jezreel. The hand of the LORD had come upon Elijah. He tied up his skirts and ran in front of Ahab all the way to Jezreel.

I Kings, XVIII, 41–46

Through heavily cross-hatched strokes, Chagall conveys a monumental portrayal of Elijah, whose massive, rounded form takes on the quality of the mountain itself. The stippling of the sky suggests the first intimations of the coming rain clouds, anxiously awaited by the prophet.

87. ELIJAH TOUCHED BY AN ANGEL

He lay down and fell asleep under a broom bush. Suddenly an angel touched him and said to him, "Arise and eat." He looked about; and there, beside his head, was a cake baked on hot stones and a jar of water! He ate and drank, and lay down again. The angel of the LORD came a second time and touched him and said, "Arise and eat, or the journey will be too much for you." He arose and ate and drank; and with the strength from that meal he walked forty days and forty nights as far as the mountain of God at Horeb.

I Kings, XIX, 5–8

Of all the angels in Chagall's Bible, generally depicted as heroic, dramatic or fierce messengers of God, this angel is remarkable for its delicacy. Shyly approaching the prophet as a young child might observe a sleeping parent, the angel gently touches the prophet's weary head. In flight from Jezebel's wrath and willing himself to die, Elijah is saved by the angel's gift of the small jar of water and a small cake. The tenderness of the angel's gesture is comparable to the delicacy of Chagall's fine black touches which outline the angel's form, Elijah's face and hands, the horizon line and the young trees.

88. ELIJAH'S VISION

There he went into a cave, and there he spent the night.

Then the word of the LORD came to him. He said to him, "Why are you here, Elijah?" He replied, "I am moved by zeal for the LORD, the God of Hosts, for the Israelites have forsaken Your covenant, torn down Your altars, and put Your prophets to the sword. I alone am left, and they are out to take my life." "Come out," He called, "and stand on the mountain before the LORD."

And lo, the LORD passed by. There was a great and mighty wind, splitting mountains and shattering rocks by the power of the LORD; but the LORD was not in the wind. After the wind—an earthquake; but the LORD was not in the earthquake. After the earthquake—fire; but the LORD was not in the fire. And after the fire—a soft murmuring sound.

When Elijah heard it, he wrapped his mantle about his face and went out and stood at the entrance of the cave. Then a voice addressed him: "Why are you here, Elijah?"

I Kings, XIX, 9–13

Chagall unites God's messenger and Elijah by mirroring their dramatic poses. The charged setting for their encounter is composed of cubistic, fragmented and overlapping planes of black, white and gray.

89. ELIJAH CARRIED OFF TO HEAVEN

As they were crossing, Elijah said to Elisha, "Tell me, what can I do for you before I am taken from you?" Elisha answered, "Let a double portion of your spirit pass on to me." "You have asked a difficult thing," he said. "If you see me as I am being taken from you, this will be granted to you; if not, it will not." As they kept on walking and talking, a fiery chariot with fiery horses suddenly appeared and separated one from the other; and Elijah went up to heaven in a whirlwind. Elisha saw it, and he cried out, "Oh, father, father! Israel's chariots and horsemen!" When he could no longer see him, he grasped his garments and rent them in two.

II Kings, II, 9–12

Elijah's ascension to heaven is a subject which fascinates Chagall throughout his oeuvre. The motif of Elijah's flying chariot appears as early as *The Flying Carriage* (1913),[119] where a Russian peasant flies away in his cart, and reappears in Chagall's set design of *A Fantasy of St. Petersburg* (1942) for the ballet *Aleko*.[120]

This etching becomes the dominant prototype for Elijah in Chagall's Biblical Message mosaic (1970) as well as for his stained glass window for the Union Church of Pocantico Hills, N.Y. (1965–66).

90. PROPHECY OVER JERUSALEM

In the days to come,
The Mount of the LORD's House
Shall stand firm above the mountains
And tower above the hills;
And all the nations
Shall gaze on it with joy.
And the many peoples shall go and say:
"Come,
Let us go up to the Mount of the LORD,
To the House of the God of Jacob;
That he may instruct us in His ways,
And that we may walk in His paths."
For instruction shall come forth from Zion,
The word of the LORD from Jerusalem.
Thus He will judge among the nations

And arbitrate for the many peoples,
And they shall beat their swords into plowshares
And their spears into pruning hooks:
Nation shall not take up
Sword against nation;
They shall never again know war.

O House of Jacob!
Come, let us walk
By the light of the LORD.

Isaiah, II, 2–5

For this etching, Chagall reprises elements from two tragic Jerusalem scenes. He quotes *David Ascending the Mount of Olives* [Plate 71] for the crowd of figures and the distant view of Zion and *David Mourns Absalom* [Plate 73] for the foreground seated figure and the vivid rays of the sun. The spirit of this etching, however, is one of redemption. In the foreground, Isaiah contemplates his joyous prophecy, while the crowd below him expresses jubilation. The angel above carries the scroll of the *Torah*, demonstrating that the source of God's instruction to man will come out of Jerusalem.

91. VISION OF ISAIAH

In the year that King Uzziah died, I beheld my Lord seated on a high and lofty throne; and the skirts of His robe filled the Temple. Seraphs stood in attendance on Him. Each of them had six wings: with two he covered his face, with two he covered his legs, and with two he would fly.

And one would call to the other,
"Holy, holy, holy!
The LORD of Hosts!
His presence fills all the earth!"

The doorposts would shake at the sound of the one who called, and the House kept filling with smoke. I cried,

"Woe is me; I am lost!
For I am a man
Of unclean lips
And I live among a people
Of unclean lips;
Yet my own eyes have beheld
The King LORD of Hosts."

Then one of the seraphs flew over to me with a live coal, which he had taken from the altar with a pair of tongs. He touched it to my lips and declared,

"Now that this has touched your lips,
Your guilt shall depart
And your sin be purged away."

Isaiah, VI, 1–7

Isaiah's purification by a burning coal is a subject that relates to Chagall's childhood memories of his little sister Rachel. "She wasted away as the result of eating charcoal. At last, pale and thin, she breathed her last sigh. Her eyes filled with the blue of heaven, with dark silver."[121]

92. MESSIANIC TIMES

Justice shall be the girdle of his loins,
And faithfulness the girdle of his waist.
The wolf shall dwell with the lamb,
The leopard lie down with the kid;
The calf, the beast of prey,
and the fatling together,
With a little boy to herd them.
The cow and the bear shall graze,
Their young shall lie down together;
And the lion, like the ox, shall eat straw.
A babe shall play
Over a viper's hole,
And an infant pass his hand
Over an adder's den.
In all of My sacred mount
Nothing evil or vile shall be done;
For the land shall be filled with
devotion to the LORD
As water covers the sea.

<div align="right">Isaiah, XI, 5–9</div>

This etching is the first of a cycle of seven plates in the *Bible* which illustrate Isaiah's prophecies of God's redemption of the just and His retribution against the wicked. Created during the 1930s, as Chagall witnessed the rise of Nazism, the intensification of anti-Semitic persecution and the impending outbreak of war, these etchings are imbued wtih Chagall's deepest hopes for peace.

In this composition, God's circle of light now fills the world, embracing all of its creatures in peace and harmony. This etching is the model for the central image of the stained glass window *Peace (The Vision of Isaiah)* (1964) which Chagall designed for the United Nations. It also figures prominently as the *Isaiah's Prophecy* (1963–68) tapestry for Israel's Knesset.

93. ORACLE OVER BABYLON

The "Babylon" Pronouncement, a prophecy of Isaiah son of Amoz.

"Raise a standard upon a bare hill,
Cry aloud to them;
Wave a hand, and let them enter
The gates of the nobles!

I have summoned My purified guests
To execute My wrath;
Behold, I have called My stalwarts,
My proudly exultant ones."

Hark! a tumult on the mountains—
As of a mighty force;
Hark! an uproar of kingdoms,
Nations assembling!
The LORD of Hosts is mustering
A host for war.
They come from a distant land,
From the end of the sky—
The LORD with the weapons of His wrath—
To ravage all the earth!

Howl!
For the day of the LORD is near;
It shall come like havoc from Shaddai.
Therefore all hands shall grow limp,
And all men's hearts shall sink;
And, overcome by terror,
They shall be seized by pangs and throes,
Writhe like a woman in travail.
They shall gaze at each other in horror,
Their faces livid with fright.

Lo! The day of the LORD is coming
With pitiless fury and wrath,
To make the earth a desolation,
To wipe out the sinners upon it.
The stars and constellations of heaven
Shall not give off their light;
The sun shall be dark when it rises,
And the moon shall diffuse no glow.

"And I will requite to the world its evil,
And to the wicked their iniquity;
I will put an end to the pride of the arrogant
And humble the haughtiness of tyrants.
I will make people scarcer than fine gold,
And men than gold of Ophir."

Therefore shall heaven be shaken,
And earth leap out of its place,
At the fury of the LORD of Hosts
On the day of His burning wrath.
Then like gazelles that are chased,
And like sheep that no man gathers,
Each man shall turn back to his people,
They shall flee every one to his land.
All who remain shall be pierced through,
All who are caught
Shall fall by the sword.
And their babes shall be dashed to pieces in their sight,
Their homes shall be plundered,
And their wives shall be raped.

"Behold,
I stir up the Medes against them,
Who do not value silver
Or delight in gold.
Their bows shall shatter the young;

They shall show no pity to infants,
They shall not spare the children."

And Babylon, glory of kingdoms,
Proud splendor of the Chaldeans,
Shall become like Sodom and Gomorrah
Overturned by God.
Nevermore shall it be settled
Nor dwelt in through all the ages.
No Arab shall pitch his tent there,
No shepherds make flocks lie down there.
But beasts shall lie down there,
And the houses be filled with owls;
There shall ostriches make their home,
And there shall satyrs dance.

<div align="right">Isaiah, XIII</div>

The darkness of this prophecy has a contemporary reality for Chagall. God's imminent wrath against a wicked world speaks as powerfully to pre-World War II Europe as to ancient Babylon.

94. GOD WILL HAVE PITY ON JACOB

But the LORD will pardon Jacob, and will again choose Israel, and will settle them on their own soil. And strangers shall join them and shall cleave to the House of Jacob. For peoples shall take them and bring them to their homeland; and the House of Israel shall possess them as slaves and handmaids on the soil of the LORD. They shall be captors of their captors and masters to their taskmasters.

And when the LORD has given you rest from your sorrow and trouble, and from the hard service that you were made to serve, you shall recite this song of scorn over the king of Babylon:

How is the taskmaster vanished,
How is oppression ended!
The LORD has broken the staff
of the wicked,
The rod of tyrants,
That smote peoples in wrath
With stroke unceasing,
That belabored nations in fury
In relentless pursuit.
All the earth is calm, untroubled;
Loudly it cheers.

<div align="right">Isaiah, XIV, 1–7</div>

Chagall composes this depiction of the return to Jerusalem with multiple circular forms: the dome-like hill on which Jerusalem rests, the curve of the procession around the walls ringing the city, the rainbow over Jerusalem (symbolic of God's Covenant with Noah) and the circle of God's light. The dynamic harmony achieved by these overlapping disks and arcs recalls Chagall's works of 1911–12 and his close friendship with Delaunay while the latter was creating his cosmic disk abstractions.

95. DELIVERANCE OF JERUSALEM

Awake, awake, O Zion!
Clothe yourself in splendor;
Put on your robes of majesty,
Jerusalem, holy city!
For the uncircumcised and the unclean
Shall never enter you again.
Arise, shake off the dust,
Sit [on your throne], Jerusalem!
Loose the bonds from your neck,
O captive one, Fair Zion!

For thus said the LORD:
You were sold for no price,
And shall be redeemed without money.
For thus said the Lord God:
Of old, My people went down
To Egypt to sojourn there;
But Assyria has robbed them,
Giving nothing in return.
What therefore do I gain here?
—declares the LORD—
For My people has been carried off for nothing,
Their mockers howl
—declares the LORD—
And constantly, unceasingly,
My name is reviled.
Assuredly, My people shall learn My name,
Assuredly [they shall learn] on that day
That I, the one who promised,
Am now at hand.

How welcome on the mountain
Are the footsteps of the herald
Announcing happiness,
Heralding good fortune,
Announcing victory,
Telling Zion, "Your God is King!"

<div align="right">Isaiah, LII, 1–7</div>

The circle of God's light has become a lens through which we glimpse the deliverance of Jerusalem. Judaic symbols surround this vision—the *tefilin* traditionally worn by praying Jews adorning the angel's forehead, the *shofar* out of which the Hebrew letters for Jerusalem seem to pour, and the small inscription of the star of David. This view of Jerusalem is the prototype for an important motif in Chagall's *Entry Into Jerusalem* (1964–68) tapestry for Israel's Knesset.

96. PROMISE TO JERUSALEM

The LORD has called you back
As a wife forlorn and forsaken.

Can one cast off the wife of his youth?
—said your God.
For a little while I forsook you,
But with vast love I will bring you back.
In slight anger, for a moment,
I hid My face from you;
But with kindness everlasting
I will take you back in love
—said the LORD your Redeemer.
For this to Me is like the waters of Noah:
As I swore that the waters of Noah
Nevermore would flood the earth,
So I swear that I will not
Be angry with you or rebuke you.
For the mountains may move
And the hills be shaken,
But my loyalty shall never move from you,
Nor My covenant of friendship be shaken
—said the LORD, who takes you back in love.

Isaiah, LIV, 6–10

God's covenant with Israel is reiterated through three symbolic representations: the angel unfurling his Baroque drapery to reveal his face; the rainbow and angel which appeared to Noah; and the disk inscribed with God's name present at Creation. In this etching, Chagall has chosen an unlikely text for illustration which is unknown in other biblical cycles.[122] As one of the thirty-nine etchings which were printed from 1952–56, the symbolism of the text takes on an additional meaning for Chagall with the rebirth of the Jewish people after the Holocaust and the 1948 establishment of the State of Israel.

97. MAN GUIDED BY GOD

Then shall your light burst through like the dawn
And your healing spring up quickly;
Your Vindicator shall march before you,
The Presence of the LORD shall be your rear guard.
Then, when you call, the LORD will answer;
When you cry, He will say: Here I am.
If you banish the yoke from your midst,
The menacing hand, and evil speech,
And you offer your compassion to the hungry
And satisfy the famished creature—
Then shall your light shine in darkness,
And your gloom shall be like noonday.
The LORD will guide you always;
He will slake your thirst in parched places
And give strength to your bones.
You shall be like a watered garden,
Like a spring whose waters do not fail.

Isaiah, LVIII, 8–11

Chagall conveys the omnipresence of God by the winged angel leading man forward and the disk of God's light shining behind him. Man is illuminated and guided by their light, which bursts through the surrounding darkness. The monumental profile forms of man and the angel (whose Janus-like body faces forward and backward at the same time) are reminiscent of the gigantic bas-reliefs of the Assyrian and Babylonian temples.[123] Chagall's archaicizing depiction suggests that God's covenant with man is rooted in antiquity and fixed for eternity.

98. SALVATION FOR JERUSALEM

For the sake of Zion I will not be silent
For the sake of Jerusalem I will not be still,
Till her victory emerge resplendent
And her triumph like a flaming torch.
Nations shall see your victory,
And every king your majesty;
And you shall be called by a new name
Which the LORD Himself shall bestow,
You shall be a glorious crown
In the hand of the LORD,
And a royal diadem
In the palm of your God.

Nevermore shall you be called "Forsaken,"
Nor shall your land be called "Desolate";
But you shall be called "I delight in her,"
And your land "Espoused."
For the LORD takes delight in you,
And your land shall be espoused.
As a youth espouses a maiden,
Your sons shall espouse you;
And as a bridegroom rejoices over his bride,
So will our God rejoice over you.

Isaiah, LXII, 1–5

From the text, Chagall compares the love of God for Israel with the love between a man and his bride. His lovers float over Jerusalem, blessed by an angel outspread as a canopy over their heads. In the foreground, the crowned lion of Judah guards over the city.

The floating lovers in this etching recall Chagall's 1915 paintings celebrating his joyous reunion and marriage with Bella, after the long separation of Chagall's sojourn in Paris. The reunion of the lovers can also symbolize the return from exile to Jerusalem—particularly apt with the founding of the State of Israel in 1948, several years before this plate was finally printed.

Chagall's inflection of biblical symbolism (Israel as the 'bride' of God) into his familiar imagery of lovers reminds us that his works often have multiple layers of meaning open to many interpretations.

99. ISAIAH'S PRAYER

But now, O LORD You are our Father;
We are the clay, and You are the Potter,
We are all the work of Your hands.
Be not implacably angry, O LORD,
Do not remember iniquity forever.
Oh, look down to Your people, to us all!
Your holy cities have become a desert:
Zion has become a desert,
Jerusalem a desolation.
Our holy Temple, our pride,
Where our fathers praised You,
Has been consumed by fire:
And all that was dear to us is ruined.
At such things will You restrain Yourself, O LORD,
Will you stand idly by and let us suffer so heavily?

<div align="right">Isaiah, LXIV, 7–12</div>

Isaiah's seated figure, cloaked and shielded by encircled arms, appears like a formless mass—the clay to be worked by God's hands. The hidden face and anger of God decried by Isaiah are suggested in the inverted inscription of God's name in the disk of light and the aggressive sweep of the angel. In this etching, printed after the second World War, Chagall addresses God's absence in antiquity and, perhaps, at Auschwitz.

100. CALLING OF JEREMIAH

The word of the LORD came to me:

Before I created you in the womb, I selected you;
Before you were born, I consecrated you;
I appointed you a prophet concerning the nations.

I replied:
Ah, Lord GOD!
I don't know how to speak,
For I am still a boy.
And the LORD said to me:
Do not say, "I am still a boy,"
But go wherever I send you
And speak whatever I command you.
Have no fear of them,
For I am with you to deliver you

<div align="right">— declares the LORD</div>

The LORD put out His hand and touched my
mouth, and the LORD said to me: Herewith I put
My words into your mouth.

See I appoint you this day
Over nations and kingdoms:
To uproot and to pull down,
To destroy and to overthrow,
To build and to plant.

<div align="right">Jeremiah, I, 4–10</div>

Chagall devotes four etchings in the *Bible* to Jeremiah, the prophet of Israel's tragic fate. Jeremiah's dark prophetic vision is of suffering, defeat and destruction.

101. CAPTURE OF JERUSALEM

Thus said the LORD, the God of Israel: I am going to turn around the weapons in your hands with which you are battling outside the wall against those who are besieging you—the king of Babylon and the Chaldeans—and I will take them into the midst of this city; and I Myself will battle against you with an outstretched mighty arm, with anger and rage and great wrath. I will strike the inhabitants of this city, man and beast: they shall die by a terrible pestilence. And then—declares the LORD—I will deliver King Zedekiah of Judah and his courtiers and the people—those in this city who survive the pestilence, the sword, and the famine—into the hands of King Nebuchadrezzar of Babylon, into the hands of their enemies, into the hands of those who seek their lives. He will put them to the sword without pity, without compassion, without mercy.

<div align="right">Jeremiah, XXI, 4–7</div>

As Chagall etched this plate in 1939 (the last of the suite completed before the war),[124] he was expressing the perilous state of contemporary European Jewry as much as the capture of Jerusalem in antiquity. The exile and destruction of ancient Israel depicted in this plate are prophetic images of the Holocaust. Once again forsaken by God, terror and violence prevail and there is no salvation.

102. JEREMIAH IN THE PIT

Then the officials said to the king, "Let that man be put to death, for he disheartens the soldiers, and all the people who are left in this city, by speaking such things to them. That man is not seeking the welfare of this people, but their harm!" King Zedekiah replied, "He is in your hands; the king cannot oppose you in anything!"
So they took Jeremiah and put him down in the pit of Malchiah, the king's son, which was in the prison compound; they let Jeremiah down by ropes. There was no water in the pit, only mud, and Jeremiah sank into the mud.

<div align="right">Jeremiah, XXXVIII, 4–6</div>

In the blackened depths of the pit, a diagonal shaft of brilliant light illuminates the stoic prophet. God's presence is indicated by the angel lurking in the shadows, whose outstretched hand becomes transparent in the light.

103. SUFFERINGS OF JEREMIAH

Alas!
Lonely sits the city
Once great with people!
She that was great among nations
Is become like a widow;
The princess among states
Is become a thrall.
Bitterly she weeps in the night,
Her cheek wet with tears.
There is none to comfort her
Of all her friends.
All her allies have betrayed her;
They have become her foes.
Judah has gone into exile
Because of misery and harsh oppression;
When she settled among the nations,
She found no rest;
All her pursuers overtook her
In the narrow places.
Zion's roads are in mourning,
Empty of festival pilgrims;
All her gates are deserted.
Her priests sigh,
Her maidens are unhappy—
She is utterly disconsolate!
Her enemies are now the masters,
Her foes are at ease,
Because the LORD has afflicted her
For her many transgressions;
Her infants have gone into captivity
Before the enemy.
Gone from Fair Zion are all
That were her glory;
Her leaders are like stags
That found no pasture;
They could only walk feebly
Before the pursuer.

All the precious things she had
In the days of old
Jerusalem recalled
In her days of woe and sorrow,
When her people fell by enemy hands
With none to help her;
When enemies looked on and gloated
Over her downfall.
Jerusalem has greatly sinned,
Therefore she is become a mockery
All who admired her despise her,
For they have seen her disgraced;
And she can only sigh
And shrink back.
Her uncleanness clings to her skirts.
She gave no thought to her future;
She has sunk appallingly,
With none to comfort her.—
See, O LORD, my misery;
How the enemy jeers!

Lamentations, III, 1–9

Begun before the war, Chagall returned to the plate in 1951 to complete this etching. The heavily worked, elaborately textured etching is an extraordinary example of Chagall's gifts as a printmaker. In limiting the image to the prophet's face and hand, Chagall is able to concentrate the intensity of the emotion. In the aftermath of the destruction of European Jewry, Chagall's portrait of Jeremiah expresses the pain of the surviving witnesses.

104. EZEKIEL'S VISION

However, each had four faces, and each of them had four wings; the legs of each were [fused into] a single rigid leg, and the feet of each were like a single calf's hoof; and their sparkle was like the luster of burnished bronze. They had human hands below their wings. The four of them had their faces and their wings on their four sides. Each one's wings touched those of the other. They did not turn when they moved; each could move in the direction of any of its faces.

Each of them had a human face [at the front]; each of the four had the face of a lion on the right; each of the four had the face of an ox on the left; and each of the four had the face of an eagle [at the back]. Such were their faces. As for their wings, they were separated: above, each had two touching those of the others, while the other two covered its body. And each could move in the direction of any of its faces; they went wherever the spirit impelled them to go, without turning when they moved.

Such then was the appearance of the creatures. With them was something that looked like burning coals of fire. This fire, suggestive of torches, kept moving about among the creatures; the fire had a radiance, and lightning issued from the fire. Dashing to and fro [among] the creatures was something that looked like flares.

Ezekiel, I, 6–14

Ezekiel's terrifying vision is enveloped in vivid light and flames. Chagall's depiction of these multifaced and winged creatures of God calls upon his own unique repertory of animal-personages.

105. CALLING OF EZEKIEL

"And you, mortal, heed what I say to you: Do not be rebellious like that rebellious breed. Open your mouth and eat what I am giving you."

—as He said to me, "Mortal, feed your stomach and fill your belly with this scroll that I give you." I ate it, and it tasted as sweet as honey to me.

Ezekiel, II, 8; III, 3

Chagall completes his *Bible* with the vision of Ezekiel eating the scroll handed down by God, thus symbolizing that the bitter lessons inscribed in the sacred text are our sustenance. Morally and spiritually, this text feeds us and grants us wisdom and strength. Through this sustenance, and the knowledge it imparts, there is hope for all mankind.

Notes

1. Charles Sorlier, ed., *Chagall by Chagall* (New York: Harrison House, 1979), 187.

2. Author's conversation with Meyer Schapiro, January 27, 1987.

3. Jacques Maritain, "Eaux-Fortes de Chagall pour la Bible," *Cahiers d'Art*, 1–4 (1934): 84.

4. Meyer Schapiro, "Chagall's *Illustrations for the Bible*," *Verve, Bible-Marc Chagall*, vol. VII, Paris, 1956 reprinted in *Modern Art, 19th and 20th Centuries, Selected Papers* (New York: George Braziller, 1978), 122 (hereafter cited as *Chagall*).

5. Raissa Maritain, *Marc Chagall ou l'orage enchanté* (Geneva-Paris: Editions Trois Collines, 1948), 98.

6. Schapiro, *Chagall*, p. 133.

7. Camille Bourniquel, "The Master of the Imaginary," in G. di San Lazzaro, ed., *Homage to Chagall* (New York: Tudor, n.d.), 23.

8. Marc Chagall, *My Life* (New York: Orion Press, 1960), 106–7.

9. Sorlier, *Chagall by Chagall*, p. 241.

10. Jacques Lassaigne, *Chagall* (Paris: Maeght Editeur, 1957), 28.

11. Riva Castleman, *Chagall—Prints, Monotypes, Illustrated Books* (New York: Museum of Modern Art, 1979), 11.

12. Susan Compton, *Chagall* (Philadelphia: Philadelphia Museum of Art, 1985), 264.

13. Una E. Johnson, *Ambroise Vollard, Editeur—Prints, Books, Bronzes,* (New York: Museum of Modern Art, 1977), 33 (hereafter cited as *Vollard*).

14. Waldemar George, "Chagall Graveur," *Le Courier Graphique* 34 (Janvier/Février 1948): 26.

15. Johnson, *Vollard*, p. 44.

16. Johnson, *Vollard*, p. 74.

17. George, "Chagall Graveur," p. 30.

18. Jean Leymarie, *Hommage à Tériade* (Paris: Grand Palais, 1973), 93.

19. Leymarie, *Hommage à Tériade*, p. 86.

20. Leymarie, *Hommage à Tériade*, p. *vii–xiv*.

21. Lassaigne, *Chagall*, 70–80.

22. Marc Chagall, "Avant Propos," *Chagall Lithographie I* (Paris: Editions André Sauret, 1960), 11.

23. Franz Meyer, *Marc Chagall, His Graphic Work* (New York: Abrams, 1957), *v* (hereafter cited as *Graphic Work*).

24. Chagall's 20 etchings for *Mein Leben* were ultimately issued as a portfolio by Cassirer in 1923; Chagall's text was first published only in 1931.

25. Meyer, *Graphic Work*, p. *vi*.

26. For a detailed analysis of Chagall's etching technique, see Una E. Johnson, *Ambroise Vollard, Editeur, 1867–1939, An Appreciation and Catalogue* (New York, Wittenborn, 1944), 43 (hereafter cited as *Vollard, 1867–1939*); Lassaigne, *Chagall*, 80; Johnson, *Vollard*, 33–34; Meyer, *Graphic Work*, xxv.

27. Chagall, *My Life*, p. 14.

28. Leon Leneman, *Un Enfant Juif de Vitebsk* (Paris: Le Comité Pour la Langue et la Culture Yiddish en France, 1983), 16; and "Vitebsk," *Encyclopaedia Judaica* (Jerusalem-New York: MacMillan, Co., 1971), 191.

29. "Vitebsk," p. 191.

30. Chagall, *My Life*, p. 44.

31. Chagall, *My Life*, p. 29.

32. Chagall, *My Life*, p. 14.

33. Chagall, *My Life*, p. 127–8.

34. Chagall, *My Life*, p. 39.

35. Gilbert Lascault, "Monumental Paintings," in Leon Amiel, ed., *Homage to Chagall* (New York: Leon Amiel, 1982), 70.

36. Marcel Brion, *Chagall* (New York: Harry N. Abrams, Inc., 1961), 65.

37. Letter from Chagall to Leon Leneman dated September 13, 1974, in Leneman, *Un Enfant Juif de Vitebsk*, 155.

38. Ziva Amishai-Maisels, "Chagall's Jewish In-Jokes," *Journal of Jewish Art* 5 (1978), 89–92.

39. Compton, *Chagall*, p. 195.

40. Chagall, *My Life*, p. 37, 39.

41. Chagall, *My Life*, p. 43–44.

42. Chagall, *My Life*, p. 27.

43. Sorlier, *Chagall on Chagall*, p. 195.

44. Franz Meyer, *Marc Chagall* (New York: Harry N. Abrams, Inc., 1963), 384.

45. Jean Cassou, *Chagall* (New York-Washington: Frederick A. Praeger, 1965), 248.

46. Meyer, *Chagall*, p. 385.

47. Meyer, *Chagall*, p. 385.

48. Meyer, *Chagall*, p. 385.

49. Compton, *Chagall*, p. 46.

50. Compton, *Chagall*, p. 46.

51. Meyer, *Chagall*, p. 14.

52. Sorlier, *Chagall by Chagall*, p. 201.

53. Dora Vallier, "From Memories to Myth," in G. di San Lazzaro, ed., *Homage to Marc Chagall* (New York: Tudor, n.d.), 65.

54. Chagall, *My Life*, p. 134.

55. Compton, *Chagall*, p. 46.

56. Marc Chagall, "For the Artist-Martyrs," (1950) reprinted in Yiddish facsimile and French translation in Leneman,

Un Enfant Juif de Vitebsk, p. 138.

57. Marc Chagall, "For the Artist-Martyrs," 140.

58. Meyer, *Graphic Work*, p. *vi*.

59. See Jean Chatelain, *Le Message Biblique-Marc Chagall* (Paris: Mourlot, 1972).

60. See Robert Marteau, *Les Vitraux de Chagall, 1957–1970* (Paris: A. C. Mazo, 1972).

61. See Irmgard Vogelsanger-de Roche, *Die Chagall-Fenster in Zurich* (Zurich: Orell Füssli, 1971).

62. See Bernice Rose, *9 Windows by Chagall* (New York: Museum of Modern Art, 1978).

63. See Charles Sorlier, *Les Ceramiques et Sculptures de Chagall* (Monaco: Editions André Sauret, 1972), 38–81.

64. See Ziva Amishai-Maisels, *Marc Chagall and the Knesset* (New York: Tudor, 1973). The proscription of the representation of the human figure for Chagall's stained glass windows for the Hadassah-Hebrew University Medical Center in Jerusalem prevented Chagall from quoting the portraits of the *Bible* suite. For these windows, Chagall created a new symbolic vocabulary of emblems and animals to represent the 12 Tribes of Israel.

65. Sorlier, *Chagall by Chagall*, p. 193.

66. Bernard Dorival, *Le Message Biblique de Marc Chagall— Donation Marc et Valentina Chagall* (Paris: Musée du Louvre Gallerie Mollien, 1967), 3–7.

67. Schapiro, *Chagall*, 130.

68. Pierre Provoyeur, *Chagall, Biblical Interpretations* (New York-London: Alpine Fine Arts Collection, 1983); 117 (hereafter cited as *Chagall*).

69. Chagall, *My Life*, p. 11.

70. Meyer, *Chagall*, p. 380.

71. Compton, *Chagall*, p. 213.

72. Chagall, *My Life*, p. 45–46.

73. Amishai-Maisels, "Chagall's Jewish In-Jokes," p. 79.

74. Chagall, *My Life*, p. 5.

75. Provoyeur, *Chagall*, p. 124.

76. Schapiro, *Chagall*, p. 129.

77. Schapiro, *Chagall*, p. 132.

78. Chagall, *My Life*, p. 27.

79. Marc Chagall, "Sur le pays neuf," (1950–60), excerpted and translated into English in Compton, *Chagall*, p. 255.

80. Provoyeur, *Chagall*, p. 132.

81. Chagall, *My Life*, p. 73–74.

82. Pierre Provoyeur, Marc Chagall, *Oeuvres sur Papier* (Paris: Centre Georges Pompidou-Musée National d'Art Moderne, 1984), 176.

83. Meyer, *Chagall*, p. 383.

84. Meyer, *Chagall*, p. 400.

85. Schapiro, *Chagall*, p. 127.

86. Schapiro, *Chagall*, p. 127.

87. Chagall, *My Life*, p. 134.

88. Compton, *Chagall*, p. 46.

89. Johnson, *Vollard, 1867–1939*, p. 43.

90. *Exodus*, XXXI, 1–5 describes how God has singled out Bezalel and endowed him with a divine spirit of skill, ability and knowledge in every kind of craft.

91. *Exodus*, XXV, 31–40.

92. *Exodus*, XXVIII, 15–30.

93. *Exodus*, XXVIII, 31–35.

94. *Exodus*, XXVIII, 36–38.

95. "Chagall et les 'elements du monde,'" *L'Art Sacré* 11–12 (Juillet-Aôut 1961), 5.

96. Chagall, *My Life*, p. 5, 11.

97. Schapiro, *Chagall*, p. 126.

98. Provoyeur, *Chagall*, p. 30.

99. Schapiro, *Chagall*, p. 129.

100. I *Samuel*, IX, 2.

101. I *Samuel*, IX, 9.

102. I *Samuel*, XVI, 12.

103. I *Samuel*, XVI, 18.

104. Schapiro, *Chagall*, p. 126.

105. Chagall, *My Life*, p. 27.

106. Virginia Haggard, *My Life with Chagall* (New York: Donald I. Fine, 1986), 127.

107. Lascault, "Monumental Paintings," p. 106–7.

108. Compton, *Chagall*, p. 227.

109. II *Samuel*, V, 7.

110. Lassaigne, *Chagall*, p. 59.

111. II *Samuel*, XIV, 26.

112. Gilbert Lascault, "In Alice's Wonderland," in G. di San Lazzaro, ed., *Homage to Marc Chagall* (New York: Tudor, n.d.), 112.

113. I *Kings*, III, 13.

114. Lassaigne, *Chagall*, p. 30.

115. Meyer, *Chagall*, p. 14.

116. Chagall, *My Life*, p. 37.

117. Chagall, *My Life*, p. 39.

118. Chagall, *My Life*, p. 1.

119. Compton, *Chagall*, p. 180–181.

120. Compton, *Chagall*, p. 248.

121. Chagall, *My Life*, p. 60.

122. Schapiro, *Chagall*, p. 126.

123. Schapiro, *Chagall*, p. 127.

124. Compton, *Chagall*, p. 272.